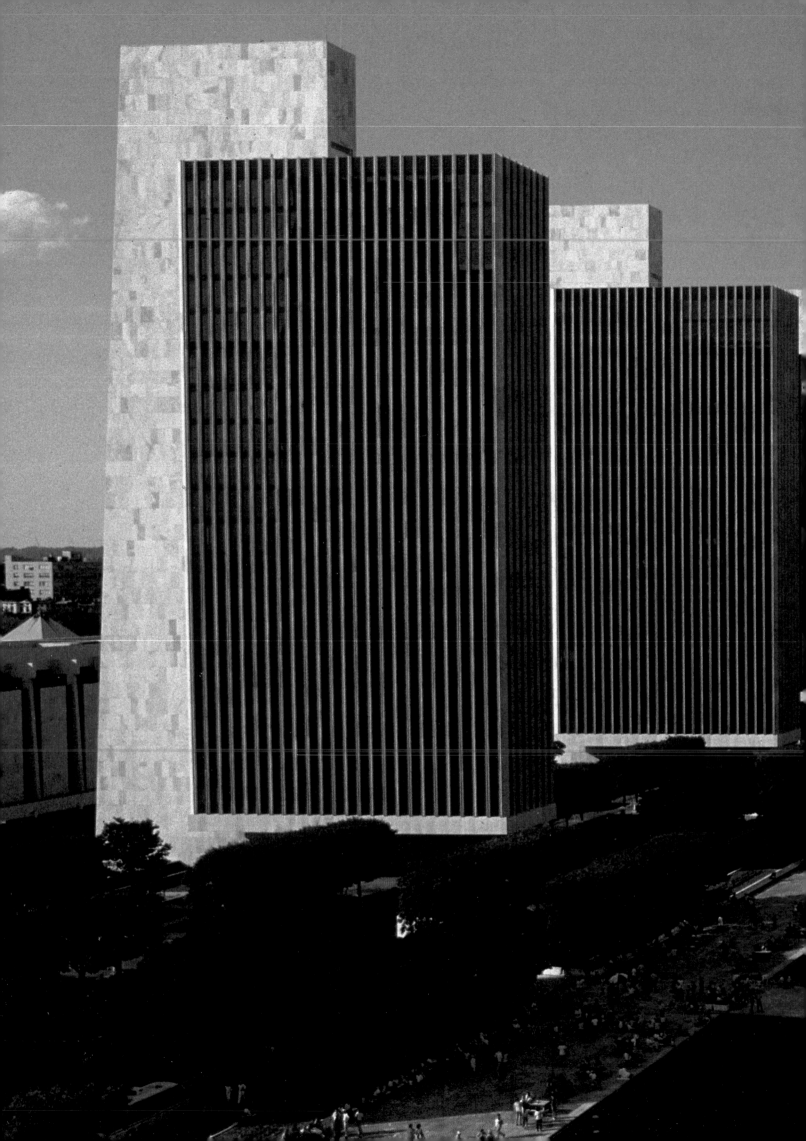

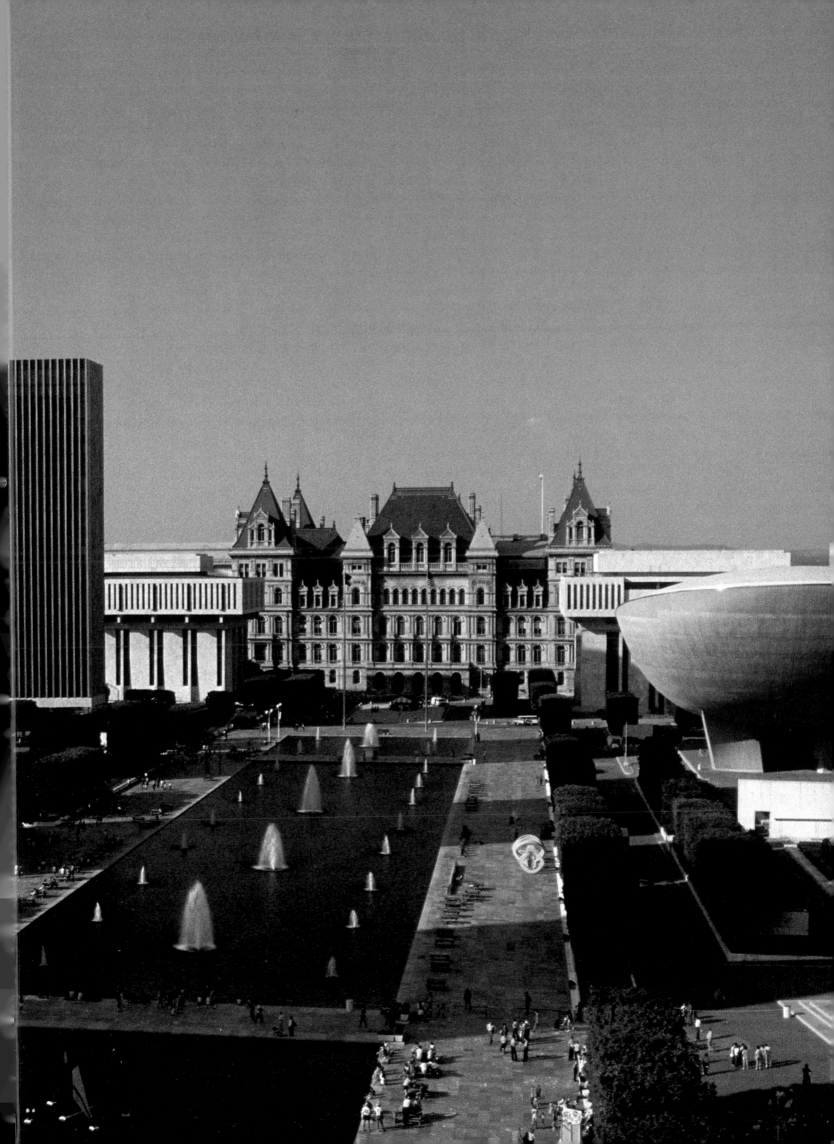

The Empire State Collection:

Art For The Public

Governor Mario M. Cuomo:

Foreword

Irving Sandler:

Introduction

Lee Boltin:

Photography

Empire State Plaza Art Commission, Albany

in association with

Harry N. Abrams, Inc., New York

Library of Congress Cataloging
in Publication Data

The Empire State collection.
Catalogue.
1. New York school of art Catalogs.
2. Art, American Catalogs.
3. Art, Modern 20th century
United States Catalogs.
4. Public art New York (State)
Albany Catalogs.
5. Empire State Plaza (Albany, N.Y.)
Catalogs.
I. Empire State Plaza Art
Commission.
N6512.5.N4E47 1987
709'.73'074014743 86–26452
ISBN 0–8109–0884–0

Copyright © 1987
by Empire State Plaza Art
Commission

Printed in
the United States of America
New York State

Editor:
Elizabeth W. Easton

Photography:
Lee Boltin

Design:
Rudolph de Harak & Associates, Inc.
Typesetting:
Monotype Composition Co.
Boston, MA
Printing:
Rapoport Printing Corp.
New York, NY
Binding:
Publishers Book Bindery
Long Island City, NY

Cover:
Alexander Calder
1898–1976
Triangles and Arches, 1965
painted steel
19'-0" x 30'-0"

Frontispiece:
The Governor Nelson A. Rockefeller
Empire State Plaza, Albany, New York

Acknowledgements

Purchased by New York State between 1966 and 1973 on the recommendation of such distinguished scholars and patrons as Wallace K. Harrison, René d'Harnoncourt, Dorothy C. Miller, Seymour H. Knox, and Robert M. Doty, the Empire State Plaza Art Collection contains outstanding examples of the work of most of the important American artists of the 1960s who lived and worked in New York State.

This catalogue represents the efforts of many people. Senator Tarky Lombardi and Assemblyman William Passannante not only initiated the idea of and sponsored the legislation for this Commisison, but also shepherded the bills through three legislative sessions in Albany. On August 12, 1983 Governor Mario Cuomo's signature brought into being the Empire State Plaza Art Commission. Charged with responsibility to oversee the collection, the Commission's first goal is the publication of this definitive catalogue of the collection's ninety-two works.

There would be no catalogue without the generous funds provided by David and Laurance S. Rockefeller, in honor of their brother Nelson. The Commission is also grateful for support from its Commission member, Sidney Cohn, and the New York State Council on the Arts, which awarded a grant to the Albany Institute of History and Art for the publication of the catalogue.

Commissioner John C. Egan of the Office of General Services (OGS) provided dynamic leadership throughout the project. He was assisted by then Deputy Commissioner, Richard J. Van Zandt. Emeric Levatich, OGS Counsel, prepared the contracts for the catalogue production and Michael E. Rush, Director of Fiscal Services, supervised the budgetary concerns. Deputy Commissioner Milagros Baez O'Toole and Empire State Plaza Manager Thomas Christensen supervised the maintenance and security of the collection while Joan G. Whitbeck, Arts Administrator, acted as liaison between the Empire State Plaza Art Commission and the Office of General Services on all aspects of the catalogue.

The Albany Institute of History and Art, under the direction of Norman S. Rice, and Christine M. Miles as of April 1986, has ably administered the Curatorial Services Office since 1978. Tammis K. Groft, Curator of the Empire State Plaza Art Collection, has for many years kept her watchful eye on the collection's curatorial, conservation and educational programs. She has been assisted in this task by Janice M. Fontanella and Carolyn D. Wilson.

Mrs. Mario Cuomo generously provided her enthusiastic counsel and the Executive Mansion for the meetings of the Commission.

The Commission is also grateful to Irving Sandler, who not only wrote the introductory essay but also attended the Commission meetings. Tiffany Bell wrote the majority of catalogue entries while Kathy O'Dell added a sizeable number. Their research would not have been complete without the aid of Tammis Groft and Janice Fontanella, who not only wrote entries but also made available all the files and documents about the works in the collection. They were assisted by Monique Desormeau and research volunteers Philip Drapkin and Ruth Weinberg.

Rudolph de Harak and Richard Poulin designed a catalogue of the highest quality, with the assistance of Ran VanKoten. Photographer Lee Bolton spent many days in Albany photographing the collection in all seasons, with the assistance of Richard Haynes.

Rosalyn Deutsche skillfully edited the text and Tom Repensek did a thorough job of copy editing and proofreading. Carol Eliel, Emily Braun, and Anne Umland provided invaluable administrative support to the production of the catalogue. Clare Zannoni and Robin Drummond prepared the copy for publication.

Marti Malovaney enthusiastically supervised the project at Harry N. Abrams, Inc. The editorial staff, under the direction of Leta Bostelman, is certainly to be thanked for its comprehensive advice about the text. Phyllis Freeman especially deserves thanks for her effort.

Elizabeth Easton coordinated the project from first to last; without her this catalogue could not have been published.

Dedicated to the people of New York State, and intended for the benefit of both scholars and the general public, we are proud to publish a catalogue reflecting Governor Rockefeller's view that:

> If one loves beautiful things and is in tune with the life and culture of one's own time, the most natural fulfillment is to collect contemporary art that reflects the period. Art is the symbol of the culture to which it belongs.

Empire State Plaza Art Commission

Contents

Editor:

Elizabeth W. Easton

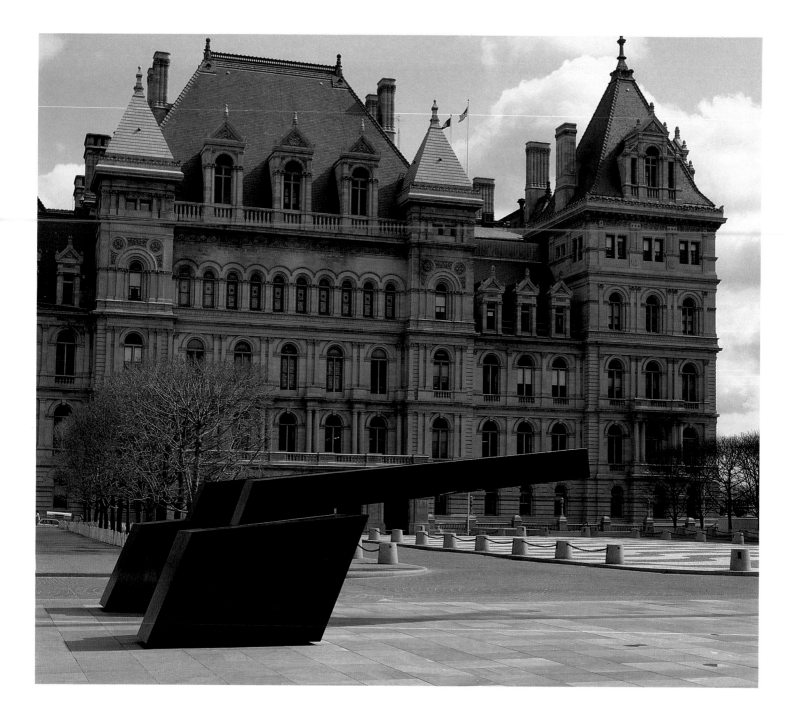

This collection of paintings and sculptures by the New York School is one of the treasures of New York State. These ninety-two works constitute a significant example of governmental patronage of the arts and represent a monumental integration of contemporary art, architecture, and public life.

Each work of art was selected by a distinguished group of art historians and museum professionals under the direction of my predecessor, Nelson A. Rockefeller. All New Yorkers should celebrate the collection as testimony both to the greatest collective endeavor of *The New York School*, the first American art movement to have a truly international influence, and to an original concept of art in a great public space.

The collection needed a catalogue, and in 1984, I appointed a commission of citizens for that purpose. They have created a catalogue of superior quality in order that the collection will be available to both the public and the art historical community. We are now pleased to present this fine document to the people of New York.

January 7, 1987

Mario M. Cuomo
Governor
State of New York

The ninety-two paintings, sculptures, and tapestries on display in The Governor Nelson A. Rockefeller Empire State Plaza form the greatest collection of modern American art in any single public site that is not a museum. Indeed, during working hours, the quarter-of-a-mile-long concourse which connects all the main government buildings, and is the locus for fairs, trade shows, festivals, and public events of every kind, is as busy a thoroughfare as any in the United States. Both the architectural complex and the art that graces it were the vision of Nelson Rockefeller, Governor of New York from 1959 to 1973. During his years in office, no other public figure in America had the inclination and the imagination to plan a program of building and art acquisition as ambitious as that in Albany, and the resolve and political acumen to realize it.

Family tradition surely played a part in the Governor's devotion to architecture and art. The Rockefellers have been instrumental in the building of Rockefeller Center, Lincoln Center, and the World Trade Center in New York City, and restoring Reims Cathedral and the palaces of Versailles and Fontainebleau in France. The Governor himself was responsible for 390 State University architectural projects, many of them on brand-new campuses, and 90,000 low- to middle-income housing units, among other building enterprises. "He confessed to having an 'edifice complex' and unrealized ambitions to be an architect."[1] In fact, it was he who proposed the basic design of the Empire State Plaza; its model was to be the palace of the Dalai Lama at Lhasa, Tibet, which had profoundly impressed him in a never-forgotten visit.[2]

The Governor's mother, Abby Aldrich Rockefeller, had been one of the three "Ladies" who in 1929 had founded The Museum of Modern Art in New York City. She had selected Nelson from among her five sons — he was the second — to carry on her efforts on behalf of art. In 1930, at the age of twenty-two, just one year after his graduation from Dartmouth College, he was appointed to The Museum of Modern Art's Advisory Committee. He was then elevated to chairman of the Advisory Committee, member of the Board of Trustees, Museum treasurer, and, in 1939, president. Moreover, with the advice of Alfred H. Barr, Jr., the Museum's founding director, and Barr's close associate, Dorothy C. Miller, Rockefeller assembled one of the finest private collections of modern art in America.

By the sixties, it was clear that New York State needed a new complex of government buildings, partly because existing office facilities had become too cramped, partly to spearhead needed urban renewal in Albany. Rockefeller's aspiration, as the commission he set up reported in 1963, was to build "a Capital City" befitting New York State's place in America's history, that is, "second to none in our Nation — or indeed, in our world."[3] Art would be vital to help attain this goal. As Rockefeller said: "Throughout human history, the flourishing of great civilizations has been synonymous with the flourishing of great art and architecture."[4] Indeed, art and architecture reflect the true worth of a people. Rockefeller could have pointed to illustrious predecessors, for example, Pericles, who commissioned Phidias to create sculpture for the Parthenon in Athens, and Pope Julius II, who enlisted Raphael and Michelangelo when he rebuilt St. Peter's in Rome.

Painting and sculpture of the stature envisioned by Rockefeller was available. The present was, as he remarked, "an exciting era in art. New York is the center of the contemporary movement in the [international] art world. And, therefore, it is eminently fitting that . . . great artists [who live there] should be represented in this state complex."[5] But on the whole, the vaunted art of the New York School was abstract. That made the Governor's proposal politically risky; the public at large did not approve of modern art, much less abstraction. Public opinion was changing, however, and Rockefeller seems to have been among the first to sense this. During the sixties, interest in art grew to an unprecedented degree, manifested in the proliferation of museums, community art centers and schools, and departments of art in universities and colleges. New and difficult avant-garde art achieved greater acceptance than ever before. Moreover, government attitudes toward state patronage of art were changing. Rockefeller played a seminal role in this change; in 1960, he conceived of the New York State Council on the Arts, whose purpose would be the advancement of the arts, helped legislate it into being, and shaped its programs. The council became the model for the National Endowment for the Arts, which was formed in 1965, and subsequently for arts councils in other states. Local, state, and federal governments were ceasing to be reluctant patrons. Quite the contrary, they were becoming enthusiastic supporters of living art.

This change of attitude is attested to in the remarks of the American Presidents most responsible for inaugurating the National Endowment for the Arts. In 1963 John F. Kennedy said: "I see little of more importance to the future of our country and our civilization than full recognition of the place of the artist." Lyndon B. Johnson reaffirmed Kennedy's sentiment in 1965: "Art is a nation's most pre-

cious heritage. For it is in our works of art that we reveal to ourselves, and to others, the inner vision which guides us as a nation. And where there is no vision, the people perish."[6]

Rockefeller's timing was right not only politically but aesthetically. Contemporary artists had been creating ever bigger works suited to large spaces. Many painters, among them Mark Rothko and Clyfford Still, used color in larger and larger expanses to make a strong visual and emotional impact. To intensify the immediate effect of their pictures, the artists turned them into environments, sometimes replacing entire walls, figuratively enveloping the viewer. Sculpture also grew to such proportions that it looked cramped in private homes, galleries, and even museums, and seemed better suited to plazas, concourses, streets, and parks. Naturally, this led sculptors to think of installing their work in public places, and to consider the relation of the work to its environment and to the people who lived in the neighborhood about its public role.

Sculptors began to construct pieces in and for specific sites, as Herbert Ferber did, or to assemble works to cover the walls of rooms and fill the space from floor to ceiling, as Louise Nevelson did, or to incorporate elements from the actual environment into their life-size works, as George Segal did. So conscious of their surroundings did artists become that a number moved out-of-doors into landscape, forming huge works from earth and other natural substances. Thus, just at a time when growing numbers of artists began to require public spaces to display their works most effectively, public agencies, among the first of which was New York State, made such spaces available.

To assure that art would be incorporated into the Empire State Plaza, Rockefeller saw to it that every construction contract contained a clause allotting a percentage of the total cost of a building for the purchase of art. In so doing, Rockefeller was one of the first to point the way to what has now become a common practice of growing numbers of federal agencies, and state and municipal governments. To select the paintings and sculptures, Rockefeller appointed a distinguished Art Commission in 1965; it served until 1973. Its members were Wallace K. Harrison as chairperson, Seymour H. Knox, René d'Harnoncourt, succeeded after his death in 1968 by Dorothy C. Miller, and Robert M. Doty as secretary. The commission was free to choose whatever art it believed appropriate. The Governor did make an occasional recommendation—works by Jason Seley and François Stahly—and had final approval; he could veto committee selections if he wished, but did not.

However, his taste was well known to his appointees; all but Doty were old friends. Indeed, Harrison and Miller were among the four people to whom Rockefeller claimed in 1978 to have been "especially indebted . . . for the endless joy" modern art had given him for half a century. The other two were his mother and Alfred Barr.[7]

The commission's chairman, Harrison, was the principal architect for the Plaza. His personal and professional association with Rockefeller dated from the construction of Rockefeller Center in New York City in the middle thirties. Sharing Rockefeller's enthusiasm for modern art, Harrison had commissioned Henri Matisse and Fernand Léger to create murals for Rockefeller's apartment in 1936. Harrison also incorporated in his buildings works by, among others, Alexander Calder, Naum Gabo, and Isamu Noguchi. Major sculptures by these three twentieth-century masters would be acquired for the Empire State Plaza. Seymour Knox had been the president of the Buffalo Fine Arts Academy since 1938, had been largely responsible for the formation of the Albright-Knox Art Gallery, and had donated more than half of its world-famous permanent collection, including a splendid representation of post–World War II American abstract painting and sculpture. He also provided the funds for the construction of a new wing of the Albright-Knox to house the contemporary holdings. Impressed by his contribution to the arts, Rockefeller appointed Knox to be the first chairman of the New York State Council on the Arts.

D'Harnoncourt had worked with Rockefeller in the Inter-American Affairs Office of the federal government during World War II. He then joined the staff of The Museum of Modern Art, becoming its director in 1949. Miller had been in the Modern's employ since 1934. From 1942 to 1963 she had organized six prestigious if controversial shows of "Americans." "In terms of picking all-time winners," art historian Robert Rosenblum wrote, "they add up to an amazing record of historical and critical wisdom."[8] In 1958 Miller mounted "The New American Painting," the first major museum survey of the leading Abstract Expressionists. Robert M. Doty was brought into the commission as secretary by Knox; he would soon become a curator at the Whitney Museum of American Art and is currently the director of the Currier Gallery of Art in Manchester, New Hampshire.

Public art takes a variety of forms and serves a variety of purposes: landmarks, functional works, didactic works, memorials, decorative works, and works that are made and chosen primarily for their aesthetic quality. The Art

Commission decided to concentrate on the last category. Its first priority would be to acquire art by living artists. The art had to be of the highest quality — and reasonably priced; the commissioners were very conscious that they were spending taxpayers' money. The place to look for contemporary art was New York City, since it had replaced Paris as the capital of global art during World War II and had maintained (and continued to maintain) its leadership. Avant-garde painting in the United States, commonly labeled Abstract Expressionism, had achieved growing national and international influence as the most vital and original complex of styles in our times. Featured in "The New American Painting," a show that toured eight European countries and then ended at The Museum of Modern Art in 1959, Abstract Expressionism was widely acclaimed, marking what would later be viewed as the triumph of American painting.

Because the best of world art was being created by American painters and sculptors, most of whom lived in New York, the commissioners decided to confine their acquisitions (but not rigidly) to these artists. (A sculpture by Stahly, a French artist, was included among the American works.) The commissioners believed that abstract art was "the most important development in contemporary American art" and also decided to limit the collection to it. (Exceptions were made in the cases of George Segal, Allan D'Arcangelo, and Jason Seley.) They concluded that confining the acquisitions to abstractions would "give uniformity to the selection of art works."[9] It also made sense to incorporate abstract art into modern architecture; traditional art might not have fit as well.

Like Rockefeller, the Art Commissioners were disposed to art that was fresh and alive, even though some of it would be difficult for the general public to understand. They were knowledgeable and secure enough in their taste to risk the purchase of new work by living artists. As a result, the ninety-two paintings, sculptures, and tapestries in the Empire State Plaza constitute a sixties collection, and it turned out to be an accurate cross section of the finest abstract art of the decade in which it was acquired. It is noteworthy that the art is of the same period as the architecture; in this sense, they are complementary.

The commissioners did not limit their purchases only to works of artists who emerged in the sixties. They acquired a superb representation of works by older artists, notably Abstract Expressionist painters, such as Adolph Gottlieb, Philip Guston, Franz Kline, Robert Motherwell, Mark Rothko, and Clyfford Still. Within Abstract Expression-

ism, there were two main tendencies: one is commonly called color-field painting; the other, action or gesture or painterly painting. Painterly painting, that of older artists, such as James Brooks, Guston, and Kline, and of younger ones, such as Helen Frankenthaler, Grace Hartigan, and Joan Mitchell, aims to find form for the creative experience of the artist. As Meyer Schapiro remarked: "The consciousness of the personal and the spontaneous . . . stimulates the artist to invent devices of handling, processing, surfacing, which confer to the utmost degree the aspect of the freely made. Hence the importance of the mark, the stroke, the brush, the drip, the quality of the substance of the paint itself, and the surface of the canvas as a texture and field of operation — all signs of the artist's active presence."[10] Painters believed with justification that if they shaped their images according to the dictates of their inner needs, the feeling generated would be conveyed to viewers.

The color-field painters Clyfford Still and Mark Rothko were visionaries intent on suggesting the sublime or what Rothko called "transcendental experience" and Still, "revelation." Most if not all of us have experienced the sublime before certain awesome natural phenomena, for example, Niagara Falls, the Grand Canyon, or the Rockies. Rothko and Still aimed to evoke the sublime in painting solely through the use of color. To intensify color's visual and emotional impact, they eliminated subject matter, simplified drawing and surface textures that distract attention from color, suppressed the contrast of light and dark values that dulls color, and enlarged the size of their canvases, striving literally to overwhelm viewers with color. Their vast, boundless abstractions can be thought of as personal expressions of the American Sublime.

From the thirties through the fifties, avant-garde sculpture meant welded metal construction; its pioneers were Alexander Calder and David Smith. Departing from traditional Western sculpture, whose massive forms were carved from stone or wood or modeled in clay, plaster, or wax and cast in bronze, they fragmented mass and "drew in space" with linear and planar elements. Their constructions reach out into space and turn it into forms, often making voids the primary components of the work. The technique of assembly prompted sculptors to introduce a variety of new materials into their work — the scrap metal of which Smith's abstract figures are composed, for example. These materials stimulated artists to improvise and invent fresh images that can be considered metaphors for our industrial civilization. Despite its machine-made appearance, however, welded construction possesses a human aspect; it fre-

quently calls to mind human gestures, such as a dramatic leap or the clenchedness of muscles or gravity-defying soaring, and other physical actions.

During the fifties, painterly painting, which aspired to express the artist's inner experience during the process of painting, was the dominant vanguard style. In the sixties, a new generation reacted against the subjectivity of painterly painting, evident in its spontaneous and ambiguous images. Instead, the younger painters opted for clarity of form, design, and color. In fact, they *valued* clarity. They also prized boldness and bigness—a kind of public artistic statement. Those generally labeled the hard-edge painters, among them Nassos Daphnis, Al Held, Nicholas Krushenick, and William T. Williams, focused on the expressiveness of color shapes. Another group, including Morris Louis and Kenneth Noland, known as the stained color-field painters, treated the picture as an open field of disembodied areas or zones of color. Louis and Noland were inspired by the formal ideas of Rothko and Still, but instead of attempting to evoke the American Sublime, they strove to create an art of beauty, decorative and sensuous.

Like the painters, sculptors who emerged in the sixties shared the urge for clarity. Instead of fashioning open, linear constructions in the manner of David Smith, for example, young sculptors, generally called the Minimalists, fabricated elemental geometric volumes. A number of them, Donald Judd, for one, were matter-of-fact in dealing with their materials, often industrial in origin. Others, among them Ronald Bladen, Clement Meadmore, and Tony Smith, who might be called the monumental Minimalists, constructed monoliths that call to mind the look of the buildings on the Empire State Plaza, but despite their abstractness, they also can be viewed as grand metaphors for Man-as-Hero.

The Art Commission purchased more than four-fifths of the works in the Plaza from New York galleries rather than commissioning them. Most of the older artists had never worked in public spaces and their inclination to do so was untested. Moreover, in the view of the commission, their existing work admirably suited the demands of the project. However, when no appropriate work was available, the commissioners decided to risk commissioning sixteen artists, providing them with architectural blueprints.[11] Younger artists were excited by the prospect of producing work in a public context, with specific sites in mind. Adjusting to external factors came easier to sixties artists than to their elders, because their attitude was less subjective. Moreover, many sculptors had turned from studio practices based on hand-making to impersonal, machine-shop fabrication on a scale that lends itself to public places.[12] Artists were also intrigued by the immense outdoor spaces in the thirty-five-acre Plaza and, in the concourse, the bays, each of which was over a hundred feet long, and accepted these sites as a challenge.

Ideally, public art ought to be made by artists in collaboration with architects from the inception of a building, with each able to suggest modifications in the plans of the other. Second best is commissioning an artist to work in a specific site, as was done in several cases in the Empire State Plaza, since this allows the artist to make critical decisions concerning how his or her work will be integrated into its setting. Least desirable is the installation of existing works in existing spaces, which was the common practice in Albany, although the commission compensated somewhat for this by inviting artists, for example, Herbert Ferber, George Sugarman, and Clement Meadmore, to suggest where their works should go. Harrison, D'Harnoncourt, and Miller were very sensitive in matching works of art to best advantage in architectural settings; for instance, the work by James Rosati was purchased with a specific site in mind.

A few mistakes in installation were made, however, the worst of which was placing five masterworks by David Smith against a massive wall that overwhelms them. But it must be remembered that the Empire State Plaza Art Collection was one of the first ventures into modern public art in the United States. There was little experience on the part of the artists or the public agencies involved. Consequently, lapses should be forgiven; they were necessary for public art to evolve—to instruct artists who proposed to work in public places as to what might be successful and what might not. The Empire State Plaza art project helped define the problems and offer solutions. Errors in siting can often be corrected; a number of works on the Plaza have been relocated to better advantage and others still may be.

In actuality, the issue of the appropriateness of placement of any particular work in any particular site is not critical because the collection in the Plaza tends to present itself as an ensemble. Indeed, the uniqueness of the collection is that in number and quality, it is a museum collection. It differs from the latter, because it was assembled over and spans a short period of time, and, since it is placed in a public space, it is experienced by most who see it as part of their everyday activity. And in its cumulative effect, it also differs from what is generally thought of as public art—the single sculpture or mural in front of or in

the lobby of a building. How is the body of work that one expects to encounter in the hushed precincts of a museum perceived in the crowded, bustling, noisy hub of state government, especially in the concourse? One finds oneself fluctuating between the "vernacular glance" and the "museum stare," to use the words of Brian O'Doherty: "The vernacular glance is what carries us through the city every day, a mode of almost unconscious, or at least divided attention. [It] tags the unexpected and quickly makes it the familiar. . . . The vernacular glance doesn't recognize categories of the beautiful and ugly. It's just interested in what's there . . . it dispenses with hierarchies of importance, since they are constantly changing according to where you are and what you need. . . . The vernacular glance is . . . extraordinarily versatile in dealing with experience that would be totally confusing otherwise."[13] But in the Empire State Plaza, one can switch whenever one likes from the vernacular glance to the museum stare —pausing to stand or to sit on a bench—and experience the riches that only great art can provide. Art in the Plaza is not a haven *from* the world, as it is in a museum, but a haven *in* the world, requiring only that one change one's mode of perception.

The art collection at the Empire State Plaza has raised another question which has plagued public art—namely, its upkeep. It is one thing to commission and install paintings and sculptures and to point with pride at the achievement in the dedication ceremonies. But after the fanfare dies down, it is another thing to safeguard and maintain the art. Most of the work had been installed by 1975 under Governor Malcolm Wilson's administration. By 1976 there was already a conservation problem. The jostling of the pictures by the crowds of people in the concourse and the ravages of weather out-of-doors had already begun to show.

In 1978 the State retained the Albany Institute of History and Art as consultants in charge of conserving, maintaining, and safeguarding the art collection. The Institute also established an education program to provide the public with information about the painting and sculpture through tours, films, and lectures. Given recent vandalism, the ongoing need for this program is amply clear, as is the need for greater protection of the works.

In 1983, to oversee security, maintenance, and education, the Empire State Plaza Art Commission was authorized by the legislature and appointments were made to it by Governor Mario Cuomo. One of its first acts was to provide for this catalogue. When the Plaza art collection was conceived, there was no consideration as to what the public's response to the art might be. It was deemed sufficient to provide the public with what art professionals—museum directors and curators, art editors, critics, and historians —believed to be painting and sculpture of the highest quality. Today, artists, art professionals, and administrators pay close attention to the public's expectations and requirements. Thus, this catalogue is not only *about* the public art in the Plaza but is itself a *part of the process* of public art, namely, the dissemination of information about the collection.

The Empire State Plaza Collection and its installation cost $2,653,000—a fraction of what the art is worth today. It has been in place for more than a decade. What is most remarkable about it is how well so many of the works have stood the judgment of time, that is, how the artistic quality seems as high now as it did two decades ago and how large a percentage of the participating artists have turned out to be the most significant and the best of their respective generations. Alfred Barr, who assembled a great permanent collection for The Museum of Modern Art, once wrote: "When it acquires a dozen recent paintings, it [the Museum] will be lucky if in ten years three will still seem worth looking at, if in twenty only one will survive."[15] Listing just the names of the eleven deceased artists whose works represent almost a quarter of the collection—Alexander Calder, Naum Gabo, Adolph Gottlieb, Philip Guston, Alfred Jensen, Franz Kline, Morris Louis, Mark Rothko, David Smith, Tony Smith, and Clyfford Still —testifies to how well the commission did its work of choosing.

Irving Sandler

Richard Anuszkiewicz
1930–

Grand Spectra, 1968
acrylic on canvas
10′-0″ x 10′-0″

Richard Anuszkiewicz was born in Erie, Pennsylvania, in 1930. He received a bachelor of fine arts degree at the Cleveland Institute of Art and earned an additional degree —in education—at Kent State University in 1956. He has taught at numerous institutions including Cooper Union, Dartmouth College, and Cornell University. Anuszkiewicz turned his attention to geometric form in the mid-1950s. Line became an essential organizing element of his work, and in 1963 he started using architectural charting tapes to fabricate his paintings. After applying three coats of gesso, sanding between coats, and adding five coats of a single color to the canvas surface, he uses these tapes to create a design over which a second color is painted. When dry, the tapes are removed, revealing the first pattern. This process is repeated as often as necessary to produce the final design.

Anuszkiewicz is often referred to as the father of Op Art —an accolade he rejects. Nonetheless, his works do share certain characteristics with Op Art; they stimulate visual perception through rhyming geometric shapes, interactive complementary colors, and mathematical structuring principles. *Grand Spectra*'s composition is based on repeated squares. Each square unit contains numerous outlines of squares in decreasing size and also forms part of the larger square; in turn, this larger square constitutes only one of four square panels that make up the entire painting. Color also encourages the eye to move in various directions. Brilliant reds framed by blue and green mark each corner, attracting attention to the perimeter of the work. At the same time, vision is directed toward a central point at which the numerous shades of yellow become uniform.

The term "Op Art" appeared in articles in *Time* and *Life* magazines in 1964. The following year William Seitz, in The Museum of Modern Art exhibition entitled "The Responsive Eye," maintained that the paintings of artists such as Bridget Riley, Larry Poons, and Anuszkiewicz were predominantly optical.

Anuszkiewicz's designs had, by the time of The Museum of Modern Art show, become popular models for a variety of mass-produced commodities. Anuszkiewicz had designed items that ranged from stockings to gift wrap to silver animals for Tiffany's. In 1970 the design of *Grand Spectra* became the model for a set of rearrangeable coasters for an *Art in America* multiples project. Karl Lunde, Anuszkiewicz's biographer, observes that the artist's production of applied art is consistent with the stated aim of Bauhaus artists in the 1920s to merge the fine and applied arts. Lunde points out that these aims would have been known to Anuszkiewicz from his work with Josef Albers at Yale, where Anuszkiewicz received a master of fine arts degree in 1955.[1]

K.O.

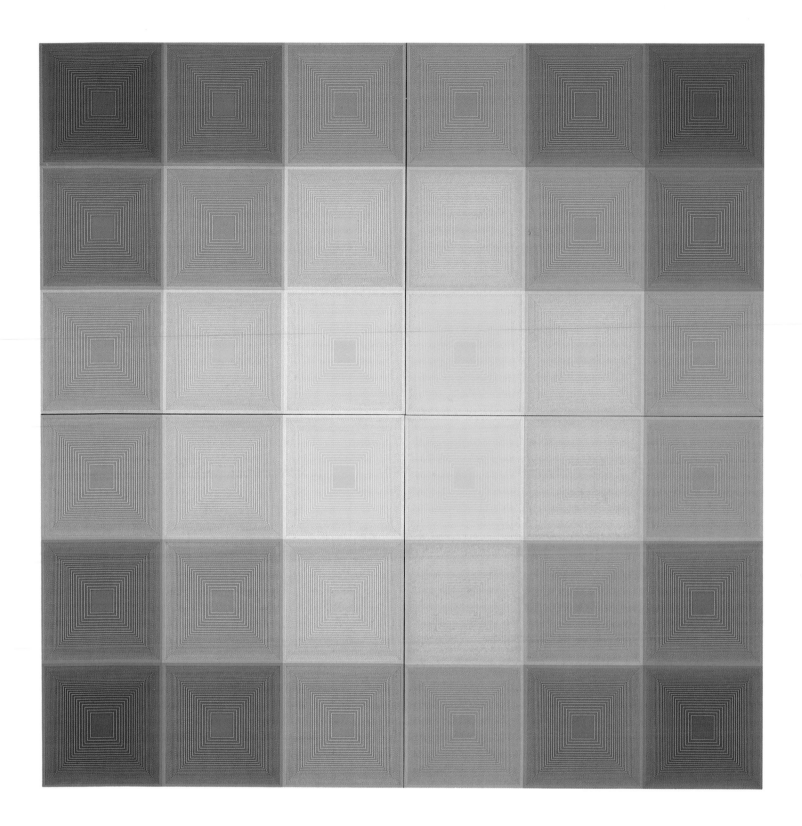

Ronald Bladen
1918–

The Cathedral Evening, 1972
painted cor-ten steel
10'-3" x 29'-3" x 24'-8½"

Ronald Bladen's work first received public attention when it was included in the 1964 "Primary Structures" exhibition at the Jewish Museum in New York City. The exhibition was one of the first cohesive presentations of Minimal Art, and from this time Bladen's work became associated with the sculpture of Donald Judd, Robert Morris, and Dan Flavin. Although Bladen's simple geometric forms and symmetrical compositions are characteristic of Minimalism, certain aspects of his work, such as its grand, monumental scale, evoke the expressive dynamism of Abstract Expressionist painting.

Bladen was born in Vancouver, British Columbia, in 1918. He studied at the Vancouver School of Art from 1936 to 1937 and the California School of Fine Arts in San Francisco in 1939. Remaining in San Francisco until 1958, Bladen painted and became friendly with a number of well-known poets. He supported himself by working in shipyards and machine shops. He then moved to New York City and became a founding member of the Brata Gallery—a cooperative artist-run gallery on Tenth Street—where he had his first New York exhibition in 1958. Bladen's earliest exhibited works were heavily impastoed paintings of abstracted landscapes. These developed, first, into collages of folded paper that extended out from the surface and, later, into constructed reliefs. The images and associations with nature disappeared as he moved toward pure abstraction. In 1963 Bladen began producing freestanding sculptures. His mature work was characterized by simple forms executed on an architectural or monumental scale.

Cathedral Evening was conceived for the exhibition "14 Sculptors: The Industrial Edge" at the Walker Art Center in Minneapolis in 1969. The original massive wood construction of two large converging diagonals projecting from pontoons like an arrow pointing upward, aggressively asserted its presence in a confined interior space. The tension caused by the contrast between the soaring thrust of the sculpture and its enclosure is dissipated somewhat by the placement of the steel version in the Empire State Plaza Art Collection. Since it is outdoors, the surrounding architecture tends to dominate when the sculpture is viewed from a distance. Nonetheless, as one approaches the piece, its larger than human scale and the intensity of its expansive gesture assert themselves and it becomes evocative of powerful physical forces. As Bladen explained:

My involvement in sculpture outside of man's scale is an attempt to reach that area of excitement belonging to natural phenomena such as a gigantic wave poised before it makes its fall or man-made phenomena such

as the high bridge spanning two distant points.

The scale becomes aggressive or heroic. The esthetic a depersonalized one. The space exploded or compressed rather than presented. The drama taut in its implication is best described as awesome or breathtaking. In rare moments I think these things can be gathered to produce a particular beauty.[1]
T.B.

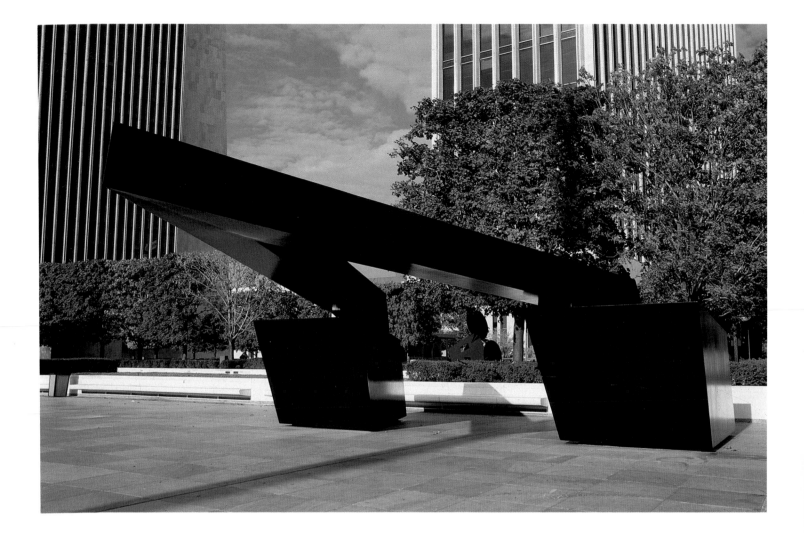

Roger Bolomey
1918–

Untitled, 1969–71
bronze
18′-0″ x 12′-0″ x 8′-0″

Roger Bolomey attracted the attention of critics in the mid-1960s when he began working with a new and unorthodox medium — polyurethane. He discovered this material in the late 1950s when he saw a store-window display showing polyurethane foaming in a cup. After the bubbling process, the substance hardened into a strong, durable material.[1] Bolomey produced experimental wall reliefs and sculptures that integrated polyurethane into structures of wood and metal. Although he was living in California at the time, aspects of his work were related to the art of the New York School. Bolomey's artistic procedure, in which the material flowed and expanded, creating its own form and suggesting natural growth processes, paralleled the method of staining used by Morris Louis and others. The novelty of polyurethane also responded to the prevalent modernist interest in industrial materials. By the late 1960s, however, Bolomey became dissatisfied with the loose form of polyurethane and found metal more suitable for his new geometric sculptures.

Bolomey, a citizen of both Switzerland and the United States, was born in Torrington, Connecticut, in 1918, and spent most of his youth in Switzerland. He attended the Accademia di Belle Arti in Florence in 1947, and from 1948 to 1950 studied at the California College of Arts and Crafts in Oakland. Interest in his work brought him to New York in 1962, where he lived until 1975, when he returned to California. He currently lives in Vermont.

Bolomey received the commission for the Empire State Plaza works during the transitional period between his polyurethane pieces and his metal geometric sculptures. Originally, he agreed to provide reliefs for the two large porticos opening into the Plaza from Swan Street. This idea evolved into a proposal for two freestanding sculptures to be positioned within the porticos. In 1967 Bolomey explained the concerns motivating his plans in a letter to Governor Rockefeller:

> I have especially considered the esthetic spirit in rapport with the building. It will be a work looking ahead in its solid and simple statement, escaping a too personal idiom. I feel that a commission which becomes an integral part of a building must take fully into consideration the whole environment. Regardless of possible restrictions it will end up as a true statement from the artist chosen to do the work.[2]

Both sculptures contrast open and solid spaces. The smaller, seen on entering the north portico, resembles two interlocking T's, the upper portion formed by open rectangles floating above solid columns. When the piece is viewed from the side, however, the top becomes solid and the bottom, open rectangles. The larger sculpture contains a similar but more complex juxtaposition of rectilinear spaces. Together, they reinforce the architectural function of the portals and the sense of passage through space.

T.B.

24

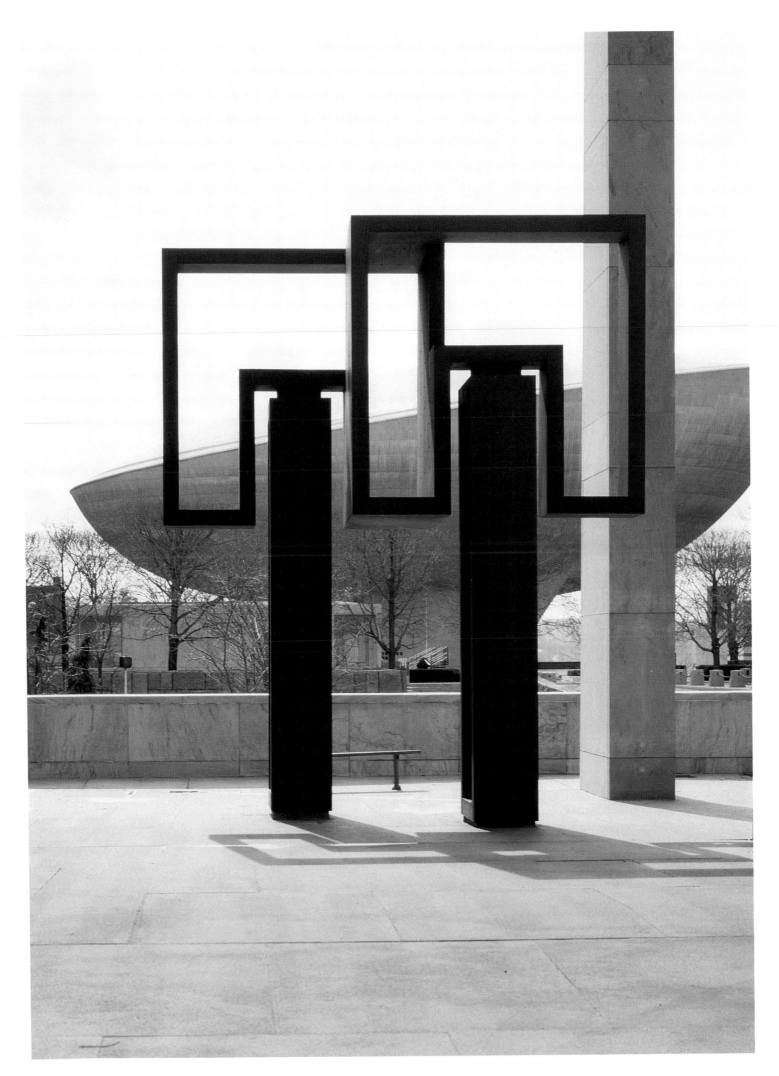

Roger Bolomey
1918–

Untitled, 1969–71
bronze
20'-0" x 18'-0" x 10'-0"

Untitled, 1969–71
bronze
20'-0" x 18'-0" x 10'-0"

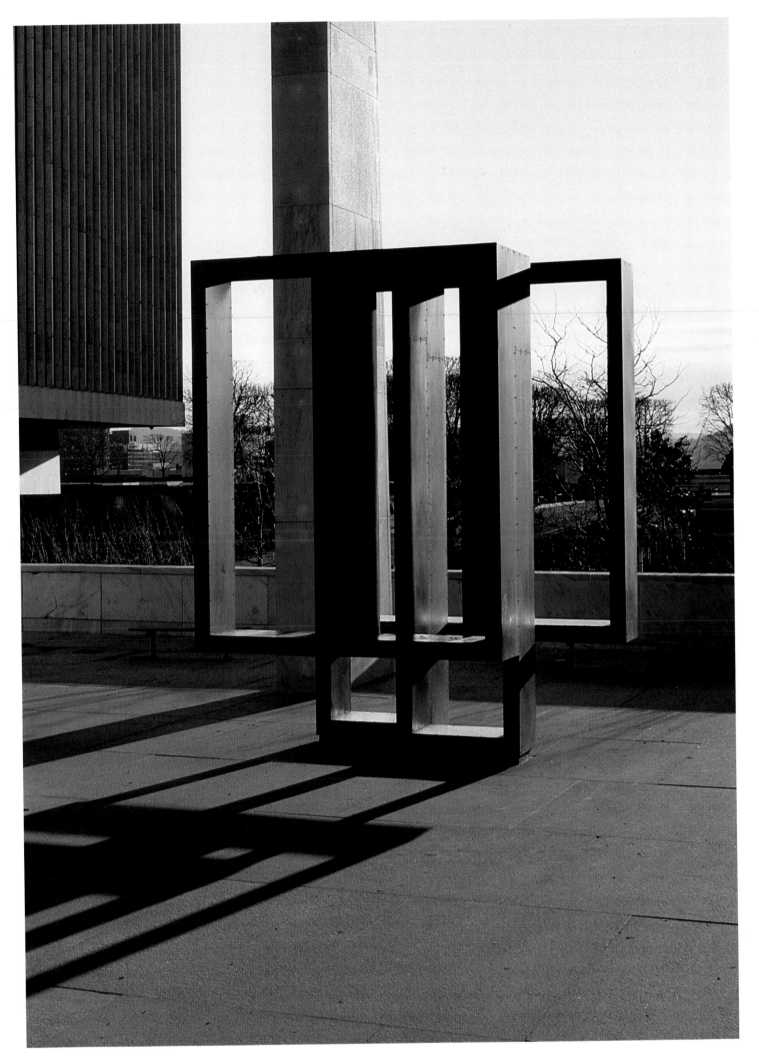

Ilya Bolotowsky
1907–1981

Large Tondo, 1969
acrylic on canvas
6'7" diameter

Born in Russia in 1907, Ilya Bolotowsky moved to Constantinople after the Russian Revolution and in 1923 immigrated to the United States. He studied painting and drawing at the National Academy of Design in New York City from 1924 to 1930. During the 1930s Bolotowsky was one of The Ten, a group of figurative expressionists, including Adolph Gottlieb and Mark Rothko. From 1936 to 1941 Bolotowsky worked for the Work Projects Administration's Federal Art Project in the mural division, headed by Burgoyne Diller, and painted one of the first abstract murals in the United States.

Bolotowsky's earliest works were figurative, made in a semiabstract style, and reminiscent of Braque; by the 1940s, however, he decided for the most part to banish diagonal lines and biomorphs, adopting instead Piet Mondrian's vocabulary of right-angled geometry. A leading abstract painter and theoretician, Mondrian coined the term "Neo-Plasticism" to designate a geometric abstraction based on the balance and tension of horizontal and vertical lines and rectangular planes. Mondrian restricted his use of color to the primaries together with white, gray, and black.

Although Bolotowsky embraced the principles of Mondrian's Neo-Plasticism, he went on to develop his own personal style, which, in contrast to Mondrian's ascetic abstractions of the 1920s, was romantic and sensuous, particularly in terms of his experimentation with color.[1] During the 1940s and 1950s his palette included white, pale primaries, and pastel lavenders, oranges, and greens, all set off by gray and black lines of varying widths. By the 1960s Bolotowsky's primaries became more full-blown and intense. He eliminated small bars of color, using instead white and black bands that varied in dimension according to their function in the overall composition. The shape of the canvas was also integral to his compositions and during the 1940s he began to use diamond-shaped canvases; he gradually expanded his repertoire to include tondos (circles), ellipses, trapezoids, and long narrow rectangles.

Bolotowsky was interested in expressing an ideal of balance, order, and harmony. Using color and elements of pure geometry, his goal was the creation of a perfect tension and rhythm. *Large Tondo* is characteristically elegant, with its subtle interplay of color, shape, and line. Composed of four asymmetrical quadrants, two of white and two of a pale lemon yellow, the painting has a rich blue vertical band in the bottom left quadrant. The overall rhythm and tension is heightened by the four thin black lines that run the full height of the canvas and effectively counterbalance its circular shape. The round canvas seems to spin like a wheel, yet Bolotowsky's use of linear elements locks the circle in place.

In addition to being a painter, Bolotowsky was also a filmmaker, sculptor, and a devoted and articulate teacher. He taught at Black Mountain College in North Carolina from 1946 to 1948, and, after moving to New York City in 1958, he continued to teach at numerous colleges and art schools in the area until his death at the age of seventy-four.

T.G.

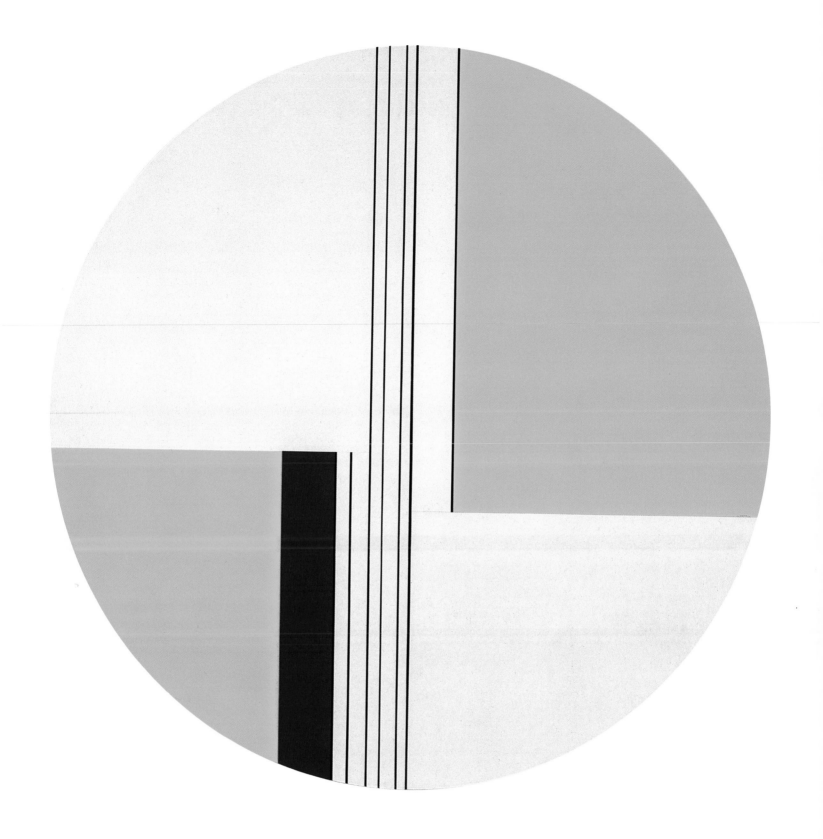

Lee Bontecou
1931–

Untitled, 1966
paint, fiberglass, and leather
on welded metal framework
8'-4" x 7'-6" x 2'-2"

In the 1960s Lee Bontecou was among those artists working at the forefront of the avant-garde. Donald Judd, the Minimalist critic and artist, was an early supporter of Bontecou's art, and her work attracted critical attention from major art publications. Along with Jasper Johns, Robert Rauschenberg, Andy Warhol, and Frank Stella, Bontecou exhibited at the Leo Castelli Gallery in New York City. The Museum of Modern Art and the Whitney Museum included her work in exhibitions of contemporary artists, and in 1964 a major relief was chosen by the architect Philip Johnson to decorate the entrance foyer of the New York State Theater at Lincoln Center. The construction now in the Empire State Plaza Art Collection was exhibited at the Whitney Annual of 1966.

Bontecou was born in Providence, Rhode Island, in 1931. She studied with William Zorach and John Hovannes at the Art Students League in New York City from 1952 until 1955. In 1957 she was awarded a Fulbright Grant for study in Rome. Her early sculptures were made of plaster and bronze in the form of birds and animals. The interior wire structures of these early plaster pieces inspired the work that gained her recognition. She brought the interior structure to the outside, using reliefs of wire and rods that projected from a rectangular support, the arrangement of the forms frequently creating a dark, central hole. Pieces of canvas and cloth were then attached to the wire, forming three-dimensional objects that projected from the wall. Judd found these works formally innovative because they negated the traditional artistic categories of painting and sculpture. From these works, Bontecou developed more complicated reliefs, of which the piece in the Empire State Plaza Art Collection, dated 1966, is an example. Here, the large central holes of her earlier work have been reduced to two small openings in the upper half of the composition. The rest of the piece is dominated by rich, convoluted forms that protrude as far as two feet and create deep recesses that contrast with the rounded, bulging forms. The work is made of fiberglass and leather applied to a welded metal framework built up from a bed frame. Black velvet is stretched across the back of the construction, intensifying the blackness of its holes and cavities. Parts of the work have been painted with black-and-white or red-and-white stripes that emphasize the sense of rounded form and depth.

Bontecou has been associated with Art Nouveau, Surrealism, Dada, Pop, primitivist, and feminist art. Her work, however, derives its strength from its individuality—it resonates with many contradictory sources and associations.

Carter Ratcliff has pointed out an opposition of mechanistic and biological aspects in Bontecou's seemingly "organic machines."[1] Referring to the contrast between the aggressive, almost frightening quality of her images and their invitingly erotic presence, Judd has described her work as "extend[ing] from something as social as war to something as private as sex."[2] Similarly, the machinelike aspects of this work give it a futuristic look, whereas the roughness and crudeness of its materials impart an almost archaic quality. In 1968 Bontecou radically transformed her work, making three-dimensional flowers and fish out of vacuum-formed plastic. Her last exhibition was in 1971.

T.B.

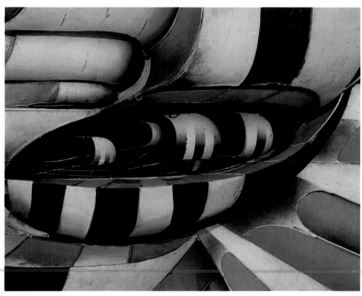

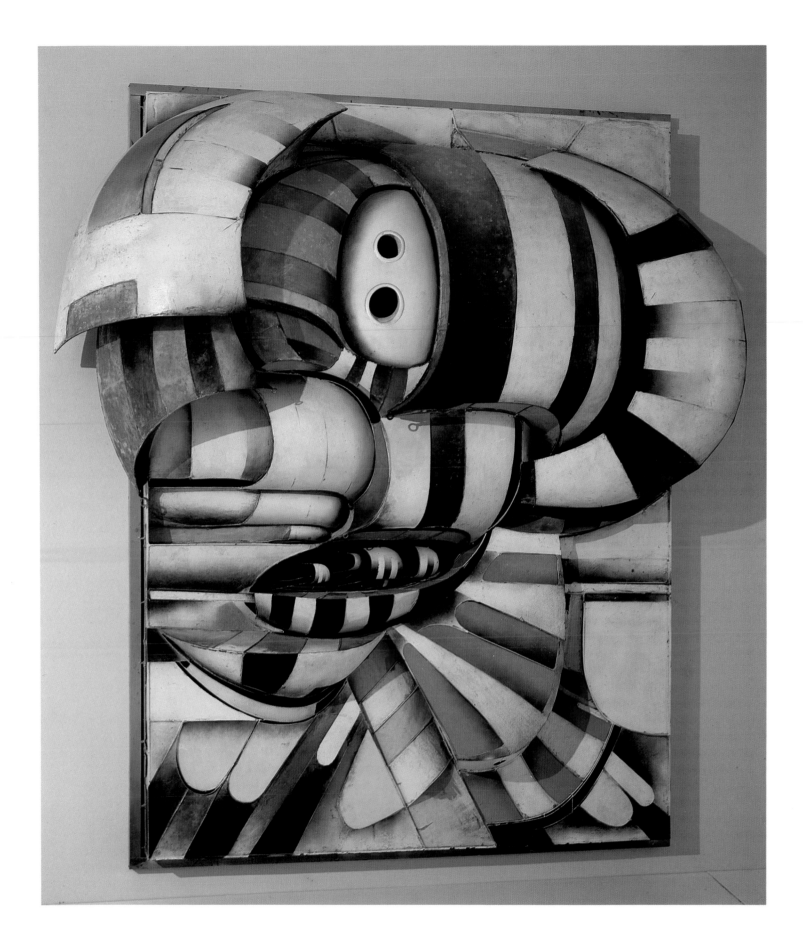

James Brooks
1906–

Chaco, 1965
oil on canvas
6'-2" x 6'-8"

James Brooks, a member of the first generation of Abstract Expressionists, was born in St. Louis and received a bachelor of fine arts degree from Southern Methodist University in Dallas, Texas. Brooks moved to New York City in 1926, and was enrolled in the Art Students League from 1927 to 1930. Like many Abstract Expressionists, he began his career in the 1930s during the Depression and was associated with the Regionalists and Social Realists, although he did not share in either of their political aspirations. At this time his paintings were characterized by realistic themes, although his active brushwork presaged his development toward abstraction.

Between 1936 and 1942 Brooks supported himself as a muralist for the Work Projects Administration (WPA), which administered the Federal Art Project. *Flight*, Brooks's best-known mural, and one of the last and largest murals painted during the Federal Art Project, depicts the history of man's effort to fly. Located in the International Marine Terminal at La Guardia Airport (then called Sea Plane Terminal Building), the mural was begun by Brooks in 1938 and completed in 1942. It was painted over by order of the Port of New York Authority in 1950, but was restored in 1980 with funds provided by Laurance Rockefeller and DeWitt Wallace.

In 1942 Brooks was drafted and served in the U.S. Army in the Middle East as an art correspondent. Upon his return to New York City in 1945, he renewed friendships with Jackson Pollock, Bradley Walker Tomlin, and Philip Guston. His paintings from this period, based on figurative and still-life themes, exhibit layered brushstrokes within compressed linear shapes.

Jackson Pollock's drip paintings of 1948 had a liberating effect on Brooks, whose canvases became increasingly loose, improvisational, and abstract. "I used Pollock's drip method to great advantage because it did free me from earlier work and from being too self-conscious."[1] That same year, while using black glue to paste collage shapes onto a painting, Brooks discovered that the glue caused irregular shapes to soak through to the reverse side of the canvas.[2] Fascinated by the surrealistic implications of the automatic images, Brooks began staining his pigments directly onto raw canvas, abandoning his previous formal Cubist abstractions. Along with Helen Frankenthaler, he was among the first artists to deliberately stain pigment into unprimed canvas.[3]

For Brooks and the other emerging Abstract Expressionists, spontaneity in the arrangement of color, shape, and line was of primary importance. His colors—which center around a limited core of reds, yellows, oranges, lacy whites, and velvety blacks and blues—have always been rich and may be muted, romantic, bright, or dissonant depending on his mood. Shapes ranging from curvilinear floating forms to the rectilinear are defined by either active brushstrokes or thin calligraphic lines. Brooks's paintings from the 1950s are characterized by organic, slow-moving shapes spread from edge to edge, rendered with large, airy brushstrokes.

During the 1960s Brooks returned to the use of thin calligraphic lines in combination with broadly brushed areas of rich, saturated color, as exemplified in *Chaco*. In this painting the velvet texture of the ultramarine field unifies the canvas and creates a sense of depth from which two broad areas of pale luminous shapes and brushstrokes emerge. Balance is an important component of Brooks's work. The light-colored shape in the lower left is echoed by a similar shape of light blue flanked by red in the opposite corner; thinly drawn calligraphic lines and red and white brushstrokes actively direct the viewer's eye into the two opposing corners, leaving the center of this painting calm and serene. Since the 1950s Brooks has used nondescriptive titles in an attempt to direct the viewer's interpretation as little as possible. Brooks was delighted with the results because he found people looking for something entirely new and unknown in his work.

T.G.

Lawrence Calcagno
1916–

Red-Black, 1967
oil and acrylic on canvas
two panels
6'-0" x 8'-2" overall

Unlike the work of many American Abstract Expressionists who abandoned the representation of nature, Calcagno's work is characterized by forms derived from the landscape. He has stated that, in his art, landscape "becomes a visible symbol of an all-embracing universe."[1] Born in San Francisco in 1916, Calcagno spent a significant portion of his youth on his family's ranch in a remote area of California. Later, he worked as a merchant seaman, traveling in the Orient. His contact with Oriental thought has influenced his view of nature as a harmonious unity in which opposites are resolved and spirit and matter become one. From 1941 to 1945, while serving in the U.S. Air Force, he won an award in the National Army Arts Contest at the National Gallery of Art in Washington. He continued to paint and travel but had no formal art education until, in 1947, he enrolled at the California School of Fine Arts in San Francisco. There he was exposed to the ideas of Abstract Expressionism by his teacher, Clyfford Still, and by Mark Rothko, a visiting artist. Calcagno also studied in France and Italy and has traveled extensively. Since the seventies, he has divided his time between New York, Taos, and Honolulu.

By 1954 Calcagno had developed a pictorial format consisting of horizontal bands of color that evoke the sea, sky, and geological strata of the earth. *Red-Black* is a later exploration of this theme. The image is divided into two canvases. The bottom panel, a thin, flatly painted black horizontal, anchors the composition. A shadow is cast on the wall between the two canvases. Above, three horizontal bands of light red are distinguished from one another by alternation in the direction of the brushstrokes — vertical, horizontal, vertical — rather than by changes in color. These bands lead into a brilliant area of deeper red above. A black shadow, illusionistically painted just above the lower area of dark red, echoes the real shadow above the bottom panel. Although the imagery of *Red-Black* may derive from an impression of the sun setting in a glow of red interrupted by a thin haze at the horizon, the painting is primarily an abstract manipulation of real and pictorial space. The viewer's eye is led from the anti-illusionist, object quality of the flat, thin black panel with its real shadow to the nuanced expanse of red and painted, illusionistic shadow in the upper panel in a synthesis of illusion and reality.

T.B.

Alexander Calder
1898–1976

Four at Forty-five, 1966
polychromed sheet metal
5'-0" x 18'-0"

Triangles and Arches, 1965
painted steel
19'-0" x 30'-0"

Alexander Calder is best known as the artist who successfully incorporated motion into sculpture. Working in Paris in the late 1920s, Calder first attracted attention with his mechanical *Circus* (Whitney Museum in New York City). After a visit to Piet Mondrian's studio in 1930, Calder's work became increasingly abstract and he began to construct motorized sculptures. Finding the predictable movements of mechanized forms restrictive, he developed saillike forms that, suspended on thin wire armatures, moved in the wind. Exhibited in Paris the same year, they were given the name "mobiles" by Marcel Duchamp. Jean Arp responded by labeling Calder's later, stationary sculptures "stabiles."

Calder was one of the first artists to initiate the modern sculptural concern for articulating spaces rather than masses. His open, wire constructions define volumes without displacing space with solid forms. These "drawings-in-space" and the welding techniques Calder used to produce them were important precedents to David Smith's sculpture of the 1950s.

Calder was born in Philadelphia in 1898 to a family of artists. His grandfather and father were sculptors and his mother a painter. Calder, however, did not pursue an artistic career until he had received a degree in mechanical engineering from the Stevens Institute of Technology in 1919. In 1923 he began taking classes at the Art Students League and worked as an illustrator and caricaturist for the *National Police Gazette*. In 1926 he moved to Paris and concentrated on sculpture. Calder returned to the United States in 1931 and lived both here and in France until his death in 1976.

Much of Calder's art, which includes mobiles, stabiles, paintings, drawings, and jewelry, is characterized by a whimsical gaiety. His mobiles are especially playful, dancing in the air with their often brightly colored discs that dangle in eccentric yet balanced compositions. According to Joan Marter, the imagery in Calder's earliest mobiles — different-sized spheres traversing space — was derived from models of the universe.[1] Calder later combined these associations to planets and stars with references to plants and animals.

The gentle, slow movement of Calder's work implies the continuous and mysterious flow of time acting on natural objects. *Four at Forty-five* is constructed of brightly colored, biomorphically shaped discs that hang from a red armature. The largest shapes resemble lily pads and dangle from chains, appearing to float. The others are colorful abstract bodies that slowly move through space. The red,

blue, and yellow colors and the eccentric shapes impart a festive atmosphere to the predominantly gray lobby of the Tower Building.

The stabile *Triangles and Arches*, although it incorporates shapes that are unmistakably identified with Calder, is less fanciful than the mobile. It is related to a number of monumental stabiles Calder made in the 1960s that pursued architectural and environmental themes. Seen in public locations throughout the United States and Europe, including Lincoln Center in New York City, they are comprised of large plates of steel welded and bolted together and usually painted black. Dramatically positioned at the center of a large pool, this sculpture is composed of several large triangular forms with curved sides that appear to grow from each other and resemble the buttresses of Gothic cathedrals; the pointed tips of the triangles allude to church spires. The impression of the sculpture is most evident from its western elevation; it appears to rise above the distant landscape and its "spires" echo the towers of the Cathedral of the Immaculate Conception to the southeast of the Empire State Plaza.

T.B.

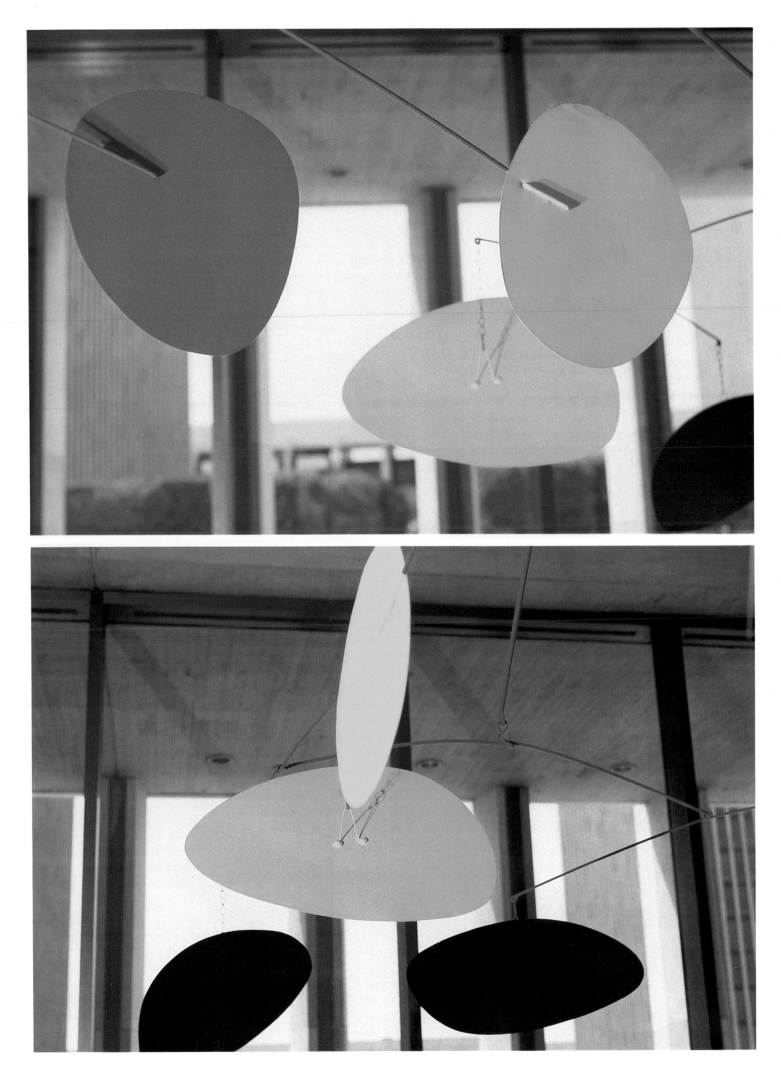

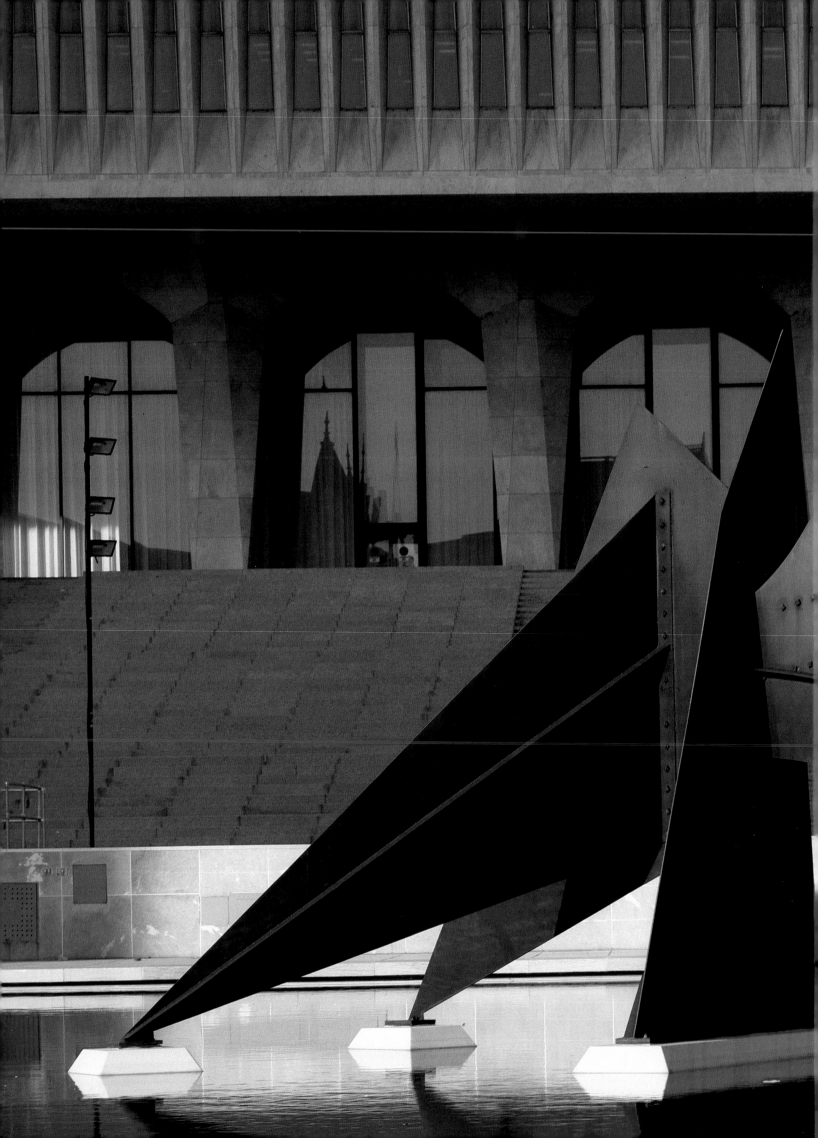

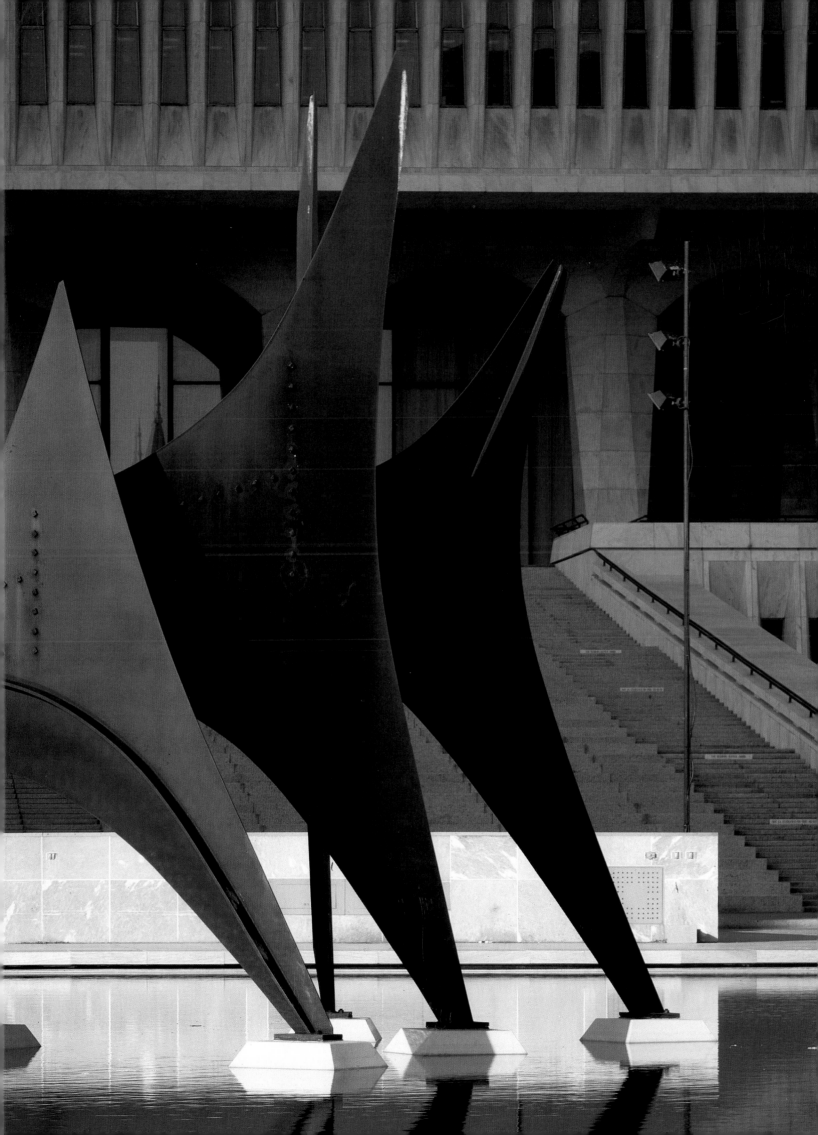

Mary Callery
1903–1977

Z, 1963
brass
5'-2" x 7'-1" x 3'-6"

Unlike most of the art in the Empire State Plaza Art
Collection, Mary Callery's sculpture maintains a reliance
on the representation of the model. She is best known for
her attenuated acrobatic figures that bend and twist in
space. Callery was born in 1903 in New York City. Her
father was a prosperous businessman, and she was encour-
aged as a child to become an artist. In the early 1920s she
studied for several years at the Art Students League. She
went to Paris in 1930 and studied for two years in the studio
of the Russian-French sculptor Jacques Loutchansky.
Remaining in France for another eight years, she became
friendly with several well-known artists including Pablo
Picasso, Fernand Léger, Amédée Ozenfant, and Henri
Laurens. After the fall of France in 1940 she returned to
New York City and in 1944 had her first exhibition there
at the Buchholz Gallery. She continued to show regularly
and received a number of major commissions for public
works. After World War II, she maintained studios in
New York and Paris; most of her time was spent in Paris,
where she died in 1977.

Callery's work from the 1930s is in the classical style
associated with the sculpture of Aristide Maillol. Later,
she was influenced by the Cubist art of Picasso and Léger.
Beginning in 1943, she and Léger collaborated on a num-
ber of works in which he painted backgrounds for figures
that she modeled in plaster. Callery incorporated all these
influences into a personal style based on the reduction of
natural forms to linear, rhythmic shapes. Frequently, she
depicted anecdotal scenes of animals, acrobats, or
dancers.

Around 1949 she employed her somewhat calligraphic
designs in the production of sculptures based on various
symbols. Z is one of a series of works derived from the
letters of the alphabet and it is more abstract than most of
Callery's work. Art critic Christian Zervos observed, how-
ever, that letters themselves are abstract signs that provide
the means for communication of all kinds of feelings and
ideas. Thus, "for Callery the sign has the same power as
a living model of creating tension in the depths of the
unconscious, of provoking unexpected stimulations, of
containing a host of formal combinations."[1] This sculpture
is structured around a linear element forming a Z and
resembling a spine to which strips of metal have been
attached like ribs. Callery has transformed the letter into
an evocative curvilinear shape that recalls the image of a
prehistoric dinosaur skeleton.

T.B.

Chryssa
1933–

Arrow: Homage to Times Square, 1958
painted cast aluminum
8'-0" x 8'-0"

Chryssa is probably best known for her calligraphic images of urban environments constructed from brilliantly colored neon tubing. For Chryssa, New York City and especially the bright, flashing lights of Times Square epitomize the vitality, poetic nature, and raw power of the United States.

Reared and educated in Athens, Chryssa left Greece and in 1953 went to study art in Paris. After traveling to the United States and studying briefly at the California School of Fine Arts in San Francisco, she moved to New York City in 1954. Of her early works, the best known are the *Cycladic Books*. Made in 1955, they are a series of almost featureless molded clay sculptures consisting of a slightly raised, wide, T-shaped image that recalls the flattened faces of Bronze Age idols found on the Cycladic islands off the coast of Greece. Focusing her energies on typography beginning in 1955, Chryssa depicted in her raised and engraved tablets and paintings of 1955–60 uniform fields of repeated or fragmented words or letters that often resembled the typography of newsprint and signs. She also portrayed products of mass production such as sheets of postage stamps, automobile tires, and cigarette lighters, using a photographic-plate process first introduced by Andy Warhol. Chryssa's use of letters and signs paralleled the emergence of Pop Art, which also elevated everyday images of popular culture to subject matter for high art.[1] In addition to the repetition of words and letters, which is highly characteristic of her work to the present day, she constructed sculptures of individual letters, often magnified to huge scale, in molded plaster and cast aluminum or bronze.

Arrow: Homage to Times Square is the first in a long series of sculptures dedicated to the lights of Times Square. Chryssa considers it to be a pivotal work because in it she concentrated for the first time on what she calls "static light" as a sculptural medium. A departure from her usual sign or letter imagery, the arrow is created by a series of individually cast, white, T-shaped elements placed on a large square so that the stem of the T is attached to the background and the viewer sees a flat rectangle projecting from its support. The intentional irregularity of the white forms, which vary in height and placement on the large white square, creates an interplay of form and shadow. According to Chryssa, although the T-shaped form is "static," it is actually doubled by its shadow. The form and its shadow together create static light. The static light in *Arrow: Homage to Times Square*, which is more clearly defined in the center than at the sides, changes depending on the position of the viewer.

After experimenting with static light in *Arrow: Homage to Times Square*, Chryssa went on to bridge the gap between Pop Art and light sculpture by using illuminated words in her works.

T.G.

Calvert Coggeshall
1907–

Touching, 1968
casein on canvas
two panels
5'-7" x 8'-6½" overall

Calvert Coggeshall was born in Utica, New York, in 1907. He attended the University of Pennsylvania, where he studied fine arts and architecture, and, like many of the other artists represented in the Empire State Plaza Art Collection, also spent some time studying at the Art Students League in New York City. In 1949 he worked with Bradley Walker Tomlin, who was at that time emerging as one of the early Abstract Expressionists. Coggeshall had his first solo exhibition at the Betty Parsons Gallery in 1951 and continued to show there intermittently until the late seventies. Throughout his career, Coggeshall has also worked in architecture and furniture design.

The paintings shown in Coggeshall's earliest exhibitions were Abstract Expressionist in style. Coggeshall, however, did not adopt the spontaneous gestural mode of artists such as Franz Kline or Philip Guston. Intertwining geometric and calligraphic shapes give his paintings a more structured appearance, similar to those of his mentor, Tomlin, and to Ad Reinhardt's paintings of the late forties. Perhaps his background in architecture and design overrode the impulse toward expressionist gesture; for by the mid-sixties, Coggeshall had abandoned Abstract Expressionism. He began composing paintings from simple, solidly colored forms, works that recall those of earlier twentieth-century geometric art movements such as Neo-Plasticism or Constructivism. In the sixties the art world was more receptive to a simplified, geometric look. Barnett Newman's paintings were becoming well known and Minimalism was a dominant style. Coggeshall himself was represented by his more geometric work in shows at both The Museum of Modern Art and the Whitney Museum in 1967.

Touching, an example of Coggeshall's later style, is clearly related to Neo-Plasticism and color-field painting. The use of two primary colors—blue and red—in simple geometric forms on a white ground is reminiscent of Mondrian, though the large scale of the painting is very different from Mondrian's easel-sized works. The size, as well as the use of two contrasting panels, is closely related to color-field painting. The forms are basically rectangular, their placement at angles to the edge of the canvas distinguishing them from the more regularized balance of Neo-Plastic composition, while their slightly skewed positioning holds them together in a suspended tension. Similarly, the painting does not have the insistently flat surface of much color-field painting. The casein displays neither the sheen of oil nor the plastic look of acrylic. Nor do its forms have the hard, color-field edge of artists such as Ellsworth Kelly. A soft, mat surface, slightly irregular edges, and resonant color produce in *Touching* a gentle, lyrical effect.

T.B.

Nassos Daphnis
1914–

2-68, 1968
epoxy paint on canvas
7'-0" x 7'-0"

Nassos Daphnis was born in Greece in 1914 and emigrated to the United States at the age of sixteen. Without formal artistic education, he began to exhibit his landscapes based on mythological or religious themes in 1938. His career was interrupted from 1942 to 1946 by military service during World War II. In the army he learned to use a spray gun to paint camouflage patterns on trucks, and this would influence his sense of scale and the technique of his later work.[1] Immediately following his discharge, he painted landscapes whose bleakness reflected his war experiences.

In 1951 Daphnis's work changed radically, a transformation that he attributes to a visit to Greece in 1950. Impressed by the intense light of the region, which eliminates detail and flattens forms,[2] he abandoned his amorphous, organic shapes for simplified planes of color; by 1952 he further reduced his color scheme and began using geometric forms. Thus, just as gestural Abstract Expressionism was gaining prominence in the art world, Daphnis was turning to the geometric abstraction of Piet Mondrian.

In 1955 Daphnis developed a personal color theory. He visualized pictorial space as comprised of a hundred recessive planes and assigned numbers to these planes. The depth positions of the numbered planes corresponded to pure, unmodulated colors. Black, the color that he observed as being closest to the surface, corresponded to planes 0–10; blue, 10–20; red, 20–50; yellow, 60–90; and white, his most recessive color, 90–100. Expanding upon this theory, he selected particular colors to symbolize various phases of human life, for example, correlating black with birth and white with death.[3]

Daphnis's later paintings, such as *2–68*, consist of complicated juxtapositions of undulating bands of color that exemplify the systematic application of his color theory. In a symmetrical pattern, the space gradually recedes to the black corners from the white bands, and then comes forward again, flattening in the central black area. To obtain perfectly even color and an enamellike surface, Daphnis taped out each band and sprayed the colors individually. It has been observed that Daphnis's sharp, clearly defined forms are similar to those associated with the hard-edge abstraction of Ellsworth Kelly, and his striped format resembles Frank Stella's paintings, especially those from Stella's *Protractor* series. Despite such affinities, the oscillation between surface and illusionistic depth that characterizes Daphnis's work differs essentially from the insistent flatness of Kelly's and Stella's paintings from the same period. T.B.

Allan D'Arcangelo
1930–

American Landscape, 1967
acrylic on canvas
9'-6" x 18'-7"

Allan D'Arcangelo was born in Buffalo, New York, in 1930. In the early 1950s, after graduating from the University of Buffalo with a degree in history, he worked at the Bethlehem Steel mills in Lackawanna, New York. He began painting in 1955 in New York City and two years later went to college in Mexico City on the G.I. Bill to study art.

D'Arcangelo is best known for his paintings of the American highway. In these works, begun in 1962, D'Arcangelo abandoned his former expressionist style, adopted a clichéd image from American culture, and painted it in a style derived from commercial art.

American Landscape uses direct, simplified forms to portray a two-lane blacktop highway disappearing into an open, expansive landscape dominated by a blue sky. The perspective and the size of the canvas draw the viewer into the painting. Abstracted symbols from traffic signs refer to the highway landscape and their use typifies Pop artists' interest in public imagery. Black arrows, for example, painted in diminishing size, recall a road sign but also resemble telephone poles vanishing into the distance. At the left of the painting, a path painted in the yellow and red stripes of a road barrier appears as an imaginary route into the sky, overlapped by a large cloudlike form and an image of a road sign designating "no through passage." Although the images are general and the road signs international, D'Arcangelo need hardly have titled the painting *American Landscape* to make its American character clear. Pop Art, despite its European precedents, was quintessentially an American phenomenon.

T.B.

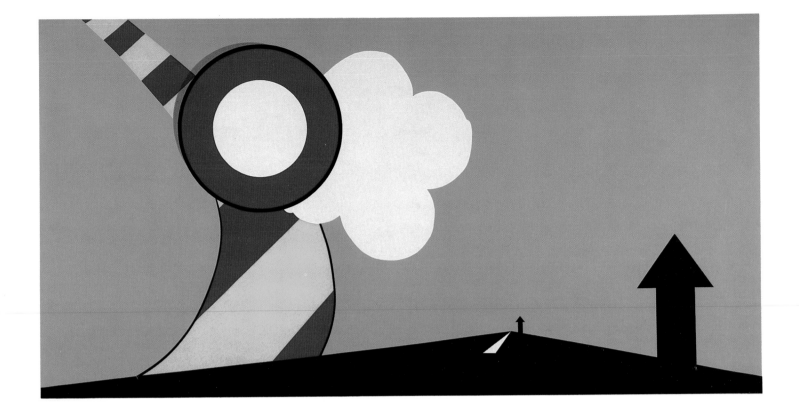

Gene Davis
1920–1985

Sky Wagon, 1969
acrylic on canvas
10'-0" x 54'-5"

Gene Davis attended the University of Maryland and supported himself as a journalist while studying art. Under the guidance of Jacob Kainen, a painter, printmaker, and graphics curator at the Smithsonian Institution, Davis began experimenting in 1949 with a range of techniques including dripped and poured paintings, collages with mirrors, massive impasto, and Pop comic strips. By 1958 he had painted his first stripe painting, departing radically from the gestural style of Jackson Pollock and Willem de Kooning that had shaped his earlier work.

In an era when the improvisational surfaces of Abstract Expressionism dominated the New York artistic avant-garde, Davis's use of rigid, impersonal stripes to structure a painting was a novel idea. Davis had derived it somewhat from Barnett Newman, who, as early as 1950, had used stripes primarily to define fields of color, and from Paul Klee's use of stripes and grids. Although his experiments with stripes preceded those of Kenneth Noland, Davis acknowledged the influence of Noland's unsized canvases and acrylic resin paints. Due partly to Davis's work, stripes became commonplace in the abstract painting of the 1960s. Davis, however, remained the most singleminded practitioner of the stripe format. As Davis expressed it: "I see the stripe as subject matter. . . . I take a simple stripe and use it in all of its many variations. I use fat stripes, thin stripes, stripes wide apart, stripes close together, bright stripes, pale stripes. It's endless; I can spend the rest of my life doing variations on it."[1] His lifelong exploration of this format ranged from works of only two or three colors to more complex pieces with many colors and from monumental stripes on city and park streets to a series of "micro paintings" only a few inches wide.

A native of Washington, D.C., Davis was a member of the Washington Color School, a group of second-generation abstractionists that included Morris Louis and Kenneth Noland. Despite the individuality of their styles, these artists were linked by geographical location and their use of unprimed canvas, which allowed diluted acrylic paint to soak directly into the fabric. This staining technique, inspired by the work of Helen Frankenthaler, emphasized the flatness of the painting surface.

Davis did not follow a particular color system or theory nor did he make preliminary studies; rather, he chose his colors intuitively, recalling the spontaneity of his Abstract Expressionist influences. "I need to surprise myself and that isn't easy. . . . When a certain color seems the obvious choice, sometimes I will deliberately select its complementary in order to create problems that stimulate tension in the picture."[2]

When Davis was commissioned to do *Sky Wagon* for the Empire State Plaza, he improvised the work, using a large exhibition hall in the Corcoran Gallery in Washington, D.C. Placing the canvas on the wall, he drew lines and selected colors as he went along, creating a color sequence of such large scale and complexity that it is impossible to experience the work in a single glance. *Sky Wagon's* 720 stripes are all the same size, but they create color sections of differing widths and intensity. There are several areas of dark and light blue stripes that repeat throughout the composition, breaking up the painting into contrasting cool and warm sections. Although *Sky Wagon* is best explored in a leisurely fashion, passers-by who do not have time to linger still perceive a rich flicker of color as they walk past.

J.F.

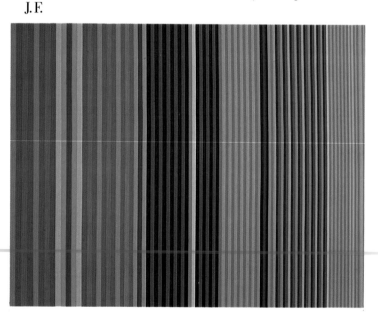

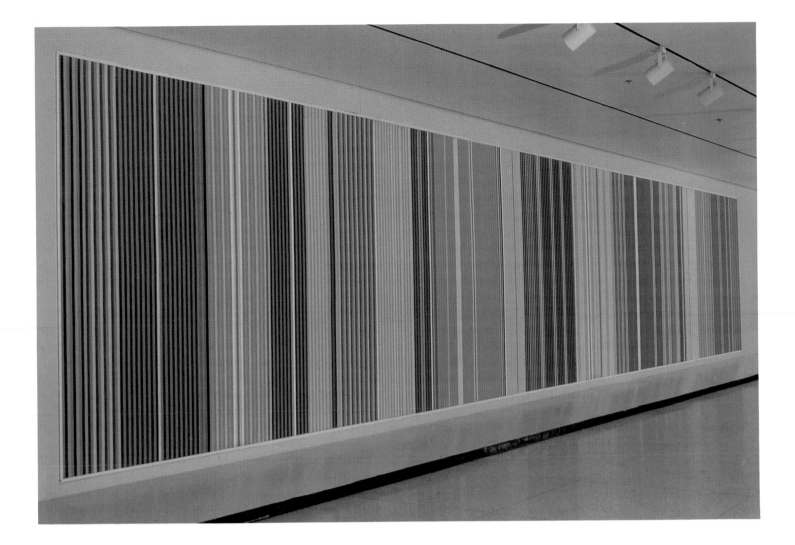

Bob Duran
1938–

Untitled, 1970
liquitex on canvas
6'-0" x 15'-0"

Bob Duran began his artistic career as a sculptor. Born in Salinas, California, in 1938, he studied at the San Francisco School of Fine Arts from 1960 to 1961. He had his first show in New York City in the late 1960s, when Pop Art and Minimalism were prominent artistic movements. Duran's sculptures were clearly influenced by the work of Minimal artists Donald Judd and Carl Andre. They were made of simple forms: rectangular and square plywood or Masonite boxes were arranged to form labyrinthine paths and were sometimes spray-painted with hazy, illusionistic films of paint. In 1970 Duran began to exhibit his paintings. His development from sculpture to painting was the opposite of those artists who had rejected the illusionism of painting in order to explore the actual existence of objects in real space. Duran's move to painting suggests that it was precisely the illusionistic and lyrical aspects of his sculpture that had most interested him.

The painting in the Empire State Plaza Art Collection is dominated by a reddish band that traverses the canvas in a diagrammatic pattern. In the spaces between the lines of the grid are shapes resembling pieces of a gigantic jigsaw puzzle. These spaces appear as voids that interact with the solid red lines. Not completely abandoning a Minimalist aesthetic, Duran maintains a flat or shallow space with the loose, gridlike patterns reinforcing the surface plane of the canvas. Similarly, Duran adopted the stain technique, used by Helen Frankenthaler, Morris Louis, and Kenneth Noland to integrate color with the surface, again reinforcing a sense of flatness that serves to unify the broad composition.

T.B.

52

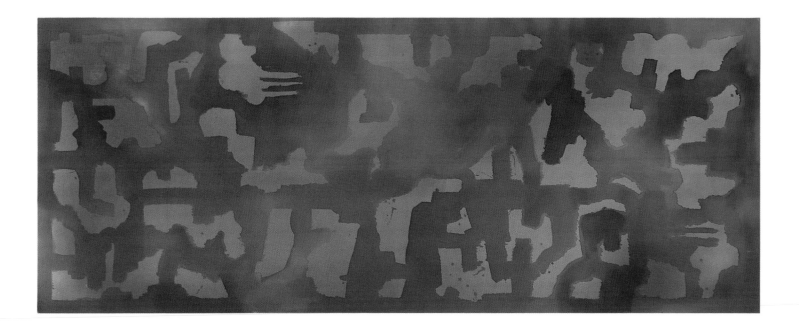

Herbert Ferber
1906–

Double One on C, 1966
copper
10'-8" x 7'-4"

Herbert Ferber, a pioneer in both direct-metal and environmental sculpture, studied art at the Beaux Arts Institute of Design in New York City from 1927 to 1930, and later, briefly, at the National Academy of Design, concentrating on painting and drawing. In 1931 Ferber turned to sculpture. His earliest works, massive figurative pieces carved in wood and inspired by William Zorach, a leading exponent of the direct-carving method, display social-realist themes and have a strong affinity to primitive art, reflecting Ferber's interest in African and Pre-Columbian sculpture. In 1938, while traveling in Europe, Ferber became fascinated by the profuse ornamentation of Romanesque sculpture, and, as a result, he was drawn to the biomorphic forms and the mythical themes of the Surrealists. By 1945, after spending a year studying the works of Henry Moore, Ferber shifted away from the figure to surrealistic abstract forms. Ferber also experimented with a variety of new materials including cast bronze and lead.

A first-generation Abstract Expressionist and member of the New York School, Ferber established his artistic reputation during the late 1940s with his surrealistic abstractions. While Abstract Expressionist painters rejected traditional artistic formulas in favor of bold, spontaneous execution, the sculptors of this group discarded the monolithic sculptural mass for open linear works in which space and form are equally important. Ferber describes his work at this time as "sculpture through which the wind could whistle and into which the edge and the hand and eventually the audience would be compelled to penetrate. Sculpture no longer displaced space as a ship does water, rather it penetrated space and held it in tension."[1]

Ferber developed his own personal direct-metal style influenced by the forms of Alexander Calder and Joan Miró. The direct-metal process allowed artists to weld randomly or braze together assorted metal pieces with an oxyacetylene torch, creating open, raw, dynamic forms with immediacy and unprecedented flexibility.[2] The torch, perfected during the war, was portable and easy to handle with metals such as bronze, lead, steel, and nickel. Ferber's sculptures from this period exhibit discontinuous, open, airy forms, and like the work of many Abstract Expressionist painters, they are gestural and calligraphic. Instead of working directly with a torch and metal pieces, Ferber began each project with one or more drawings, then made a small working model before moving on to the larger work. An excellent draftsman, Ferber also made elaborate wash drawings, placing his works in imaginary landscapes.

Double One on C is an excellent example of the work Ferber did between 1963 and 1968, when he focused on freestanding, vertical sculpture with strongly drawn calligraphic images, especially S curves, commas, and apostrophes. This sculpture also demonstrates Ferber's concern with the creation of counterthrusting forms. The upward momentum produced by the soaring curved shapes makes the sculpture appear much larger than it is. Beautifully sited in an intimate square bounded on three sides by maple trees, it pierces the sky when viewed from one direction and provides a contrast to the stark marble buildings surrounding the square when viewed from another. Ferber used sheets of beaten copper brazed with bronze to create a highly reflective and textured surface, which is further heightened by the intermittent black flickers produced by the flame of the torch. A similar sculpture, *Calligraph KC*, made in 1963–64, was purchased by Nelson Rockefeller and remains on the grounds of Kykuit at Pocantico Hills in Tarrytown, New York, the Rockefeller residence bequeathed in 1979 to the National Trust for Historic Preservation.

T.G.

Helen Frankenthaler
1928–

Capri, 1967
acrylic on canvas
10'-4" x 9'-11½"

Critics, historians, and artists have credited Helen Frankenthaler with initiating the development of that branch of Abstract Expressionism known as color-field painting. Frankenthaler was influenced by Jackson Pollock's revolutionary technique of dripping paint on large canvases laid out on the floor and by the open, expansive scale of his paintings. She concentrated on using color stained directly into canvas. Through this technique, she was able to achieve the modernist objective of identifying color and form with the flatness and materiality of the canvas while simultaneously creating an illusion of space through the contrast of color. During a well-documented visit to her studio, Morris Louis and Kenneth Noland were deeply impressed by the formal possibilities of staining after seeing *Mountains and Sea* (1952), the painting in which Frankenthaler's technique was first fully realized.

Frankenthaler was born in New York in 1928. She began her artistic training at an early age, taking art classes at the Dalton School from the Mexican muralist Rufino Tamayo. In 1946 she enrolled at Bennington College in Vermont, where she studied with the painter Paul Feeley. From him, she gained a comprehensive knowledge of the work of early twentieth-century European and American artists. After graduating in 1949, she returned to New York City, where she met Clement Greenberg the next year. Greenberg introduced her to the younger Abstract Expressionists with whom she participated in the now-celebrated discussions at the Cedar Bar and The Club. At Greenberg's suggestion, Frankenthaler briefly attended classes with Hans Hofmann in Provincetown in the 1950s. Then, in 1951 Greenberg took her to Jackson Pollock's studio, where he discussed his own analysis of Pollock's work. At the time, Frankenthaler was painting forms abstracted from nature and nonobjective works derived from Hofmann's style. Soon after this visit, Frankenthaler's work underwent a radical transformation, issuing in the development of the staining technique.

Frankenthaler employed an automatic procedure aimed at the free and spontaneous expression of the unconscious mind. Compared to the heavily impastoed surfaces of the work of action painters like Grace Hartigan or Joan Mitchell, Frankenthaler's are thin. Rather than emphasizing personal gesture, her process produced distinct forms that appear to have been created independently of the artist. *Capri*, for example, is vaguely reminiscent of a landscape seen from an aerial perspective. Encouraged by the title, which refers to the Italian resort just off the west coast of Italy, the viewer might read the central dark shape as an

island surrounded by water. The bright, luminous color of the painting and its thin, watery consistency reinforce this impression. Nevertheless, these associations remain ambiguous, and *Capri* can more readily be compared to the abstract paintings of Mark Rothko. Its large size, floating forms, and format, which vaguely reinforces the rectilinear outline of the stretcher, recall the older artist's paintings.

T.B.

Naum Gabo
1890–1977

Construction in Space: Spheric Theme, 1969
stainless and cor-ten steel
8'-0" x 8'-0"

Naum Gabo was born Naum Neemia Pevsner in Briansk, an industrial city in central Russia. Later he changed his name to distinguish himself from his brother, Anton Pevsner, a painter with whom he was closely allied. Gabo received a scientific education at the University of Munich between 1910 and 1912, and in 1913 went to visit his brother, who now called himself Antoine, in Paris, where he first became acquainted with Cubism. During World War I his father sent him and his other brother, Alexei, to Oslo, Norway, and there, without formal training, Gabo employed engineering techniques to produce his first three-dimensional constructions. These first sculptures— a series of human heads and figures made with flat or curved planes of cardboard or metal—were slotted or glued together, resulting in a honeycombed structure open to light and space.

After the Russian Revolution in 1917, Gabo and Antoine became associated with Wassily Kandinsky, Kasimir Malevich, and Vladimir Tatlin. Belief in utilitarianism and involvement in industrial production dominated the artistic program of the Russian avant-garde during these years. Gabo, however, in reaction to the stand of Tatlin and his colleagues, made a plea for a "New Style" of art, which would be worthy of advances in twentieth-century science and technology, but which would retain its "absolute" artistic value.

Gabo also sought to replace static with kinetic rhythms; in 1920 he made the world's first kinetic sculpture by attaching an electric motor to a metal rod to make it vibrate. In addition, he promoted the use of new materials —plastic, wire, and glass—which he felt would serve both his new spatial explorations and his goal of utilizing the new products of the modern industrial era. Gabo chose the term "constructive" to describe his art and philosophy. In the West, however, his art became associated with "Constructivism," a term that ironically had first been used in Russia to designate Tatlin's utilitarian, social approach to art.

In 1922, unable to accept the utilitarian imperative of Tatlin and the Russian Constructivists, Gabo left Russia and lived in Berlin for ten years, then in Paris for three years. Unhappy with the artistic climate in Paris, which revolved around Cubism and Surrealism, Gabo moved to London, where he associated with artists Ben Nicholson, Barbara Hepworth, Henry Moore, Piet Mondrian, László Moholy-Nagy, and the critic-poet Herbert Read. He concentrated on making sculpture that appeared to be based on three-dimensional mathematical formulas or models,

beginning each work with a series of pencil drawings to plot its construction from every angle. He then built several small models in order to determine the shape and thickness of his materials. During this time Gabo favored transparent materials because he felt they minimized the texturally associative materials of traditional sculpture and allowed greater concentration on form and space.[1]

A significant departure occurred in 1936, when for the first time Gabo began to base his sculptures on spherical structures. He believed that the visual character of space was spheric not angular. Among Nelson Rockefeller's most important bequests to The Museum of Modern Art in 1969 was an elegant work of this style, Construction in Space X, made in 1953. The Empire State Plaza's Construction in Space: Spheric Theme, made late in Gabo's career, is also directly related to the spheric theme works of the late 1930s. In this sculpture, the seemingly continuous curved planes are actually two identical circles bolted and held together with a network of tiny springs. These springs, which Gabo called "lines of tension," delineate depth and contribute to the sculpture's overall impression of weightlessness; they draw the eye toward the center of the work and the elements of construction. Volume has been created by a mathematical arrangement of lines and planes, and color is confined to the materials used except for the painted base and interior core.

In 1946 Gabo moved to the United States, where he was at last able to realize his dreams for large-scale public sculptures, including a hanging sculpture at the Baltimore Museum of Art in 1950–51, a wall relief for the lobby of the U.S. Rubber Building in Radio City, New York, in 1956–57 (resited in 1976 to the Celanese Corporation building on the Avenue of the Americas), an 85-foot-high sculpture at the Bijenkorf in Rotterdam in 1956–57, and a revolving fountain for the Tate Gallery in London in 1972–73.

T.G.

Fritz Glarner
1899–1972

Untitled, 1968
oil on canvas
13'-8" x 57'-6"

Fritz Glarner, a painter and muralist, was a leading figure in the geometric abstraction movement in the United States in the late 1940s and 1950s. Its adherents employed primary colors and strict geometric forms, which, these artists felt, would enable their art to embody impersonal, timeless, and universal values rather than express individual moods or feelings. They were influenced by the work and artistic theories of certain European émigrés—Piet Mondrian, Fernand Léger, and Josef Albers—and the Russian artist Wassily Kandinsky.

Born in Zurich, Glarner received an academic art education at the Royal Institute of Fine Arts in Naples, where he studied from 1914 to 1920. In 1923 he went to Paris, met a number of modern artists, and participated in the first Abstraction-Création exhibition in 1931. Soon after moving to New York City in 1936, Glarner joined the American Abstract Artists (AAA), a group formed that year to advance the cause of modernism as opposed to the figurative painting of the Regionalists and Social Realists, and was an exhibiting member from 1938 to 1944. Glarner was also a member of The Club, a group of New York School artists who met weekly for more than a decade for lively panel and roundtable discussions beginning in 1949.

The most crucial influence on Glarner's mature style was the Neo-Plastic art of Piet Mondrian. Glarner met Mondrian in Paris in 1928, and after renewing the acquaintance in 1942 in New York City, he developed a close friendship with the Dutch artist. After Mondrian's death in 1944, Glarner devoted his energies exclusively to drawing for a year. From 1945 until his death in 1972, Glarner worked in the Neo-Plastic manner, which he called "relational" painting. According to Glarner, the term relational describes paintings in which infinite, changing relationships among the pictorial elements—vertical and horizontal lines, rectangular forms, and primary colors, along with black and white and shades of gray—are resolved in self-contained, balanced compositions.[1] Like Mondrian, Glarner hoped to express universal and transcendental-aesthetic truths through this dynamic balance of pure forms. Glarner, however, included obliquely angled lines in his paintings, sometimes within circular shaped canvases, departing from Mondrian's strictly horizontal and vertical compositions.

The large size and scale of Glarner's untitled mural, the length of its trapezoidal forms, the large areas of color coupled with intimate brushstrokes, all encourage the viewer's eye to travel slowly through the composition. Massive yellow, red, and gray forms anchor the center of the mural, while vertical and horizontal trapezoidal shapes move outward in a centrifugal composition. Although Glarner did not stress visible brushwork in his earlier paintings, he later applied the paint more thickly, adding a distinctive physical dimension to his work. Here, the interplay of richly textured brushstrokes creates a strikingly mottled effect that changes with variations in light. The edges of the colored forms are not precisely drawn, as they were in Glarner's early works, but loosely painted in ragged gray, black, and white lines.

Glarner's last large commission before his death, this mural is one of sixteen works commissioned for the Empire State Plaza. Painted in three sections and attached to a wall in the Justice Building of the Plaza, Glarner's mural has an architectonic dimension that complements its setting. Glarner's other notable mural commissions include a painting executed in 1958–59 for the Time-Life Building in Rockefeller Center and another done in 1958–61 for the Hammarskjöld Library in the United Nations Building. In 1964 Nelson Rockefeller commissioned Glarner to paint a mural for the walls and ceiling of the dining room in his New York apartment.

T.G.

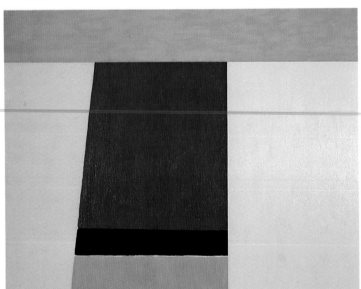

60

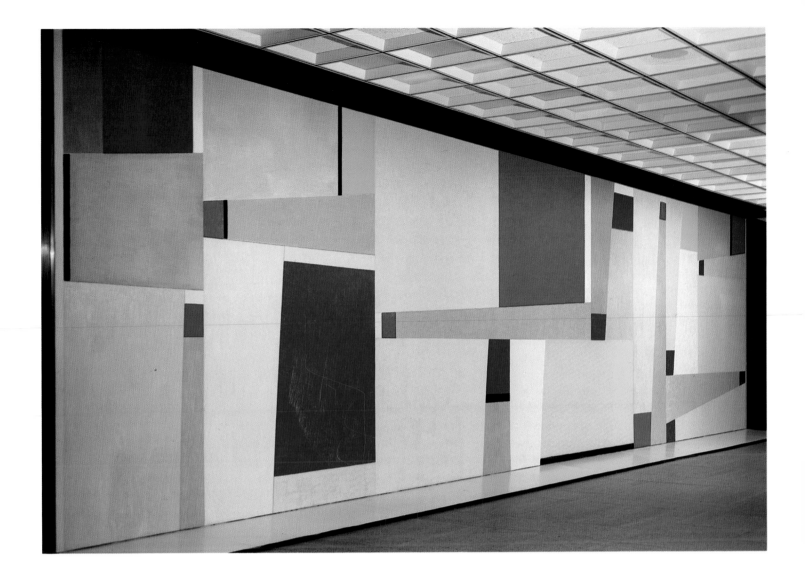

Robert Goodnough
1917–

Struggle, 1966–67
charcoal, acrylic, and oil on canvas
8'-10" x 21'-10"

Art historians and critics generally refer to Robert Goodnough as a second-generation Abstract Expressionist. His early paintings from the 1950s were clearly influenced by the loose, spontaneous markings of Jackson Pollock and Franz Kline. Nonetheless, Goodnough's paintings also revealed traces of a more rigorous structural appearance rooted in Cubism.

Born in Cortland, New York, in 1917, Goodnough received a scholarship to attend Syracuse University. Receiving a traditional art training, he became skilled as a representational painter. During service in the army from 1942 until 1945, Goodnough spent much of his time doing portraits of officers and murals of patriotic subjects. While in the army, he was exposed to modern art by reproductions he saw in magazines of the work of Pablo Picasso, Henri Matisse, and Piet Mondrian. Moving to New York City in 1946, he studied with Amédée Ozenfant, one of the founders of French Purism. Goodnough also enrolled in Hans Hofmann's school in Provincetown, Massachusetts. In 1948, while studying at New York University for a master's degree in art education, he attended lectures at Subjects of the Artist, a cooperative school run by William Baziotes, Robert Motherwell, Mark Rothko, Barnett Newman, and David Hare. Goodnough met many of the Abstract Expressionists there, and along with the sculptor Tony Smith was encouraged in the direction of abstract painting. Despite his involvement with Abstract Expressionism, however, Goodnough continued to incorporate aspects of different styles and, unlike many of his contemporaries, often included representational elements in his paintings.

In the early 1950s Goodnough became interested in the technique of collage. His use of this medium was inspired by a fascination with the reconstruction of a skeleton of a brontosaurus he saw in 1952 in New York's Museum of Natural History. The constructed look of this dinosaur inspired him to begin a series of "dinosaur" collages in which he arranged cut shapes to resemble the dinosaur skeleton. Eventually, he abandoned the dinosaur image and developed the collage technique as a way of combining a loose, spontaneous appearance with a more controlled way of working.

Though Struggle is not actually a collage, it has forms that look like cut-out shapes applied to the surface. They are arranged as overlapping planes of color in a flat, shallow space, giving the painting a formal structure related to that of Synthetic Cubism. Struggle also has an energetic, somewhat chaotic composition that incorporates drips and other "accidents," recalling the more gestural and spon-

taneous approach of Pollock and Kline. The painting is predominately nonrepresentational, evoking a feeling of struggle by means of chaotic, overlapping forms and lines concentrated in the center of the painting. Figural and landscape elements are also present. For example, an arm rises out of the mass of forms to the right of center and light blue clouds float above. These fragmented forms, caught in conflict and contrasted with a more peaceful surrounding, reinforce the subject of struggle. The content of this painting, together with its large size and vaguely Cubist style, recalls Picasso's famous tribute to the struggle of the Spanish people against Fascism in his 1937 painting Guernica.

T.B.

Adolph Gottlieb
1903–1974

Orange Glow, 1967
oil on canvas
6'-6" x 5'-6"

Adolph Gottlieb was a leading Abstract Expressionist painter. His works contain elements of the two stylistic poles that dominated Abstract Expressionism. *Orange Glow* and *Burst* are representative of both the gestural styles of Jackson Pollock and Franz Kline and the fields of colors characteristic of paintings by Barnett Newman and Mark Rothko.

Gottlieb was born in 1903 in New York City. At the age of seventeen he left high school to study at the Art Students League. His teachers there were John Sloan and Robert Henri, who were associated with the Ash Can School, a group of realists who painted scenes of everyday American urban life. After a year at the League, Gottlieb worked his way to Europe on a steamer and spent six months in Paris and a year on the Continent. He returned to New York to finish high school, spent another year studying at the League, and attended Parsons School of Design. His first one-person exhibition took place in 1930 after he had won two first prizes in the Dudensing National Competition. In the mid-1930s Gottlieb exhibited with a group known as The Ten, which included Mark Rothko and Ilya Bolotowsky. In the late 1920s and early 1930s Gottlieb was influenced first by Cézanne, and then, following the encouragement of his friend the painter Milton Avery, Matisse. In 1937, giving up his participation as an easel painter in the Federal Art Project of the Work Projects Administration (WPA), Gottlieb moved to Tucson, Arizona, where he painted still lifes of cacti, gourds, and other evocatively shaped objects collected in the desert. These forms became the basis of an artistic vocabulary that Gottlieb developed throughout his career until his death in 1974.

Gottlieb's mature phase began with his "pictographs," first produced in 1941. In these paintings he juxtaposed the forms of his desert imagery as well as motifs suggesting, among other things, eyes, heads, teeth, and eggs within a grid structure. The imagery and format of these paintings recalled primitive and archaic art. These associations represented a crucial element of Gottlieb's interest in mythology and his belief in the possibility of producing imagery with universal significance. The motifs had no specific symbolic meaning, however. They were selected and composed intuitively. Gottlieb stated: "My favorite symbols were those I didn't understand. If I knew too well what the symbol signified, then I would eliminate it because then it got to be boring."[1] Over the years Gottlieb simplified his imagery. From 1951 until 1957 he produced paintings that he referred to as "grids" and "imaginary landscapes." The grids contained the same linear grid structure as his earlier

paintings but without the symbollike images. The imaginary landscapes, on the other hand, juxtaposed images above and below a horizon line.

These paintings evolved into a group of works called "bursts," which Gottlieb produced in the final phase of his career. In the bursts the horizon line that figured so prominently in the imaginary landscapes disappeared; each painting is composed of a disc and an irregular mass grounded in a field of color. The bottom element — the irregular mass — is made up of the gestural brushstrokes and drips associated with action painting, a reference to the artist's creative process. The overall field of color grounding the images in a flat, frontal plane recalls the unitary compositions of the paintings of Rothko and Newman. The resulting tension between an active process and a motionless, solid field further maintained the contrast between the unformed mass of paint and the clearly defined shape above. These images, suspended in an elusive space, look like cosmic forms and have been interpreted mystically as symbols of "the prime act of creation."[2] They have also been seen to represent various so-called polarities, "dark and light, bland and saturated, flat and modulated, jagged and round, centripetal and centrifugal, kinetic and potential, male and female, earth and sun, and so on," juxtaposed within a whole.[3]

Orange Glow contains a hot, red disc surrounded by a lighter orange halo contrasted to a black gestural mass of paint within a pink ground. The painting is built up of thin layers of paint, a technique that allowed Gottlieb to intensify his final color by underpainting with bright, luminous hues. While the color of the pink ground is subtle and elusive, the mat surface of the paint produces a look of solidity so that the ground seems capable of supporting the shiny, painted images. Despite the oppositions implied by the images, the painting achieves an apparent unity — resolution of opposing forces. Even in the tapestry medium of *Burst*, Gottlieb unifies disparate elements through the rich orange field that contains and envelops both the bold, forceful dark mass below and the more ephemeral floating disc above.

T.B.

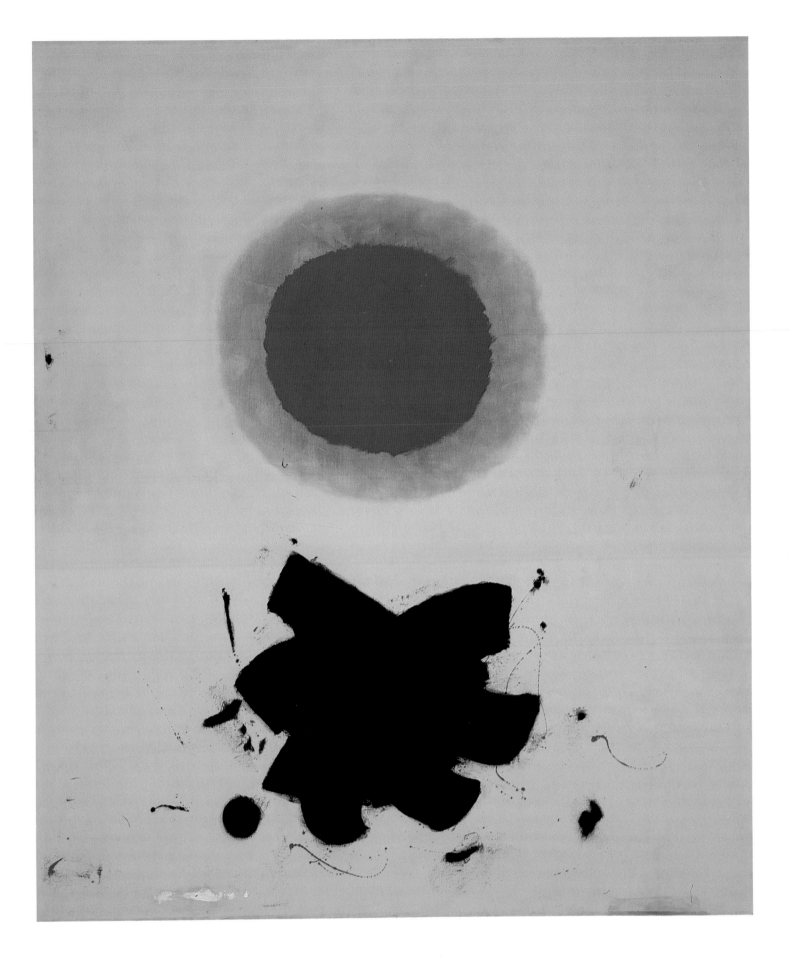

Adolph Gottlieb
1903–1974

Burst, 1968
handwoven wool tapestry
8'-0" x 6'-0"

Philip Guston
1913–1980

Smoker, 1963
oil on canvas
5'-10" x 6'-4"

Philip Guston was born in Montreal in 1913, the youngest of seven children. In 1919 his family moved to Los Angeles, where Guston's father committed suicide five years later. Guston attended Manual Arts High School until, with his closest friend, Jackson Pollock, he was expelled for writing a satirical broadside about the school's English department. On his own, he studied the Italian Renaissance painters, cartooning, and a variety of other political and art topics, and in 1934 traveled to Mexico to work as an assistant to David Alfaro Siqueiros on a mural entitled *The Struggle Against War and Fascism*. On his return, he followed Jackson Pollock to New York City and joined the mural section of the Work Projects Administration (WPA). After resigning from the WPA in 1940, Guston concentrated on his own painting. He taught at universities around the country and had his first solo New York exhibition in 1945. In 1947 Guston won a Guggenheim Fellowship and in 1948 spent a year in Europe after winning the Prix de Rome.

From the early 1940s until his death in 1980, Guston's painting developed in three distinct stages. Unlike most of the painters of the first generation of Abstract Expressionists, Guston had a relatively successful early career as a realist painter. His paintings from this period appear to be influenced by Picasso, and their themes are often the harsh social conditions of the time. In 1947 and 1948, along with artists such as Franz Kline, Jack Tworkov, and James Brooks, Guston adopted an abstract style, eventually producing delicately brushed, textured paintings with pastel patches of color floating in an amorphous space. In the late 1950s and into the sixties Guston's palette grew more subdued and his characteristic rectangular images within a textured ground became more defined. In 1970, however, Guston surprised the many admirers of his abstract paintings by showing pictures that reincorporated the figurative imagery of his earlier realist paintings.

Smoker is a painting from the later years of Guston's abstract period. It reveals his evolution toward a more sombre palette — black, white, and gray. Here, a thin layer of rose is covered by a buildup of steely grays. Employing a technique that he referred to as "erasing," Guston brushed white paint over wet black paint so that the loose rectangular images emerge as three dark forms in a gray field. As Dore Ashton has pointed out, the edges of the paintings have been left unpainted, juxtaposing the stark reality of the bare canvas with the illusionism of the painted image.[1] Despite the gestural application of paint, *Smoker* does not possess the quick, spontaneous movement that character-

izes paintings by Kline and De Kooning. Instead, the brooding, expressive quality of the black images predominates, the dark rectangles emerging from the dense atmosphere with a presence that almost seems human.
 T.B.

Dimitri Hadzi
1921–

Helmet V, 1961
bronze
8'-5" x 3'-5" x 2'-5"

Dimitri Hadzi was born in New York City in 1921. Although he began studying art at Cooper Union in 1946, his art education took place primarily in Europe at a time when the center of artistic activity had already begun to shift from Paris to New York. When Hadzi received a Fulbright Grant in 1951 to study stone sculpture at the Polytechneion in Athens, he accepted, motivated perhaps by a desire to explore his own Greek heritage and to seek alternatives to Abstract Expressionism. After leaving Athens, he studied in Rome, where he stayed until his return to the United States in 1975. Since 1977 he has been a studio professor of visual and environmental studies at Harvard University.

Influenced by the sculpture of Greece and Italy, Hadzi's work is strongly classical in nature. Until 1958 his bronze statues were of mythical subjects such as centaurs and lapiths. His style later grew more abstract, although Classical references are to be found in his *Shield* and *Helmet* series. The curved slab of thick bronze at the top of *Helmet V* resembles, as the title suggests, the headpiece of some ancient military carapace or medieval armor. Just as a helmet protects a vulnerable part of the body from danger, this curved section seems to shield the organic, heart-shaped form at the sculpture's base. Although the sculpture is cast in bronze, the three "legs" that connect the top and bottom sections appear unsteady. Despite its traditional materials and classical allusions, *Helmet V* conveys a tension between stability and instability with an immediacy that makes it relevant for the modern viewer. Indeed, Hadzi prepared for *Helmet V* by reading about World War II, reflecting upon his own involvement in the war in the air force in the South Pacific, and conducting research trips to Dachau. Hadzi produced *Helmet V* as a competition entry for the Auschwitz concentration-camp memorial.[1] Although the piece was not chosen, it received favorable reviews when it was shown at the Radich Gallery in 1962 and as a United States entry in the Venice Biennale the same year.

Helmet V marks a new phase in the sculptor's career in which abstract forms are used to evoke specific historical moments rather than timeless myths. As Albert Elsen wrote in 1978, Hadzi's sculpture is a "product of art's history and the artist's contemplation of history."[2]

K.O.

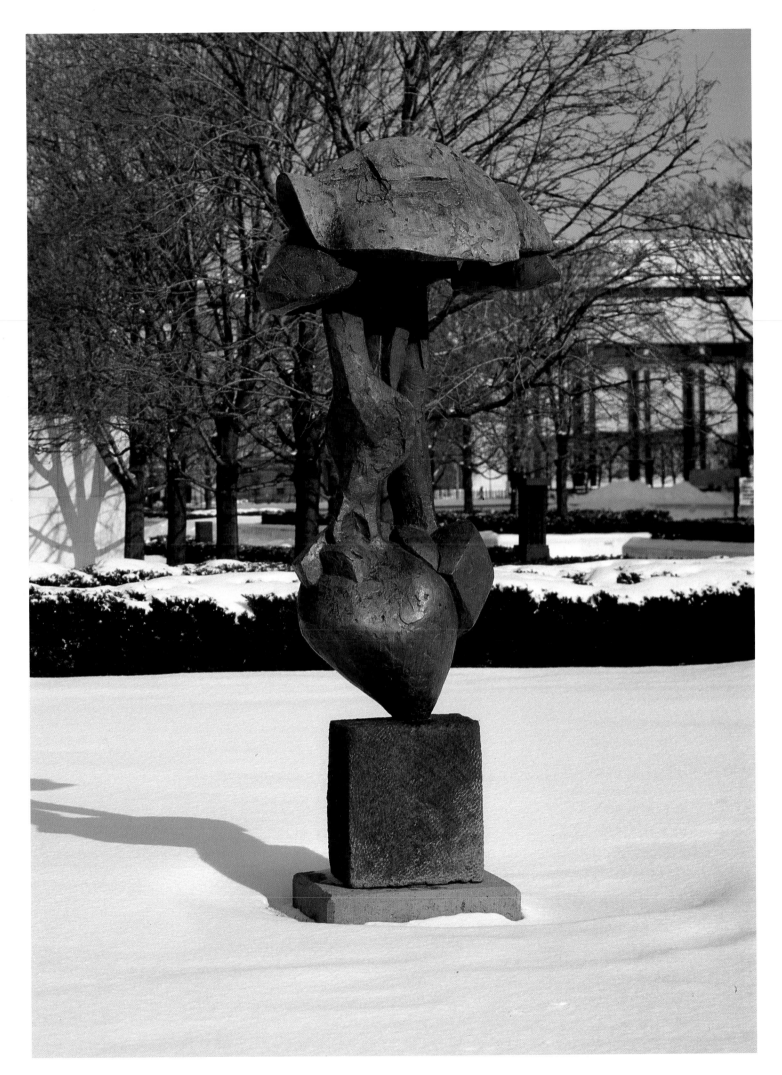

Grace Hartigan
1922–

The-The #1, 1962
oil on canvas
6'-8¾" x 9'-7½"

Grace Hartigan, born in Newark, New Jersey, received training in mechanical drawing at the Newark College of Engineering and was employed during World War II as a drafting technician. In 1946 Hartigan moved to Manhattan and was invited to join The Club, a group organized in 1949 by Willem de Kooning, Franz Kline, Jack Tworkov, and other New York School artists. As Hartigan commented: "Abstract Expressionism, so called, was born in New York, created in New York and deals with the energy of New York."[1]

Hartigan's early painting *Grand Street Brides*, completed in 1954, was inspired by a store-window display of mannequins in wedding gowns, and by the court scenes of Goya and Velázquez, revealing Hartigan's interest in the history of art and the contemporary visual world. Between 1954 and 1958 she also painted a series of "city life" scenes based on the Lower East Side. Nelson Rockefeller acquired one of these, *City Life*, painted in 1956.

Calling herself a "process artist," Hartigan allows her work to unfold without a preconceived plan. "The painting begins to talk to you, and it begins to dictate. You become almost a medium."[2] Hartigan has always been closely associated with poets, both as friends and as inspiration for her work. *The-The #1* is titled after the last line of a poem by Wallace Stevens, "The Man on the Job": "Where was it one first heard the truth? The the."[3] This large-scale, complex work contains rich reds and oranges contrasted with blue, gray, and green. Like many of Hartigan's abstract works, *The-The #1* is sprinkled with suggestions of recognizable forms and anatomical details. Lushly colored rounded forms and exuberant gestures are highlighted by heavy black lines. Filled with rich color and vibrant gestures, *The-The #1* exemplifies Hartigan's artistic credo: "I believe in beautiful drawing, in elegance, in luminous color and light."[4]

J.F.

Al Held
1912–

Rothko's Canvas, 1969–70
acrylic on canvas
10'-0" x 90'-0"

Al Held's career is notable for its radical stylistic shifts. His early canvases were loosely painted with gestural brushstrokes and are closely associated with Abstract Expressionism. Subsequently Held began producing flat, brightly colored paintings of geometric forms. He then proceeded to eliminate color and concentrated on producing an illusion of three dimensions at a time when acknowledgement of the flatness of the support was advocated by the avant-garde. More recently, he has reintroduced color in paintings that depict geometric objects projecting into deep perspectival space.

Held was born in 1912 in New York City. After attending classes at the Art Students League for a year and a half, in 1950 he went to Paris, where he studied at the Académie de la Chaumière. Returning to New York in 1953, he became affiliated with the Abstract Expressionists and painted heavily textured, nearly monochromatic paintings in earth colors. In 1955 he went to San Francisco, where he met Ronald Bladen. Upon his return to New York the following year, he founded, together with Bladen, George Sugarman, and Nicholas and John Krushenick, the Brata Gallery on Tenth Street. In 1959 he began to experiment with vaguely geometric forms, brushed freehand in bright colors. Still adhering to some of the principles of Abstract Expressionism, his new geometric forms were not hard-edged, and maintained a solid, physical presence because of their flat surfaces. His canvases revealed the process of change and correction in visible pentimenti. In 1967 Held began his black-and-white paintings of volumetric forms in space. In these works he continued to employ geometric shapes but adopted hard-edged lines. While these stylistic features were also characteristic of Minimalism, they were incorporated by Held for the antithetical purpose of producing complex spatial configurations that wove in and out in an illusionistic space.

Rothko's Canvas (titled in homage to the painter, who died the year this mural was finished) is representative of Held's black-and-white paintings. Commissioned for the Empire State Plaza Art Collection, this monumental painting extends 90 feet along the wall of an underground concourse. A profusion of cubes, rectangular boxes, rings, and circles that float in an ambiguous space are depicted. The forms are defined by a clearly delineated black line against a white ground. The width of the black outline varies with each form, suggesting a changing scale and position in space. These lines manipulate the white areas so that they appear as both empty space and solid form. The painting is full of optical illusions as multiple perspectives

make volumetric forms appear, intersect, and simultaneously advance and recede. The complexity and conflict provide an evolving visual narrative that leads the viewer from one end of the painting to the other.

T.B.

Will Horwitt
1934–1985

Spaces, 1969–70
cast aluminum
6'-1" x 5'-1½" x 10'-7"

"Sculpture," according to Will Horwitt, "isn't about the object — it's about the space around it."[1] *Spaces*, as its title implies, provides a visual parallel to Horwitt's statement. Intended to be viewed from the front, it is composed of three major parts. The first — a large rectangular shape with another rectangle cut out — frames the piece. Directly behind this frame, a flat bar extends from a point outside the right edge into the center, where it bends, forming a diagonal. A flat, solid rectangle forms a backdrop to the sculpture. The viewer is led from foreground to middle ground and finally to background, in a literal depiction of traditional, illusionistic pictorial space. The large scale gives the sculpture an architectural appearance, its spatial progression suggesting a movement from exterior to interior that involves the viewer in the object's actual space.

Horwitt exploits the expressive value of metals, manipulating textures and colors to leave traces of the artist's gesture and suggest the passage of time. Cast in bronze and aluminum poured over sand and gravel, with encrusted patinas ranging from a dark to silver gray or orange rust color, the rough, pitted elements of *Spaces* resemble the surfaces of used and discarded architectural fragments.

Horwitt was born in New York City in 1934 and studied at the Art Institute of Chicago from 1952 to 1954. He first exhibited his sculpture in the early 1960s. The works he showed were totemlike objects composed of stacked parts that suggested both geometric and organic forms. Critics described these sculptures as influenced by Constantin Brancusi. In the late 1960s Horwitt's constructions, like *Spaces*, became more architectural. By 1974 Horwitt was exhibiting paintings along with sculpture reliefs and free-standing sculptures. These canvases explored the creation of pictorial space through the relationship and balance of horizontal and vertical elements. His last works, exhibited at the time of his death in 1985, were large linear steel pieces that resembled elongated O's resting on the floor several inches from the wall. They appear to continue Horwitt's investigation in works like *Spaces* of the boundary between interior and exterior space.

T.B.

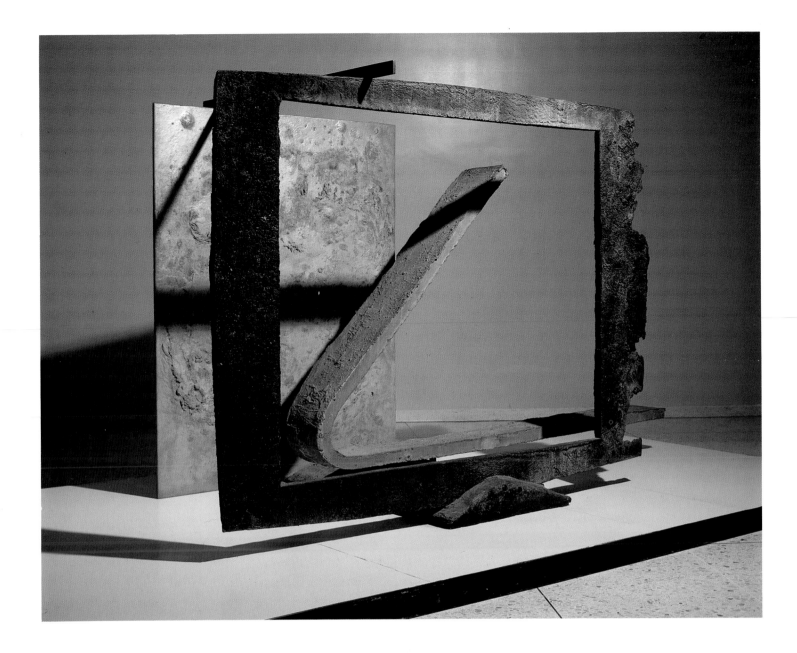

Paul Jenkins
1923–

Phenomena: Mistral Veil, 1970
acrylic on canvas
10′-0″ x 8′-0″

Paul Jenkins has been called a choreographer of color.[1] Indeed, he claims that Martha Graham's experimental dance taught him that the abstract movement of the hand could be meaningful apart from its production of recognizable imagery.[2] Nonetheless, familiar-looking forms emerge from the overlapping and intersecting layers of poured paint on his canvases. In *Phenomena: Mistral Veil*, for example, a winged entity is clearly visible, seemingly held aloft by an airy expanse of white and a translucent sheet of light blue pigment.

Jenkins initiated his characteristic pouring technique after moving to Paris in 1953, at the age of thirty. Born in Kansas City, Missouri, he first studied art in 1937 at the Kansas City Art Institute. During his student years he was also interested in theater and, while enrolled at the Art Students League in New York City from 1948 to 1952, he studied playwriting. He abandoned his study of the theater only after he moved to Paris. Perhaps his attraction to drama was manifested at this point in his new painting technique with its manipulation of huge canvases and grand gestures of pouring paint from large cans. The art critic Harold Rosenberg referred in 1952 to a "new" conception of the canvas as an "arena in which to act."[3] Chief supporter of the postwar Abstract Expressionists, Rosenberg was referring to artists like Jackson Pollock, but the notion of the theatrical use of the artist's own body in the painting process might also describe Jenkins's new methods. Several other artists in the generation after Pollock, such as Helen Frankenthaler, Morris Louis, and Kenneth Noland, also started to pour and stain their canvases about the same time as Jenkins. However, it was not until 1956 (after Jenkins's first one-person show in Paris in 1954), and his return to the United States for his first New York exhibition, that he learned of similar developments in the United States.

Jenkins's technique, like that of his counterparts and many of the first-generation Abstract Expressionists, maximizes paint's fundamental fluidity and maintains a balance between sheer chance and assertive calculation. Stapling the corners of a primed canvas to a ladder, sawhorse, or table, Jenkins adjusts the pitch of the canvas's slope so that the paint flows freely yet is still controlled. Streams of paint are poured — one acrylic pigment after another — while Jenkins directs their flow by gently folding the back side of the canvas or pressing against it with the edge of an ivory knife. A pool of mixed pigments forms at the bottom where all the streams of paint converge. The only time Jenkins touches the front of the canvas is when he

pulls, drags, or pushes paint from the pool with a long-handled, round-ended brush. As the artist explains his process, he is "trying to arrive between that dumb shape and that lyric shape."[4]

Jenkins titles a painting when he feels that the lyric shapes have been realized. The word or phrase that follows the term "phenomena" in his titles designates what the artist sees in the image and also guides the viewer's reception. In *Phenomena: Mistral Veil*, the winged object is meant to represent the presence of a cold northerly Mediterranean wind, or mistral. Through suggestive color and verbal instructions, the artist directs the viewer, as he did the paint, toward a very specific and controlled meaning.

K.O.

Alfred Jensen
1903–1981

Kronos, 1968
oil on canvas
five panels
7′-10½″ x 19′-1½″ overall

Alfred Jensen has been called an "abstract primitive." In discussions and writings about his art, Jensen referred to such diverse subjects as ancient calendar systems, the color theories of Goethe, the discoveries of nineteenth-century scientists such as Michael Faraday, and the optics of the prism. Perhaps Jensen's individualism stemmed from his background. He was born in 1903 in Guatemala to a Danish father and a Polish-German mother. Until 1924, when Jensen settled down to study art seriously, he held jobs as a seaman, a cowboy, and a farmer. In 1927, at the Hans Hofmann School in Germany, Jensen met Saidie Adler May, an American artist, art collector, and patron of the arts. May helped Jensen continue his studies and followed him to Paris. The two toured Europe, North Africa, and America, visiting studios and acquiring art by Pierre Bonnard, Alberto Giacometti, Naum Gabo, Antoine Pevsner, Edouard Vuillard, Robert Motherwell, and Jackson Pollock. In 1934 Jensen established residence in the United States, and after Saidie May's death in 1951, he settled in New York City. In 1963 he married the painter Regina Bogat. He died in 1981.

It was Saidie May who introduced Jensen to the study of philosophy, science, psychology, and various non-Western cultures. In the forties Jensen began taking notes on Goethe's color theories, the working of prisms, and related subjects in the form of painted diagrams often annotated with quotations from his readings. In 1957 he began to use these notations as subject matter for his paintings. From that point on, he composed flat, brightly colored, highly patterned paintings using geometric forms, numerical systems, words, symbols, and theories derived from mythology, astrology, the prism, and modern science.

Kronos dates from a period when Jensen was interested in the seasonal movement of the planets whose patterns were incorporated in varying ways into both the temples of Greece and the pyramids of Central America. Like most of his paintings from 1964 to 1970, *Kronos* embodies the idea of form created in time. As Linda Cathcart pointed out, "the actual paint application to these paintings reflects Jensen's involvement with measures of time. The daubs of paint — tiny checkers — applied directly from the tube mark time like the ticks of clocks across the face of the canvas."[1] These daubs of color form rectangular spirals that look like pyramids seen from above. *Kronos* consists of five panels, each composed in a different pattern of vivid colors, which produce variations between light- and dark-colored areas within each section as well as an overall design of darker panels on the ends and lighter ones in

between. In the title Jensen alludes to mythology as an ancient source of universal ideas, and to a specific myth of the creation of the universe. Its use suggests that Marcia Tucker is correct in claiming that Jensen's intention was to produce in his work a general, all-encompassing order.[2]

T.B.

Donald Judd
1928–

Untitled, 1968
stainless steel and amber Plexiglas
10 units, each 9″ x 3′-4″ x 2′-7″
total height 14′-3″

Donald Judd's sculpture and extensive critical writing have established him as a pivotal Minimalist artist. The term "Minimalism," although rejected by Judd, has come to designate a movement that emerged in the mid-1960s as a challenge to the personally expressive gestures and heroic stance of Abstract Expressionism. The Minimalist artists created geometric art usually with industrial materials, aiming to strip their objects of allusions to nature and of references to individualized creative acts.

Born in 1928 in Excelsior Springs, Missouri, Judd decided to become an artist after serving in the U.S. Army in Korea. He studied at the Art Students League while attending Columbia University in the 1950s. By 1962 Judd had begun producing reliefs that projected into space and shortly thereafter built freestanding works. In 1963 he constructed his first rectangular box, a form that has since been central to his work. The early boxes, made of wood, were often painted red and incorporated metal pipes. Later, he placed regularly shaped boxes in horizontal progressions along the wall or floor as well as in vertical stacks on the wall. By 1964 he was using raw industrial materials in the construction of his boxes.

The work in the Empire State Plaza Art Collection is one of Judd's vertical stacks. It is made of ten identical boxes, with stainless-steel sides and amber Plexiglas tops and bottoms, regularly spaced one on top of the other. Unlike a sculpture such as Tony Smith's *The Snake Is Out*, the arrangement of elements in Judd's work is completely visible at first glance and from all angles. All surfaces are visible as the transparent Plexiglas allows both the interior and exterior of the boxes to be seen. The work projects into the viewer's space simply and directly. Contrasting with the blunt, matter-of-fact design, light shines through the amber Plexiglas, coloring the space between the containers and adding a weightless, elusive airiness to the structure.

T.B.

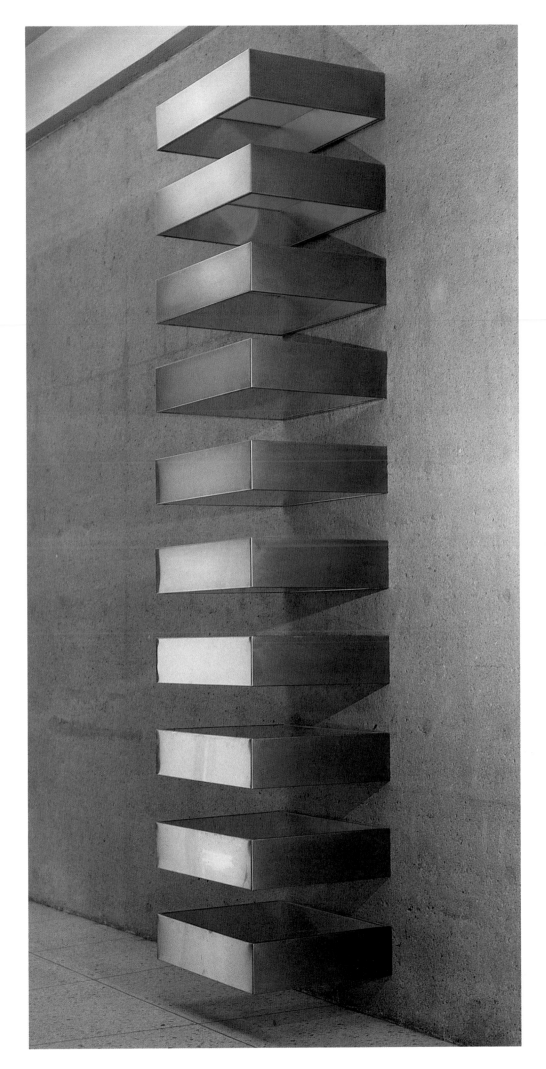

Ellsworth Kelly
1923–

Yellow Blue, 1968
painted steel
9'-6" x 16'-0" x 8'-6"

Ellsworth Kelly was born in 1923 in Newburgh, New York. After serving overseas in the army during World War II, he returned to the United States, where Abstract Expressionism was becoming the dominant mode of avant-garde painting. Rather than joining the activities of the New York School, however, Kelly settled temporarily in Boston (1946–48) and attended the School of the Museum of Fine Arts. He then moved to Paris where the ascetic, formal appearance characteristic of his mature work began to develop. When Kelly returned to the United States in 1954, he settled in New York City but continued in an artistic direction independent from that of his contemporaries.

Kelly began to experiment with allusion during his early days in Paris. Inconsequential items became sources for his drawings, paintings, and constructions: stains on a piece of cloth, the spaces between the legs of a chair, the patterns caused by light rays refracted through a window onto the River Seine or onto the pages of an open book. The artist simplified these phenomena and rendered them as abstractions.

When Kelly moved to New York, he established friendships with a wide range of artists including Pop artist Robert Indiana and Minimalist Agnes Martin. He continued his friendship with the avant-garde composer John Cage, whom he had met in Paris, and Cage introduced Kelly to Robert Rauschenberg. It was, allegedly, Agnes Martin who persuaded Kelly to experiment with sculpture in the late 1950s. While Kelly was playing with a coffee-can lid, bending it and letting it rock on the table, Martin suggested that he use the shape as a model for a sculpture. Kelly's ensuing investigation of shape became crucial to his mature work, and at the same time he began to experiment with shaped canvases.

His earliest sculptures are flat but refer to the activities of bending or shaping materials. Soon he reversed the terms of these early sculptural experiments, a reversal exemplified by *Yellow Blue*. Even though *Yellow Blue* is actually a bent form—two large, sharply angled sheets of painted steel affixed to a triangular base—when viewed from almost any position, it alludes to flatness.[1] The nonreflective primary colors contribute to this effect. Kelly does not use shape or color to produce illusions that divert attention from the materiality of the object. Rather, he emphasizes the material property of flatness.

Kelly's *Primary Tapestry* reverses this process, suggesting the illusion of depth that can be produced on a flat surface. The tapestry is based on a painting from 1963,

now in the Maeght Collection in France. By overlapping and graduating the size of the squares, he creates the illusion of space beyond the surface of the tapestry. This fictive depth is denied, however, by the identical values and intensities of the primary colors—red, yellow, and blue. The resulting equilibrium directs the viewer's attention to the surface. The tactility of the tapestry further emphasizes the materiality of the surface. The color and materials of *Primary Tapestry* counteract the effect of the arrangement of the squares; the arrangement, therefore, only signals the possibility of illusory space.

By relying on mechanical means of production—a foundry to fabricate *Yellow Blue* and a loom to produce *Primary Tapestry*—Kelly minimized the importance of the artist's personal touch in creating the artwork. This effort to eradicate the artist's presence was common in the art of the 1960s—chiefly in Minimalism—and constituted a critical reaction to the Abstract Expressionists' emphasis on the heroic artist as the ultimate source of the artwork's meaning and value. The eradication of the self from Kelly's art is not complete, however. Minimalism transfers the emphasis from the artist to the spectator by directing attention to the conditions of time and space in which the work is viewed. Kelly's art, on the other hand, remains disengaged, through the operations of allusion, from those conditions.

K.O.

84

Ellsworth Kelly
1923–

Primary Tapestry, 1968
handwoven wool tapestry
9'-9" x 10'-0"

Lyman Kipp
1929–

Wild Rice, 1967
painted steel
22'-0" x 5'-0" x 5'-0"

In 1965 Lyman Kipp stated that his sculptures were indi-
vidual, "self-contained" pieces independent of their set-
tings.[1] The bright colors of *Wild Rice* do, indeed, draw
attention to the sculpture's isolated position among the tow-
ering gray buildings of the Empire State Plaza, although
the work's cantilevered structure echoes the buildings'
repeated horizontal overhangs and vertical supports. Kipp's
contribution to the Empire State Plaza Art Collection,
then, marks a moment in his career when he began to strive
for a balance between his sculpture and its immediate
environment.

Prior to *Wild Rice*, Kipp had been producing post-and-
lintel-type constructions that projected a sense of mass
rather than monumentality. They were criticized as being
"simple objects that do not articulate the space they
occupy."[2] Such comments may have directed Kipp's inter-
ests toward the interaction of sculpture with its environ-
ment. His participation in the 1967 National Playground
Competition sponsored by the Corcoran Gallery in
Washington, D.C., no doubt also contributed to this
development. "When you work specifically for children,"
Kipp said, "the exploration of spatial relations becomes a
primary consideration."[3] As he focused on spatial con-
cerns, his sculptures became more monumental. Although
Wild Rice should, ostensibly, be dwarfed by the surround-
ing buildings, its structural relationship to those buildings
and its material give it an imposing appearance. The use
of color instills a playfulness, however, which probably
results from the Corcoran competition as well; this playful-
ness tempers the intimidating appearance of the piece.

Kipp was born in New York in 1929 and educated at
Pratt Institute and Cranbrook Academy of Art. He has
taught at various institutions since 1960 and was a member
of the faculty of Hunter College in Manhattan from 1975
until his retirement in 1985. In 1966 he was featured in the
influential "Primary Structures" exhibition at the Jewish
Museum in New York. In the catalogue introduction for the
exhibition Kynaston McShine referrred to Kipp's sculpture
as "architectonic compact constructions." This observation
describes both the self-containment Kipp had formerly
sought in his work and hints at a future trend, exemplified
in *Wild Rice:* the extension of the architectonic quality of
his work into an exploration of its relationship to an actual
architectural environment.

K.O.

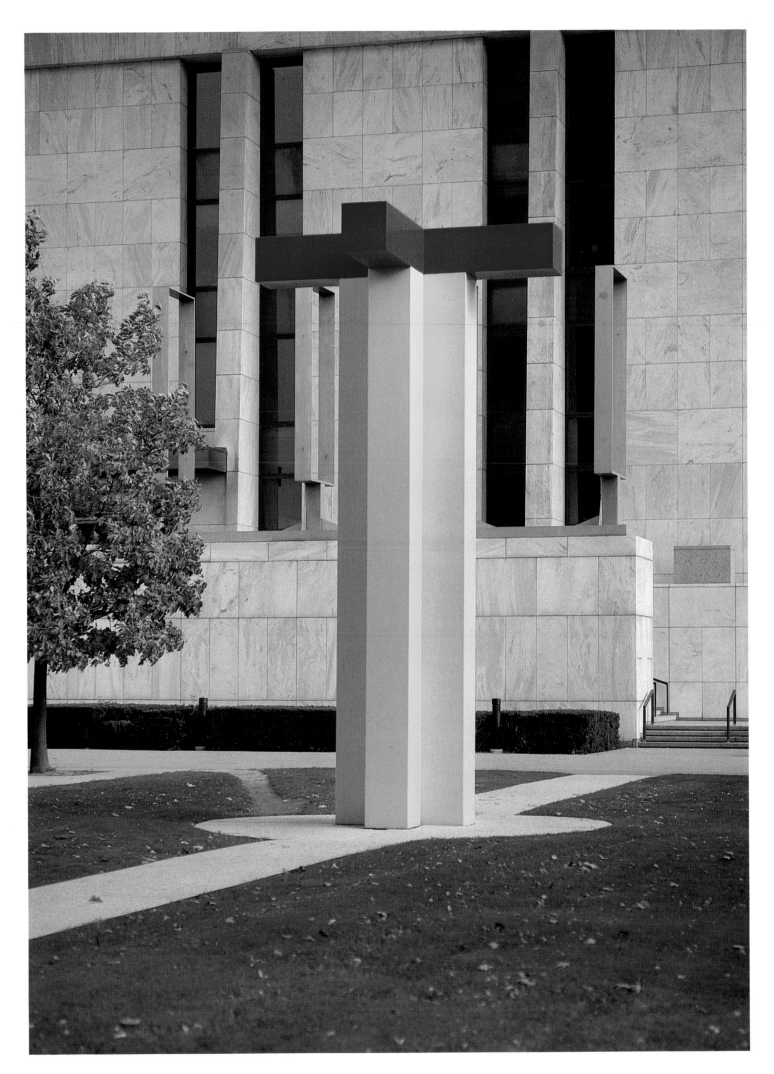

89

Franz Kline
1910–1962

Charcoal Black and Tan, 1959
oil on canvas
9'-4" x 6'-10½"

Franz Kline has been called the "architect" among the artists of the New York School. His paintings of 1950–62 are, according to his biographer Harry Gaugh, "succinct aggregate[s] of form locked resolutely in space."[1] Kline might also be called the draftsman of the Abstract Expressionists, since his mature work is characterized by monumental calligraphic strokes and a predominance of black and white. Although Kline is best known as a painter, initially he concentrated on drawing, for which he had demonstrated a proficiency at an early age as a cartoonist and illustrator for his high school newspaper.

Born in Wilkes-Barre, Pennsylvania, in 1910, Kline studied at the Boston Art Students League from 1931 to 1935 and at Heatherley's School in London from 1936 to 1937. He returned to the United States in 1938, and after a brief stay in Buffalo, where he worked as a display designer for a department store, he moved to New York City. Unlike many other future Abstract Expressionists who worked for the Federal Art Project during the 1930s and early 1940s, Kline was supported by two patrons and by independent drawing and painting projects. These ranged from a series of murals for the Bleecker Street Tavern (1940) to quick sketches of customers at the Cedar Bar—a location that would become famous during the following decade as the official meeting place for an organization of New York School artists called The Club. Kline's interest in depicting recognizable subjects, such as dancers or landscape scenes from his native Pennsylvania, gradually diminished during the 1940s, and he began to experiment seriously with abstraction in 1947—a date that was a turning point for many of his artist friends. It was not until his first one-person show at the Egan Gallery in New York City in 1950, however, that he was identified as a prominent figure among the Abstract Expressionists, who were beginning to be known as the "gesture painters."

After exposure to the work of Willem de Kooning in the late 1940s, Kline developed a method that merged his skills in drawing and painting. He began to draw numerous abstract sketches on scrap paper—often telephone-book pages—from which he would then select one to serve as a model for a painting. The early results—large canvases composed of a limited number of white and black slashed strokes—were shown at Egan's in 1950. Following this exhibition, Kline continued to paint in this manner until his death in 1962, although his forms became more complex, his use of color more obvious, and the verticality of his canvases more pronounced. All these developments are registered in *Charcoal Black and Tan* of 1959, a vertical painting in which touches of dull yellow and burnt orange are interlocked with other forms that vary from white to gray to brown to black.

Initially, the dark forms in *Charcoal Black and Tan*—as in all of Kline's Abstract Expressionist works appear to rest on a white ground. But upon extended viewing it becomes clear that the white and black shapes together create a flat, anti-illusionistic plane. Robert Goldwater has suggested that Kline's interest in preserving the integrity of the picture plane and in developing its potential forcefulness is foretold in the artist's method of preparing for his paintings by sketching on surfaces such as telephone-book pages, where the density of the print precludes any illusion of a deep recessional space.[2]

At first glance, the force of Kline's surfaces seems to derive from spontaneous and quick execution. Kline deliberated over his pieces, however, and reworked them repeatedly. This care is indicated in *Charcoal Black and Tan* by the buildup of paint in some areas. Perhaps the dynamism of Kline's surfaces derives from his brushstroke—a magnified version of the cartoonist's deft touch—which has been directed across the canvas by such a powerful and wide-sweeping gesture that it often seems that the artist's arm could not have stretched that far or sustained the energy that the painting evokes. Elaine de Kooning wrote that Kline's "big, brash, breezy gesture . . . carried to its extreme, becomes a not-unconscious parody of itself."[3] During this period, other Abstract Expressionists, such as Willem de Kooning and Robert Motherwell, also activated the opposition between black and white through dynamic painterly gestures. Unlike Kline, De Kooning returned to figuration around 1950, and both he and Motherwell gradually became influenced by a wide variety of styles, sources, and methods. For Kline, however, the framed "vital gesture"[4] constitutes the sum total of his last twelve years of work. It stands as a personal signature as well as an emblem of a concern shared by several of his New York School colleagues.

K.O.

Seymour Lipton
1903–

The Empty Room, 1964
nickel-silver on monel metal
6'-5" x 2'-8" x 2'-1"

Seymour Lipton's sculpture is often associated with Abstract Expressionist painting. Like the Abstract Expressionists, he developed his mature style in the late 1940s and early 1950s. His process of directly cutting and welding metal (as opposed to traditional methods of casting sculpture) parallels the spontaneous, intuitive approaches of gestural abstractionists such as Franz Kline and Willem de Kooning, and the rough textures of his sculptures recall the heavily impastoed surfaces produced by these painters. In other significant respects, however, Lipton's work differs: his sculptures contain evocative associations to natural and man-made objects, and his shapes resemble the ambiguous and metamorphosing images of Surrealism more than the forms of the Abstract Expressionists.

Lipton was born in 1903 in New York City, where he has lived and worked all his life. After receiving a degree in dentistry from Columbia University in 1927, he trained himself as a sculptor. He had his first solo exhibition in 1938 and has exhibited widely since then. Lipton's earliest sculptures were carved in wood and realistically depicted anguished figures of men and women affected by harsh social conditions. His first pieces after World War II revealed a continuing preoccupation with the brutality of human existence, but around 1949 Lipton began to employ abstract biological forms with less specific associations. By 1950 he was expressing more hopeful feelings in forms that suggested organic processes of growth and regeneration.

In 1945 Lipton began using sheet metal, first sketching his sculptures, then cutting sheets of metal into the preconceived forms that he bends and attaches using a torch. Working directly with the metal shapes allows him to alter them as the piece develops. After covering the outside surface with melted rods of nickel-silver, he reshapes the sculpture where necessary with a hammer. To reinforce the armature he adds an inside layer of nickel-silver. The result is a strong, rigid structure.

The Empty Room incorporates the themes and associations that pervade Lipton's later work. An unfurling, curvilinear, yet rigid wall encloses dark hollow spaces. Lipton has said of this work: "Gradually, the sense of the dark inside, the evil of things, the hidden areas of struggle became for me a part of the cyclic story of living things. The inside and outside became one in the struggle of growth, death and rebirth in the cyclic renewal process. I sought to make a thing, a sculpture as an evolving entity; to make a thing suggesting a process."[1] Here, the interior appears not only as a mysterious dark hole but also as the source of the unfolding organic form. Curiously, though, the middle section emerges as a spiral reminiscent of a machine part. Thus Lipton expands upon the contrast of interior and exterior by suggesting the opposition between the organic and the mechanistic. The violent, aggressive strength of the drill-like form adds tension to the otherwise gentle organic structure.

T.B.

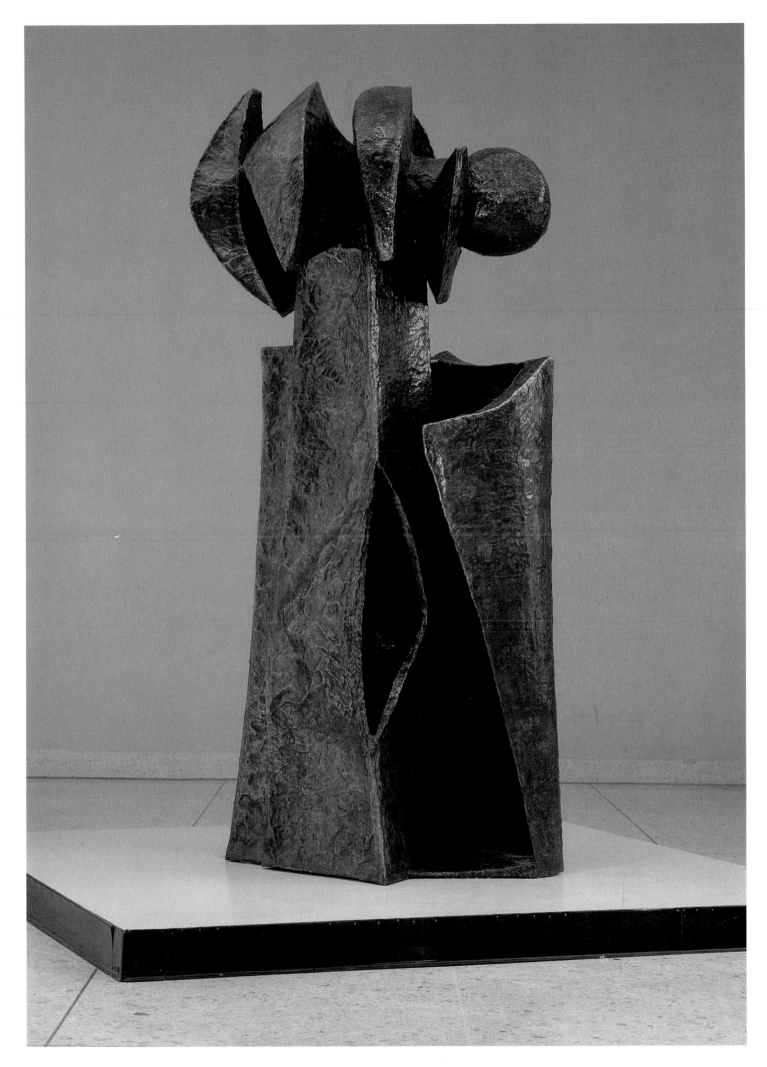

Morris Louis
1912–1962

Aleph Series IV, 1960
acrylic on canvas
8'-9" x 8'-2"

Morris Louis, born in 1912, belonged to the same generation as the early Abstract Expressionists. His painting, however, is more closely associated with that of the younger-generation color-field painters Helen Frankenthaler, Kenneth Noland, and Jules Olitski.

Louis is best known for the work he produced after 1953. Before that, his painting went through a Cubist phase, followed by a period strongly influenced by Jackson Pollock. In 1953, however, with Noland and the influential critic Clement Greenberg, Louis paid a visit to Frankenthaler's studio that precipitated a major transformation in his work. Frankenthaler at that time was using a technique derived from Pollock's drip paintings that involved pouring and staining color into raw canvas. In 1954 Louis began pouring thinned pigment over large pieces of canvas, allowing it to drip downward, forming streaks of color that mixed on the surface and sometimes created pools at the bottom. The first group of poured paintings became known as "veils." From this point on, Louis's paintings attracted the attention of Formalist critics such as Greenberg and Michael Fried. He was lauded for liberating color from the constraints of drawn boundaries. The staining procedure made the paint inseparable from its canvas support. At the same time an illusion of purely optical color was produced. This simultaneous acknowledgement and denial of the literal flatness of the picture surface was, according to Greenberg, one of the essential elements of modernist painting. Louis's process eliminated any sign of the artist's hand, so obvious in Abstract Expressionist gestural painting, and, according to Fried, Louis's paintings took on "the appearance, or illusion, of a sovereign impersonality."[1]

After the veils, Louis created three major series of paintings before his sudden death from lung cancer in 1962. These included the "florals," the "unfurleds," and the "stripes." As his paintings evolved, Louis increased the amount of control he exerted over the flow of paint, and used more intense, opaque color. *Aleph Series IV* is considered one of the florals, although the *Aleph* series, consisting of nine paintings, forms a semi-independent group. In *IV*, as in the other eight paintings, bright colors have been poured so that they mix, forming a brownish area in the center of the canvas. Unifying the image, the brown paint flows over the brighter, radiating bands of color as it moves with the force of gravity toward the bottom of the picture plane. Unlike the configurations in some of the other *Aleph* paintings, the colored image in *IV* seems to flow off the canvas.

T.B.

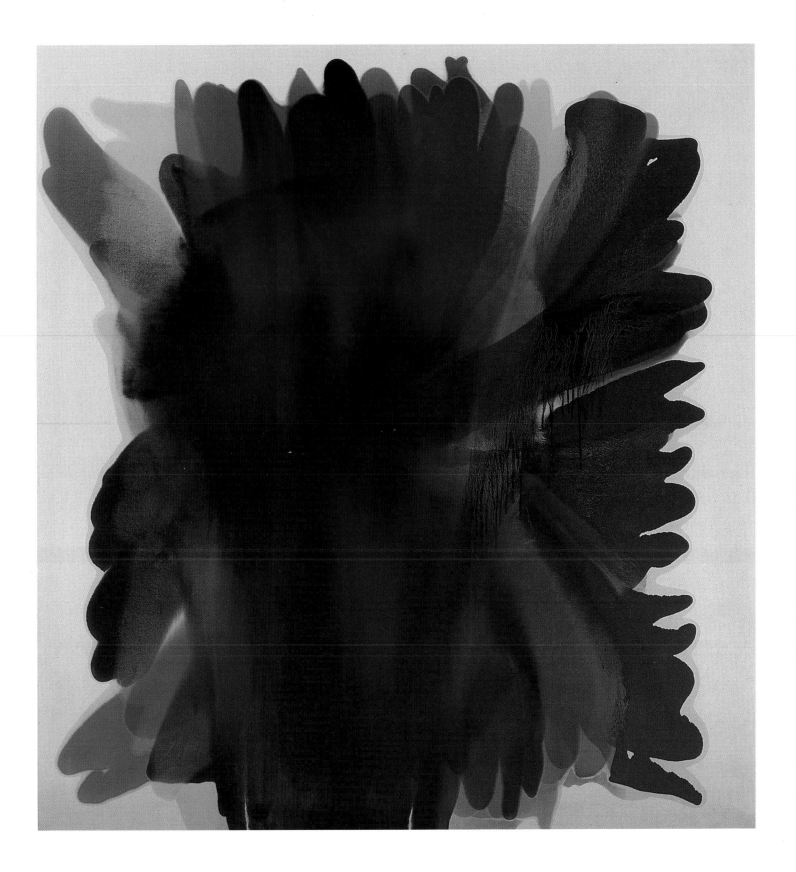

Alvin D. Loving, Jr.
1935–

New Morning I, 1973
acrylic on canvas
7'-6" x 55'-7"

In a pamphlet for an exhibition of his work at the Whitney Museum in 1970, Alvin Loving wrote: "I'm interested in using the science of color. Prisms. Colors are not always intuitive but are used intuitively. Multiplicities of color to make one color feeling. Varied. Color is already drama; we only impose the degree."[1] The repetitions that characterize the poetry of the above passage are also central to the structural composition of Loving's *New Morning I*. The parallelogram, the basic formal unit of the painting, is repeated in various hues, values, and intensities across a 55-foot expanse of wall space. The angles at which the parallelograms are joined and the juxtapositions of colors determine whether individual units appear to advance or recede. However, the direction of the spatial illusion of each form — its apparent projection or recession — always appears capable of reversal, implying that the piece could fold in on itself or be folded into one of its own units. *New Morning I* is thus invested with a rhythmic quality.

Loving was born in Detroit, Michigan, in 1935 and received a master of fine arts degree from the University of Michigan at Ann Arbor in 1965. He began his artistic career as an Abstract Expressionist, experimenting with Hans Hofmann's theories regarding the "push and pull" movement that can be established on a flat picture plane by placing color patches side by side. Subsequently, Loving organized his compositions geometrically, his installations consisting of small- and large-scale complexes of colored polyhedral forms. *New Morning I* marks the end of this period of rigid organization.

In 1973 the artist started producing collages of long strips of dyed canvas sewn together at random, overlapped, and hung vertically from the ceiling or allowed to trail on the floor. The spatial illusionism of these collages vividly contrasts with the insistent flatness of Loving's preceding pieces. *New Morning I* is composed of four sections of canvas pieced together and attached directly to the wall. This reinforcement of flatness, however, increases the tension in the work between the literal surface and the illusion that the parallelograms occupy space in front of and behind the picture plane — an illusion intensified by extended viewing. This paradox is further strengthened by *New Morning*'s colossal size, which encourages the viewer to take up multiple viewing positions. Standing at a distance, the viewer receives the impact of the overall structure of the painting, the color progressing from a cold tonal austerity at the two ends toward a cluster of warm tones at the center. Standing closer, the viewer perceives the directional variation of the brushstrokes used to paint the squares and the

alternation of mat, shiny, and iridescent surfaces. It is only by shifting positions that the spectator experiences the full range of dynamic repetitions and inversions of this piece. The high degree of physical and visual interaction elicited by *New Morning I* heightens what Loving refers to as the "drama" built into his work by virtue of its color.

K.O.

100

Sven Lukin
1934–

Untitled, 1969
enamel on wood
11'-8" x 118'-7"

Sven Lukin is one of a number of artists who, in the early 1960s, were challenging conventional distinctions between painting and sculpture and combining features of both mediums in their work. He painted on shaped supports that emphasized the three-dimensionality and object quality of a painting. This aspect of his work was associated with Frank Stella's similar use of shaped canvas. As explained by the critics, the intention of Lukin and Stella, among others, was to avoid the limitations imposed by conventional rectangular formats. They were attempting to achieve a new unity in a work of art that necessitated the avoidance of illusionism — traditionally associated with a rectangular support evoking the sense of a window to another world — in order to assert the work's presence in actual space. The object was to be expressed as a complete form incorporating every aspect of its makeup. Rather than arranging the internal elements of a painting in relation to its overall shape, thereby subordinating parts to an arbitrary though conventional format, every element was to be expressed as equally intrinsic to the whole. The rectangle was only one of many possible shapes available to the artist.[1]

Lukin was born in 1934 in Latvia, now part of the Soviet Union. Before becoming a painter, he studied architecture at the University of Pennsylvania in the mid-1950s. His earliest pictures, influenced by Mark Rothko and Ad Reinhardt, contain dark, diffuse geometric shapes that appear to melt together. By 1960 Lukin had begun to experiment with irregularly shaped canvases, and he subsequently used supports with unflat surfaces as well. When working on large paintings with curved surfaces, he found that due to the assertiveness of the shapes, "the canvas's forms would not take the indefiniteness of the soft-edged areas of color."[2] In place of his former indistinct shapes he painted clearly defined biomorphic forms like those in the hard-edged abstractions of Ellsworth Kelly. While in California in 1963, Lukin was impressed by the intensity and brightness of colors there, and this prompted him to lighten his palette and employ a more diverse range of colors. At this time he also first painted bands of color that looped in compressed or expansive curves. In the mid-1960s these bands evolved into physical objects constructed from plywood that jut out from the wall. By 1969 Lukin returned to the use of flat surfaces, representing his colored loops as folding and unfolding illusionistically on shaped canvases.

The work in the Empire State Plaza Art Collection is representative of this later period. Painted in bright, decorative colors with a flat, mat surface, it looks like a length of ribbon folded into loops that unfurl into an expanse of color extending over 100 feet. Despite the vaguely illusionistic ribbonlike bands on the left, the piece proclaims its physical presence by virtue of its great size and the unmodulated flatness of its bright colors. Commissioned specifically for its present location in the concourse of the Empire State Plaza, the piece leads the viewer visually through the long corridor it occupies as it unfolds from its compressed corner space. Toward the center, the color changes abruptly from orange to blue and a large loop interrupts the horizontal flow. It subsides again, however, into a smooth and harmonious row of colors that terminates on an uplifting note.

T.B.

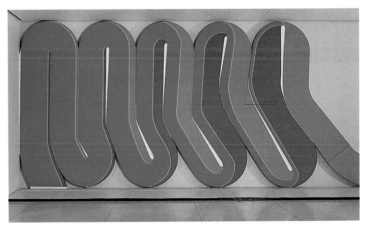

Robert Mallary
1917–

Pythia, 1966
plywood, fiberglass, epoxy, and painted steel
11′-8″ x 5′-8″ x 5′-8″

The appearance of Robert Mallary's works has varied greatly throughout his career as a result of his continued exploration of modern materials and technology. In some of his earliest paintings, he sprayed paint onto canvas through hypodermic needles; later, he began to embed sand and gravel or discarded rags and cardboard in plastic. He has also experimented with light sculptures created by marking transparent acetate with phosphorescent paints that glow when placed in a dark room illuminated only by ultraviolet light. More recently, he has explored the possibilities of generating sculpture with the aid of a computer.

Born in Toledo, Ohio, in 1917, Mallary spent most of his childhood in Berkeley, California. He studied art at an early age and attended the Escuela de Arte Libre in Mexico City from 1938 to 1939. There, under the influence of the Mexican artist David Siqueiros, Mallary experimented with plastics and other materials, and from 1942 to 1943 he and the Mexican muralist José Clemente Orozco collaborated on similar research with unconventional materials. Although Mallary often adapted his images to the nature of the materials, the significance of his art exceeds such purely technical concerns.

Mallary's work of the mid to late 1950s is composed of sand and gravel encased in a plastic medium. These materials reflected the New Mexican landscape where he lived. In 1959 he moved to New York City and began collecting debris from the streets of the city, incorporating it into constructions that resembled the contemporary assemblages and "junk" sculpture of Robert Rauschenberg, Richard Stankiewicz, and others. Mallary's best-known works, his so-called "tuxedo" pieces, developed from these assemblages. Made from cut and torn tuxedos, some of these compositions resemble contorted or tortured figures. In 1966 Mallary cast parts of these tuxedo figures in bronze.

Pythia dates from the same period as the bronze pieces, although it represents a very different formal and inconographic concern. Whereas the cast and welded bronzes contain figural references, *Pythia* is more abstract. Similarly, the rough, curvilinear forms of the bronzes show evidence of the debris they were cast from in contrast to *Pythia*'s clean-lined geometric elements. *Pythia* also directly addresses the role of the base in modern sculpture. Like the pictorial frame, the sculptural base often creates the illusion that the work of art exists in a space removed from that of the viewer and the conditions of real time and space. To challenge this idealist notion, some modern sculptors—Donald Judd and Carl Andre, for example—have eliminated the base, thereby asserting the actual continuity that exists between the space of the viewer and the artwork. In *Pythia*, Mallary has similarly, although somewhat ironically, emphasized this continuity by creating a hierarchy of bases. The white slab at the bottom supports the constructed painted steel section, which in turn acts as a pedestal for another white box. The seemingly haphazard assembly of steel parts, however, evokes a feeling of spontaneity, which contrasts with the structural regularity of the white boxes.

T.B.

104

Conrad Marca-Relli
1913–

Black Rock, 1958
oil and canvas on canvas
6'-4½" x 9'-5"

Conrad Marca-Relli is considered by most art historians to be one of the second-generation Abstract Expressionists, and his paintings of the mid-to-late 1950s, such as *Black Rock*, exhibit the large scale and gestural brushstrokes characteristic of the work of this group. Nonetheless, Marca-Relli has never identified with the Abstract Expressionist style. He has not completely renounced the use of figuration in his art, and although his paintings possess an air of spontaneity, they actually contain carefully thought-out spatial structures.

Marca-Relli's independence from the Abstract Expressionists stems from his unwillingness to abandon his European roots. He was born in Boston in 1913 to Italian parents and has lived and traveled in Europe. He attended Cooper Union in New York City for a year and took some private lessons in painting in the academic style. In the late 1930s, while working in the easel and mural division of the Federal Art Project, he was increasingly influenced by the work of the European modernists — Matisse, Miró, Picasso, and Giorgio de Chirico. His career was interrupted by service in the army from 1941 until 1945, and when he returned, he painted cityscapes and carnival scenes obviously influenced by de Chirico and the Surrealist Yves Tanguy. It was not until 1949 that Marca-Relli saw the painting of Arshile Gorky and Willem de Kooning. The loosened brushwork and more abstract images in his work of this period were evidence of their impact. In 1952 Marca-Relli began to paste pieces of canvas and paper to the surface of his paintings. This collage technique allowed him to incorporate spontaneous gestural abstraction into a composition constructed over a long period of time. In *Black Rock*, for example, Marca-Relli covers several of his initial brushstrokes with layers of painted canvas. He thereby achieves a carefully structured composition yet maintains the expressive qualities associated with bold strokes of paint.

The images in Marca-Relli's paintings of the early 1950s derive from architectural elements. By 1954, however, he was more interested in what he called the "architecture of the figure."[1] In works from this period, he used the collage technique to construct abstract figures out of blocks of color. Later, he depicted moving and clashing figures in more complicated compositions, and his images became less identifiable. *Black Rock* represents Marca-Relli's most abstract phase. Here, the movement and conflict of his more figural paintings is rendered by abstract means. Forceful black strokes are juxtaposed to painted whites and areas of unpainted canvas. A multitude of forms created by paint and actual pieces of canvas exist in interweaving and overlapping spaces held in tension. Nonetheless, the painting maintains a balance between spatial illusionism and the flat surface while it evokes energy and movement.

T.B.

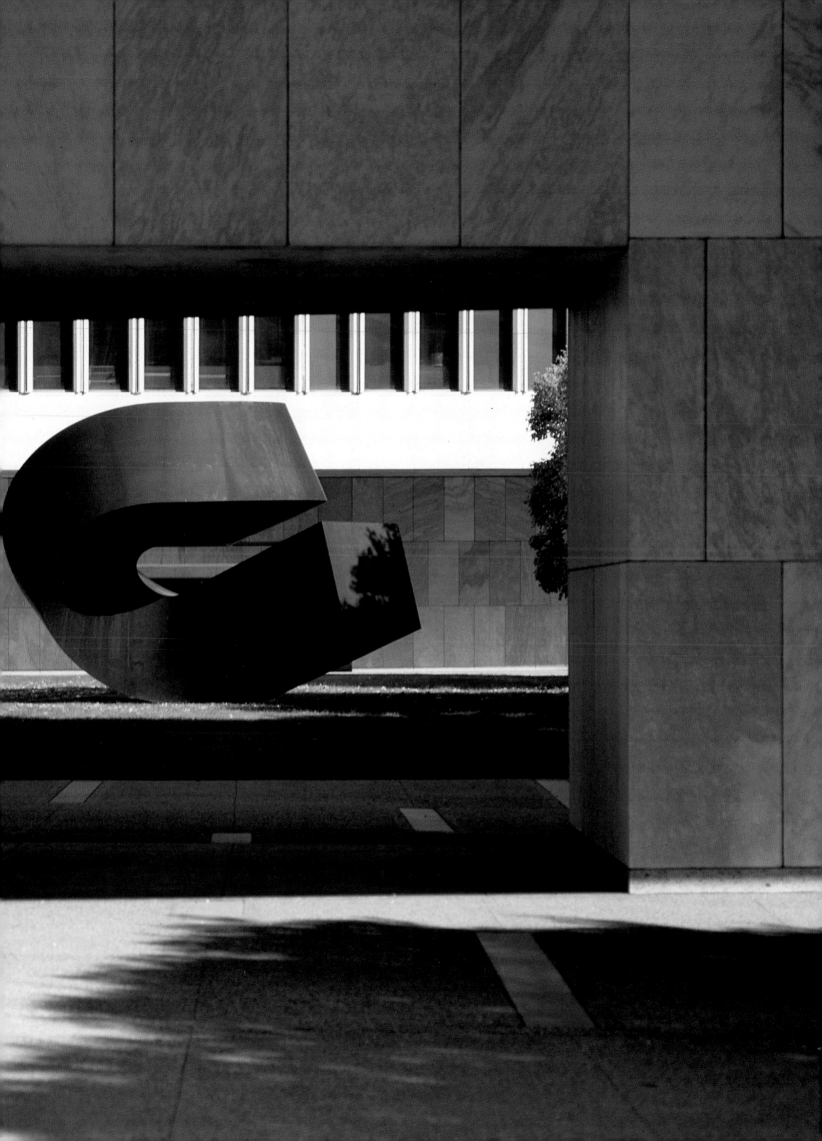

Antoni Milkowski
1935–

Salem #7, 1967
cor-ten steel
12′-0″ x 12′-0″ x 12′-0″

Antoni Milkowski's sculptures were first publicly exhibited in New York in the early 1960s and share the reductive geometric forms, modular units, and unpainted, industrial materials characteristic of the work of Minimal artists such as Donald Judd. A Polish-American born in 1935, Milkowski received a bachelor of arts degree from Kenyon College in 1957. He later attended Hunter College in New York City, where he completed the course requirements for a master's degree in 1964.

Milkowski's early works were composed of found objects. One series of pieces was made from modules built with Con Edison flagstaffs that originally marked excavations in the streets and sidewalks of New York City; other works used scraps of steel collected from construction sites. From the beginning of his career, Milkowski produced large outdoor sculptures. In 1964 he studied at the Art Academy in Warsaw, Poland, on a Fulbright Grant. During that year, he was invited to create a public sculpture for the city of Elblag. When he returned to the United States, he participated in major outdoor public exhibitions including "Art for the City," in Philadelphia in 1967, where Salem #7 was first exhibited, and "Sculpture for the Environment," in New York, also in 1967. He has received several major commissions including a sculpture for Madison Square Park in New York City.

In his public sculpture, Milkowski attempts to juxtapose his work with the environment to create a contrast that activates the space. He often sets the hard, geometric shapes of the sculpture in opposition to a natural organic setting. Although Salem #7 was not commissioned for the Plaza, it relates successfully to its present site. Named for the location of Milkowski's studio in Salem, New York, it is composed of seven 4-foot-square cubes arranged to form crosses. Resting on four points, it is positioned under the Performing Arts Center, a huge suspended elliptical-shaped building, referred to as the "Egg." The dark square forms of Salem #7 strikingly contrast with the curving shape and light color of the Egg. Although dwarfed by the Egg's large size, the work's dramatic position under the cantilevered slope of the building gives the appearance of a solid support.

T.B.

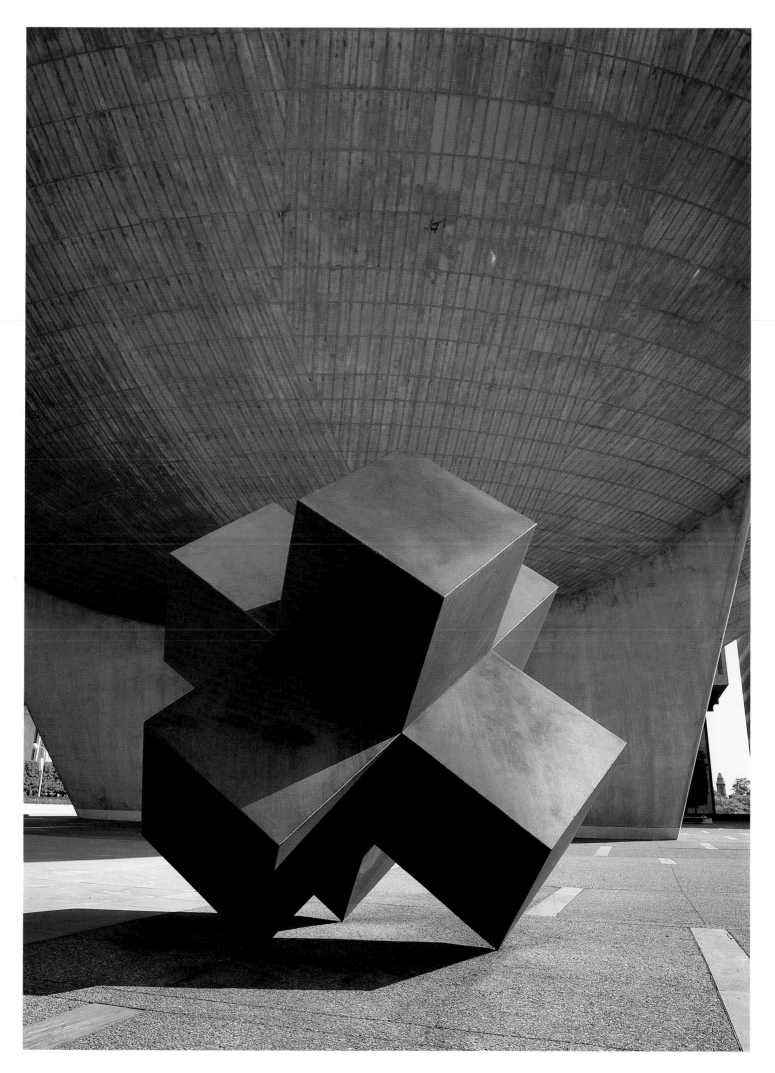

Joan Mitchell
1926–

La Seine, 1967
oil on canvas
quadriptych
6'-4¾" x 13'-9½"

Joan Mitchell, a prominent figure among the second-generation Abstract Expressionists, established her artistic reputation during the 1950s with sumptuously colored gestural paintings. The images in her work, painted from memory, have consistently been abstracted from elements of the natural world—swaying fields, diaphanous clouds, lush flowers, rushing streams, silent ponds, and trees. Born in Chicago in 1926, Mitchell studied at Smith College from 1942 to 1944, and received a bachelor of fine arts degree from The Art Institute of Chicago in 1947. Attracted briefly to Social Realism during the 1940s, Mitchell subsequently was strongly influenced by the twentieth-century European modernists and America's postwar artists Jackson Pollock, Franz Kline, and Willem de Kooning. Mitchell moved to New York City in 1952, where she attended Columbia University and received a master of fine arts degree from New York University. In 1952 she was invited to become a member of The Club, a discussion group begun by the first generation of Abstract Expressionists and attended by selected members of the second generation, including Helen Frankenthaler, Grace Hartigan, Robert Goodnough, and Alfred Leslie. Her paintings from the early 1950s, although clearly influenced by the spontaneous, poured paintings of Pollock, the energetic painterly gestures of Kline, and the vibrant palette of De Kooning, retain a basic Cubist structure of measured forms and spaces.

La Seine is the first of a series of six paintings called the La Seine series. It was her first panoramic painting executed after she moved from Paris, where she had lived since 1954, to her new studio in Vétheuil on property formerly owned by Monet. Mitchell has painted La Seine with radiant colors, especially varied shades of blue and green and red, yellow, and black. At the bottom of the picture, energetic, flickering brushstrokes and small areas of dark, rubbed-in color evoke a restless feeling. Above this are broader strokes of luxuriant color, some of thickly applied impasto, others dissolving into veils and trickles of pigment. Flanking this area are vertical masses of swirling paint that slice and weave through agitated drips and washes. At the top, misty white areas seem to allow the painting to breathe again.

Mitchell still lives in Vétheuil, where she feels released from the pressure of the New York art scene. Her paintings of the 1970s and 1980s tend to exhibit a more delicate scheme, and the brushstroke is precise and orderly, though frequently sparse.

T.G.

Robert Motherwell
1915–

Dublin 1916, with Black and Tan, 1964
oil and acrylic on canvas
7'-0" x 1'-5"

Robert Motherwell has distinguished himself not only as a painter but also as a scholar and educator. He was one of the younger artists associated with the Abstract Expressionist group whose work developed into clarified and original statements in the late forties. Having outlived most of his contemporaries, he has created a large and varied body of work that includes paintings — many of monumental scale — collages, and drawings. Motherwell has also added to the understanding of modern art through his activities as a writer, as editor for the original Wittenborn & Schultz *Documents of Modern Art* series, and as a teacher at various colleges and universities.

Motherwell was born in 1915 in Aberdeen, Washington, to a prosperous middle-class family. He spent his childhood moving among various cities on the West Coast. The bright, sunny climate of Southern California left a particularly lasting impression on him. Though well educated, Motherwell is essentially self-taught as an artist. He enrolled at Stanford University in 1932, planning to major in English. He transferred to the art department but, frustrated by the traditional course of study, earned a degree in philosophy instead. In 1937 he entered the doctoral program in philosophy at Harvard University. There he became interested in the journals of Eugène Delacroix and traveled to Paris to do further research. Motherwell then left school only to reenroll in 1940, this time at Columbia University to study art history with Meyer Schapiro. Schapiro introduced him to many prominent artists who had left Europe because of the war: Yves Tanguy, André Masson, Marcel Duchamp, Max Ernst, André Breton, Piet Mondrian, Fernand Léger, and Marc Chagall. He became particularly close to Matta Echaurren, a young Chilean Surrealist painter close to his own age. Matta was interested in automatism, a spontaneous procedure of drawing, painting, and writing developed by the earlier Surrealists to explore subconscious processes and circumvent the control exercised by the conscious mind. Although Motherwell had been painting sporadically throughout his academic career, it was not until 1941, during a trip to Mexico with Matta, that he finally made the decision to give up academic life and become an artist. Not long after that he began exhibiting his work at Peggy Guggenheim's gallery, Art of This Century, in New York City.

Motherwell's early work was related to the organic, automatic forms of Surrealism and to Cubist collage. The color and light in Matisse's painting, which reminded him of Southern California, has remained an influence. In contrast to the artistic development of those of his contemporaries who radically shifted from figurative to abstract painting, Motherwell's stylistic evolution appears to have been more organic. He is perhaps best known for two series of works. The first group are the *Elegies*, which he began in 1948. They consist of monumental ovoid and rectangular dark, often black, forms that interact as figures within a ground. In 1967 Motherwell began another group of paintings, referred to as his *Open* series. Each of these paintings contains a single ground color, often bright, and an open rectangle (a rectangle suggested by lines that do not all meet), resembling a window, which drops from the top edge of the canvas.

Dublin 1916, with Black and Tan predates the *Open* series but shares the expansiveness conveyed by its large areas of color. Also like these paintings, it is complicated by calligraphic gestures. Its forms, however, are not as simplified as those in the *Open* series. The edges of *Dublin 1916, with Black and Tan* are emphasized by bold vertical bands of black, then tan on the right and red on the left. The red is repeated toward the center of the painting, where it encloses a blue flaglike shape supported by a light blue rectangle. Within the blue area, a form resembling an arrow pointing up (or perhaps a closed number 4, a motif that had been used without any specific meaning in Motherwell's earlier work) appears like an insignia on a pennant. The flatness of this form also counters the illusion of depth created by the blue area. The title of the painting refers to the uprising of the Irish against the British on Easter Monday in 1916. The black and tan colors are those of the British soldiers' uniforms. Reference is also made to William Butler Yeats, who memorialized the revolt in his poem "Easter 1916." The large mural scale of the painting suggests that Motherwell intended it as a monument to heroism in the tradition of Picasso's *Guernica*.

Burnt Sienna belongs to a third group of Motherwell's work, revealing his interest in automatism and in the spontaneity signified by splattered paint. Throughout his career he has explored intuitive gestures in groups of works including his *Beside the Sea* series of 1962 — inspired by the spray of waves pounding against a bulkhead — the *Lyric Suite* of 1965, and the *Spontaneity* series of 1966. This tapestry may have originated from a work in one of these series. It is ironic, however, that the "spontaneous" splash of burnt sienna is rendered in a medium that concretizes the gesture because it requires such a methodical execution.

T.B.

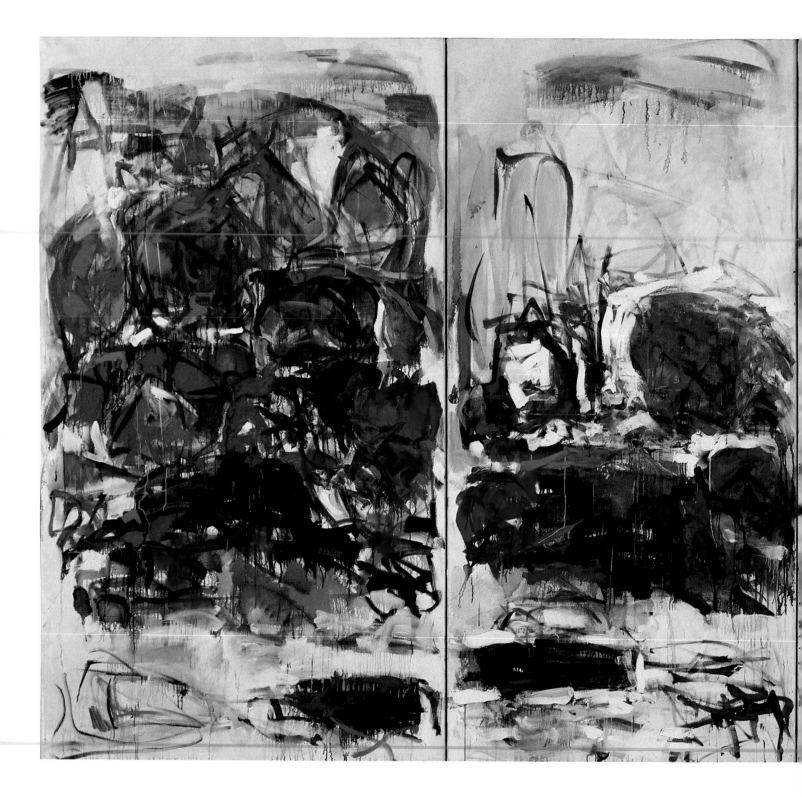

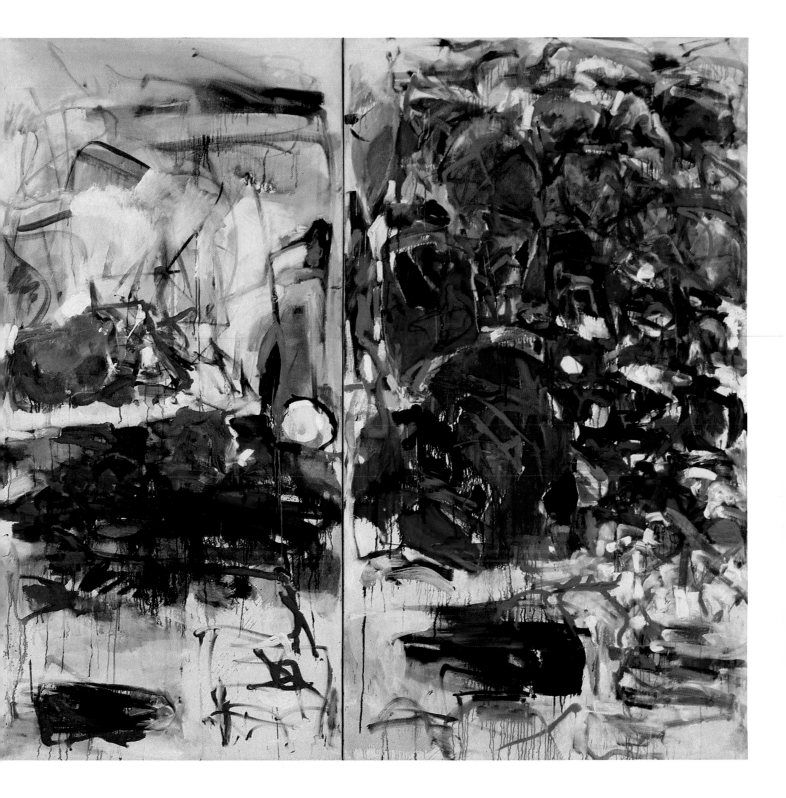

Robert Motherwell
1915–

Burnt Sienna, 1968
handwoven wool tapestry
10'-0" x 8'-2"

Forrest Myers
1941–

Untitled, 1969–70
cor-ten and stainless steel
25'-6" x 25'-6" x 25'-6"

Forrest Myers was the youngest founding member of the Park Place Gallery, an artist-run organization that operated for a few years in lower Manhattan beginning in 1965. The artists of the Park Place Group—ten painters and sculptors including David Novros, Ed Ruda, and Robert Grosvenor—shared common concerns although their work varied in appearance. As opposed to Minimalists such as Donald Judd, the Park Place sculptors often employed dramatic cantilevers, and the heroic scale of their pieces recalled the work of the first generation of New York School artists.

Myers was born in Long Beach, California, in 1941. He attended the California School of Fine Arts from 1959 to 1961 and moved to New York City the next year. He began exhibiting his work at the age of twenty-four at the Park Place Gallery and almost immediately earned a favorable response from critics. Acknowledging a range of influences that included Alexander Calder, Mark di Suvero, and Buckminster Fuller, Myers pursued several artistic directions. He used many different materials including wood, steel, aluminum, and various colored plastics, often combining them in brightly colored, eccentric compositions. Myers's sculptures have been described as having "a tomorrow, out-of-space, science-fiction look."[1] In 1968 and 1969 Myers designed pieces to reach toward "outer space," using brilliant lights projected into the sky and smoke trails of rockets. Perhaps his best-known works, however, are his large, open, linear constructions of geometric shapes using industrial materials.

The work commissioned for the Empire State Plaza is composed of two 15-foot cubes: one of square cor-ten tubing, the other of stainless-steel tubing. The dark-colored cor-ten tube sits squarely on the ground, without a base, supporting the reflective, light-colored stainless cube, which projects into the air. Although the forms are of exactly the same shape and size, one appears heavy and solid, the other light and airy. This disruption of the viewer's sense of gravity is complicated by the linear distortions that occur as one looks at the sculpture. As in Al Held's large mural *Rothko's Canvas*, optical illusions are created: lines that actually project appear at some points to recede and vice versa. Despite the simple, straightforward construction of the piece, its structure appears complicated and slightly disturbing. In this work Myers manipulates the viewer's perception of real and illusory form.

T.B.

Louise Nevelson
1899–

Atmosphere and Environment V, 1966
enamel on aluminum
8'-0" x 8'-6" x 4'-2½"

Louise Nevelson emerged as a leading New York School sculptor during the mid-1950s. The grand, mural scale of Nevelson's sculptural walls is, according to Hilton Kramer, her most original contribution to contemporary sculpture.[1] In these works Nevelson was influenced by the expansive canvases of the Abstract Expressionist painters of the 1950s and by her earlier experience as assistant to the Mexican muralist Diego Rivera in 1932. Kramer also attributes the heroic scale of her work to a long-standing interest in Pre-Columbian art and architecture.

Born in Kiev, Russia, Louise Berliawsky emigrated with her family in 1905 to Rockland, Maine, where her father established a contracting business and owned a lumberyard. In 1920 she married Charles Nevelson and moved to New York City where she studied art, drama, voice, and philosophy before attending the Art Students League in 1928 and 1930. Following her divorce from Nevelson, she traveled to Europe and briefly studied with Hans Hofmann in Munich in 1931. The following year she continued her studies with Hofmann, now at the Art Students League, and worked for Diego Rivera on his mural series *Portrait of America* for the New Workers' School on Fourteenth Street. Nevelson's first solo exhibition was with the Nierendorf Gallery in New York City in 1941, and the following year she produced her first small wood assemblages which incorporated found objects.

With a black environmental work titled *Moon Garden and One*, installed in 1958 at the Grand Central Modern Gallery in New York, Nevelson, at the age of fifty-nine, belatedly achieved critical acclaim. The dimly lit, densely packed environment included *Sky Cathedral*, Nevelson's first sculptural wall, consisting of stacked boxes filled with newel posts, balusters, finials, moldings, and scraps of wood. The following year Nevelson further secured her position in the art world with her white environment, *Dawn's Wedding Feast*, constructed for The Museum of Modern Art's "Sixteen Americans" exhibition, curated by Dorothy Miller (later a member of the Empire State Plaza Art Commission). The day before the exhibition opening, Nelson Rockefeller purchased several pieces from *Dawn's Wedding Feast* for his private collection, including a large sculptural wall which he installed in the Executive Mansion in Albany. *Royal Tides*, Nevelson's first gold-painted environment, was exhibited in 1961 at the Martha Jackson Gallery in New York City.

Nevelson has based the structural framework of her sculpture on Constructivist principles, its spatial organization on Picasso's Cubism, and her use of materials on the Surrealists' proclivity for found objects. The three principal themes of her work — royalty, marriage, and death — are reflected in her choice of colors — gold, white, and black. The black sculptures, however, constitute the core of her work. For Nevelson, black is connected with both royalty and death.[2]

In 1965 Nevelson started to produce constructed sculpture; she explored the complexities of light and shadow in small sculptures made of clear Plexiglas and chrome-plated nuts and bolts. In 1966 she designed *Atmosphere and Environment I*, the first of a series of large-scale pieces designed for outdoor installations. Constructed of black-enameled aluminum or cor-ten steel, the works in this series represent a shift from assemblages of found and carved wood objects to formal, made-to-order boxes that could be arranged in a variety of grid formats. Within the boxes she placed geometric forms, particularly concentric arcs and squares, in order to capture crisp, multilayered shadows. In *Atmosphere and Environment V*, the twenty-four individual boxes, secured with bolts and cap screws, house precise, elegant constructions, and, like a three-dimensional collage, they are subtly connected by related geometric elements that draw the viewer's eye from one unit to another. The structure is further activated by changing light conditions. The significant difference between the earlier solid walls and these new fabrications is found in Nevelson's allusions to landscape. Nevelson explains the generic title of the series, *Atmosphere and Environment*, as follows: "The landscape is the *atmosphere* that fills the spaces of the steel *environment*; the two together are sculpture."[3]

T.G.

122

Isamu Noguchi
1904–

Studies for the Sun, 1959–64
iron
3'-5" x 1'-11¾"

Isamu Noguchi was born in Los Angeles in 1904 to an American mother, who was a writer, and a Japanese father, who was a well-known poet and scholar. When he was two years old, the family moved to Japan where Noguchi lived until, at the age of thirteen, he returned to the United States to be educated. He attended high school in Indiana and then, convinced it was the practical course to follow, enrolled at Columbia University to study medicine. He soon abandoned medicine, however, in order to study sculpture. Proficient in modeling forms, he became an accomplished academic sculptor and at the age of twenty-one was elected to the National Sculpture Society. In 1927 he was one of the first recipients of a Guggenheim Fellowship. Though Noguchi intended to use his grant money to travel to India, he only went as far as Paris. There he sought out Constantin Brancusi, whose work he had seen and admired a few years earlier in New York. It was through Brancusi, his true mentor, that Noguchi was introduced to modern art, although he did not incorporate Brancusi's influence immediately. In 1931 he traveled to Japan, where he studied the techniques of traditional Japanese sculptors and painters. When he returned from this trip, Noguchi's work changed as he began to assimilate his knowledge of both modern Western art and Japanese culture. His career was briefly interrupted during World War II by relocation to a center for Japanese-American citizens in Arizona.

The three *Studies for the Sun* in the Empire State Plaza Art Collection are relatively small-scale works that are studies for one of the elements later included in a public sculpture garden for the Bieneke Library at Yale University. Since the late fifties, the sun, represented by a circular disc, has been a recurring element in Noguchi's work. This circular form was first used in a 1948 piece entitled *The Ring*. Subsequently, it has served as the basis for several important works—*The White Sun* (1966), *The Grey Sun* (1967), *The Black Sun* (c. 1973), a version of which was also in Nelson Rockefeller's private collection—in addition to the Empire State Plaza works and the sculpture at Yale. Noguchi has explained that he associates the white sun with the East, where it rises, and the black sun with the West, where it sets.[1]

Of the three studies in the Empire State Plaza Art Collection, the iron sun is closest in form to the sculpture at Yale. It is, however, smaller and darker. Gouged-out craters interrupt the flow of the gently curving lines of the ring. Its dark, heavy, and slightly corroded appearance contrasts with the pristine, smooth surface of the white

marble sun, giving the iron sun a look of age.

The bronze sun has no void in the center. Its bonded rectangular blocks look like stone. The texture and patina of the bronze reinforce this impression and give the sculpture a soft, earthy look. Noguchi again used this form as "the door opening both to life and to death" in his sets for Martha Graham's production of *Alcestis* in 1960.[2]

The most delicate of the three suns is the study in white travertine marble. Its color and smooth surface, only barely accented with slight bumps, create an illusion of lightness and openness. Noguchi preferred to work with stone rather than metal because of its association with Classical sculpture and with the earth itself. Noguchi has stated: "I love the use of stone, because it is the most flexible and meaning-impregnated material. The whole world is made of stone. . . . When I tap it, I get an echo of that which we are. Then the whole universe has resonance."[3]

T.B.

Isamu Noguchi
1904–

Studies for the Sun, 1959–64
bronze
1'-8½" x 10½"

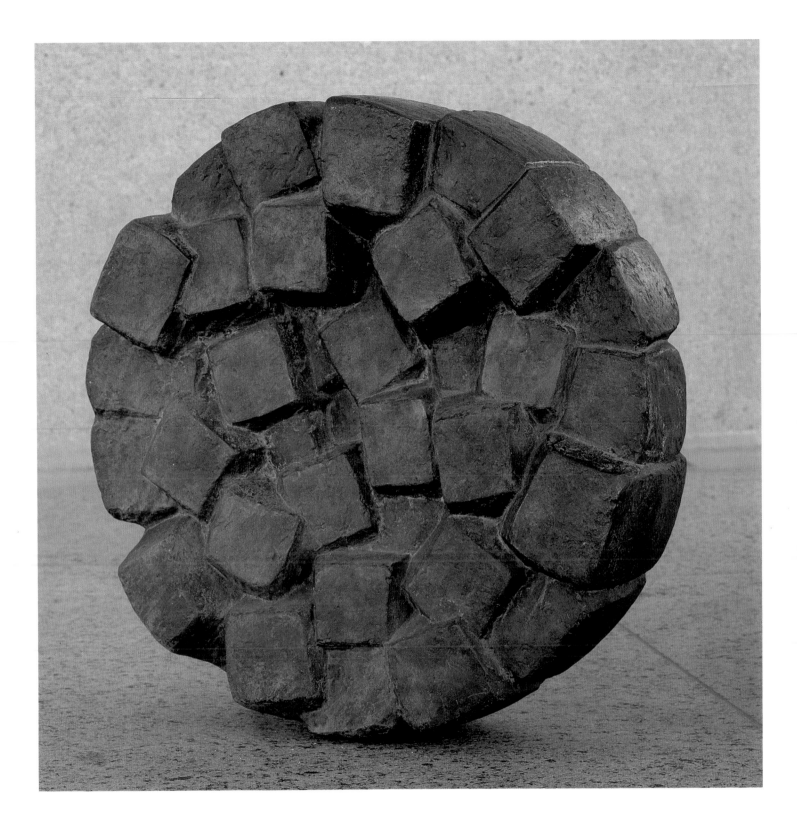

Kenneth Noland
1924–

Via Ochre, 1968
acrylic on canvas
8'-9" x 29'-4"

Kenneth Noland is one of the first painters with training entirely in abstraction to become known as a major artist; he has never painted representationally for any prolonged period. Born in Asheville, North Carolina, in 1924, Noland attended Black Mountain College from 1946 to 1948. There he was introduced to Josef Albers's color theories, which would later influence his painting. His true mentor, however, was Ilya Bolotowsky, a geometric abstractionist whose teachings were free of the Surrealist or Dada influences latent in Albers's theories.[1] In 1948 Noland went to Paris to study with the Cubist sculptor Ossip Zadkine, but he continued to paint on his own. At this time he was attracted by Henri Matisse's use of color, which he believed fully realized the physical and sensuous properties of the paint medium. Having discovered that Paris was no longer the center of the artistic avant-garde, Noland returned to the United States in 1949, settling in Washington, D.C. He continued to spend summers at Black Mountain College, where he met several members of the American avant-garde — Willem de Kooning, Theodoros Stamos, Helen Frankenthaler, and the critic Clement Greenberg, who became a close friend and a strong supporter of his work. In 1952, in Washington, Noland met Morris Louis, with whom he also developed a close and productive friendship. The following year, together with Greenberg and Louis, Noland made a now-historic visit to Frankenthaler's studio in New York, a visit that provided both artists with the insight to develop their mature styles. By observing Frankenthaler's technique of staining different colors directly into the canvas, Noland and Louis discovered a way to combine their interest in Jackson Pollock's black dripped lines with their desire to use intense color. In 1959 an exhibition at the French and Co. gallery in New York established Noland in the eyes of the Formalist critics, led by Greenberg, as one of the innovators of modernist abstract painting.

Noland's paintings of the late 1950s were composed of concentric circles of color stained into the square canvases and separated by rings of unpainted canvas. The discovery of a format in which he could present color independent of drawing was a breakthrough for Noland. Color alone, inseparable from form, created the illusion of space; he then was free to focus on the interrelationship of intense hues. Noland explored the reciprocal effect of colors in various formats, concentrating, from 1967 to 1970, on large canvases with horizontal stripes.

Via Ochre is an example of these "horizontals." Orange, yellow, white, and light blue bands of varying widths are separated by thin stripes of raw canvas. The rectangular shape of *Via Ochre* is more traditional than the forms of the shaped canvases that Noland used in other works to emphasize the support's physical limits. Any allusion to landscape inherent in the horizontal lines is denied, since the repetition of bands of color and tension between painted and unpainted areas reinforce flatness. The bottom edge is defined by a deep orange that leads into the rows of lighter variations of yellow. The most expansive and elusive color is a broad band of lemon yellow across the center. It is grounded by its relation to the other colors and the starkness of the unpainted canvas bands, which appear to pull back into the flat surface plane. The large size of the painting envelops the viewer's field of vision. Like Pollock's paintings, this work exemplifies an attempt to achieve unity through all-over composition; there are no focal points, and all areas of the picture receive equal emphasis.

T.B.

Gyora Novak
1934–

Links, 1965
black lacquer on wood
nine interlocking units
12'-6" overall length

Although Gyora Novak's work appears to have been influenced by his American contemporaries, it is distinguished by an attitude toward materials that is rooted in European traditions. Born in Israel in 1934, he has been a shepherd, soldier, collector, and parrot breeder. Self-taught, he began painting and sculpting in 1955 and since that time has lived in Israel, England, France, Japan, and the United States. Novak first showed his paintings and sculptures in New York City in the early 1960s. His art from that period is similar to the abstract and Minimal sculptures that were gaining public attention at that time. Its emphasis on craftsmanlike precision is more characteristic of the European Neo-Plastic and Bauhaus traditions, however. The precisely defined geometric shapes and the colors of Novak's large paintings create an illusion of movement. The sculptures are composed of interlocking stainless-steel rectangular slabs, carefully balanced on corners.

Links, which was exhibited at the Whitney Museum Sculpture Annual in 1967, also shares characteristics of works by Novak's American contemporaries. The large scale and repeated modular units of *Links* recall the sculpture of Donald Judd and Carl Andre. Yet, beautifully crafted in carved and laminated wood and lacquered in black, it has a more elegant look than either Judd's boxes or Andre's metal sheets. Furthermore, the placement of Novak's sculpture is not rigidly defined nor so dependent on establishing a relationship to its surrounding space. *Links* can be displayed in various positions: hanging on the wall, piled on the floor, or, as exhibited in the collection, suspended overhead. As it is shown here, the sculpture can move with the air currents and it reflects light. According to one reviewer: "The exquisite craftsmanship, the poetry of scale and the straightforward but imaginative use of module devices caused a revision in the meaning of the image employed and made these chains, not chains of affliction, but chains in the chain of life—the kind of chains that set you free."[1]
 T.B.

132

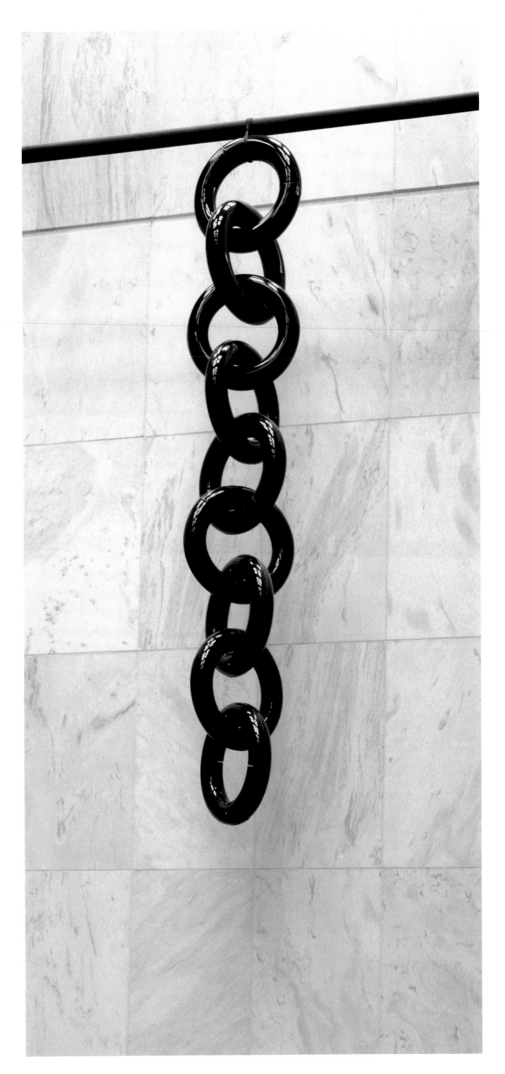

David Novros
1941–

Untitled, 1968
acrylic lacquer on fiberglass
6'-11" x 18'-6"

David Novros's work received a great deal of critical attention in the late 1960s. Born in Los Angeles in 1941, he had his first one-person exhibition there in 1966 at the Dawn Gallery. Having moved to New York in 1964, he exhibited in 1967 at the New York Dawn Gallery and at the Park Place Gallery, an artists' cooperative. Along with the paintings of Brice Marden and other young artists, Novros's work was included in a number of important Minimal Art exhibitions.

Unlike most of the artists of his generation, Novros was trained as an academic painter. He first studied classical drawing at the age of thirteen, and in his own words, "at sixteen was making competent, romantic paintings."[1] His mature work, however, was influenced by the radical ideas of the Minimalist sculptor Donald Judd. In accordance with Minimalist ideas, Novros freed his paintings from the boundaries of a traditional rectangular structure in order to incorporate the environment and to establish perception of the art object as inseparable from its specific context. In early exhibitions, he showed works comprised of several geometrically shaped canvases arranged symmetrically, often without touching, around an axis. In several of these works, an undercoat of pigment suspended in an acrylic lacquer was covered with a second layer of iridescent pigment in the same medium. The opacity and evenness of the metallic surfaces, along with the unconventional use of several canvases, heightened the viewer's awareness of "objectness" in these paintings. These works did not fit into the traditional categories of painting or sculpture but, by interacting with the wall on which they hung, were closer to reliefs. In this way, they directed the viewer's attention to the real architectural conditions in which the object was seen.

The work in the Empire State Plaza Art Collection appears motivated by similar intentions. It consists of L-shaped sections arranged so that they appear to hang from a unifying horizontal. The separate parts are more integrated than they were in Novros's earlier works, yet the wall remains an essential part of the composition. The continuity between the space of the viewer and that of the painting is emphasized by the wall, which exists as part of both. Instead of using canvas supports with thick stretcher bars as in his earlier works, here Novros has painted on fiberglass, reducing the depth of the painting. Color is extremely important. It varies subtly between grays and blues and alters with changes in light. The eye is not pulled into the painting but led across the surface, the elusive color contrasting with the tangible forms of the individual sections.

Novros continues to be concerned in his work with the relationship of the painted image to its surroundings. Although he returned to painting canvas, his compositions remained architecturally oriented. More recently, he has been painting frescoes.

T.B.

134

Kenzo Okada
1902–1982

Hagoromo, 1964
oil on canvas
7'-8" x 9'-10"

Kenzo Okada is well known for his paintings that join the color of the School of Paris, the gestural style and scale of Abstract Expressionism, and the structure and meditative quality of Japanese landscape painting. Born in Yokohama, Japan, in 1902, Okada early on developed an interest in Western art. In 1924 he left Japan for Paris, where he remained for three years. Upon his return, he became a successful realist painter and teacher. In 1950, again drawn by a fascination for the West, he left Japan, this time for New York City. He became an American citizen in 1960 and continued to live in the United States until his death in 1982.

It was in New York that Okada began painting abstractions that adapted the style of the American Abstract Expressionists to Japanese subject matter. His paintings were well received and by 1953 were being shown by Betty Parsons, an early supporter of the Abstract Expressionists Willem de Kooning, Jackson Pollock, and Barnett Newman. Nelson Rockefeller was an admirer of his work and had several of Okada's paintings in his collection.

Hagoromo is an especially beautiful example of Okada's merging of East and West. It is painted with broad washes of blues, grays, and whites, probably applied with a roller. Areas are highlighted by textured paint, which may have been applied with a palette knife. Like the American Abstract Expressionists, Okada made no sketches or studies for his paintings. As a result, the paintings have a spontaneous quality. The expansive scale of Okada's larger paintings, such as *Hagoromo*, is also characteristic of Abstract Expressionism.

Okada's paintings do distinguish themselves, however, from those of his American contemporaries. Absent are the thick, impastoed surfaces and the aggressive gestures of the work of De Kooning and Franz Kline. His colors, too, are softer and more harmonious. As described by Gordon Washburn, his paintings have a "floating detachment from an object world" that reflects his Japanese culture and an interest in Zen Buddhism. [1]

The subtle merging of forms and colors gives Okada's paintings a lyrical quality. *Hagoromo*, for example, is reminiscent of a misty seascape seen from above. It was titled after a Noh play about a poor fisherman who finds a beautiful robe on the beach. Just as the man is about to take it, a fairy approaches him, explaining that the robe belongs to her and that without it she will be unable to fly back to heaven. At first, the fisherman will not give up the garment. He finally relents, and in gratitude the fairy dances for him before she disappears. Though it is certainly not a figurative representation of the story, *Hagoromo* conveys the feeling of an imaginary, dreamlike seascape enveloping the fairy and fisherman. [2]

T.B.

Claes Oldenburg
1929–

Geometric Mouse, Variation I, 1969
painted steel and aluminum
11'-6" x 12'-0" x 8'-0"

Claes Oldenburg was among the first artists to develop the ideas and imagery now associated with Pop Art. Along with Andy Warhol, Roy Lichtenstein, and others, Oldenburg reacted against the abstract tendencies dominant in the late 1950s to make art that he believed was more responsive to the environment. Embracing familiar aspects of American popular culture, these artists introduced into their paintings and sculpture imagery derived from the artistically discredited mass media. Oldenburg is perhaps best known for his oversized sculptures in the form of baseball bats, lipsticks, ice packs, typewriter erasers, and other such things that ironically and humorously monumentalize common, banal objects.

Oldenburg, born in Stockholm in 1929, was the oldest son of a Swedish diplomat. He spent most of his childhood in Chicago and attended Yale University from 1946 until 1950, beginning his formal study of art in his last year. In 1956 he moved to New York City where he became involved with a group of artists including Allan Kaprow, Red Grooms, Robert Whitman, and others. By the time of his first show in 1959, he had begun making objects which he incorporated into invented environments. Kaprow had already published his influential article, "The Legacy of Jackson Pollock" (1958), suggesting that the arena of action painting — the canvas supporting the artists' active expression — could be extended to encompass a larger environment. Happenings — unrehearsed theatrical events in which artists and viewers became participants — resulted from Kaprow's theories. Oldenburg was active in initiating happenings, and his environments, including his storefronts with plaster reproductions of real objects, were related to these events. As his work evolved, he concentrated more directly on the objects themselves.

The mouse, recalling Disney cartoons, is a pervasive and humorous theme in Oldenburg's work. He made his first drawings and models using this image in his New Haven studio, where "at night the mice would dance on the electric cords in the bedrooms. . . . We speculated a lot about whether or not making images of mice produced more mice or deterred them; whether they, in some way, got involved in worshipping these images."[1] The mouse recurred in 1965 as a mask in the form of a movie projector for his performance *Moviehouse*. The reels looked like ears and the lens like a nose. In 1966 he designed a building in the form of a mouse's head. The geometric forms of the *Geometric Mouse* derive from the adaptation of the image to an architectural form. The first *Geometric Mouse* sculpture, identical to the one in the Empire State Plaza Art Collection, was made in 1969 for Oldenburg's exhibition at The Museum of Modern Art in New York. It is an abstraction of the face of a mouse, with two large circles representing ears, two open "windows" for eyes, and the nose simplified into a lozengelike protrusion. The image was also adapted as a logo for stationery and for banners announcing his exhibition. In this way, it became a self-portrait. Oldenburg has said: "I'm the *Mouse*. . . . In my view the *Mouse* is cerebral. It is autobiographical. It refers, perhaps, to my thinking process."[2] Since *Geometric Mouse, Variation I*, thousands of versions of the *Geometric Mouse*, in five different sizes ranging from a few inches to twenty feet high and in different colors and materials, have been constructed. Oldenburg has suggested that the mice can be thought of as one big family in which the different characteristics — size, color, material, and so on — give a range of expressions for the abstract "face."[3]

T.B.

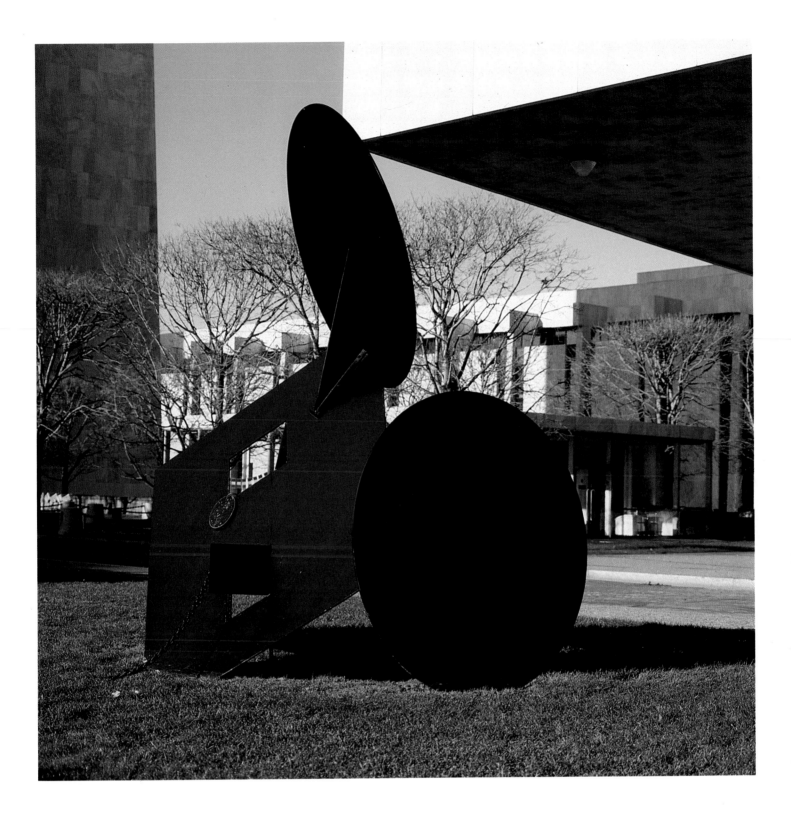

Raymond Parker
1922–

Curling Red, 1967
oil on canvas
9'-3" x 10'-6"

Raymond Parker, born in South Dakota, received his
bachelor of arts and master of fine arts degrees from the
University of Iowa, and had his first solo exhibition at the
Rochester Museum of Art in 1949. Parker moved to New
York City in 1950, and within a year of his arrival was
invited to become a member of The Club, an informal dis-
cussion group organized in 1949 by the first-generation
Abstract Expressionists Willem de Kooning, Hans
Hofmann, Franz Kline, and Jack Tworkov.

In his work from the early 1950s, which he called
"stroke paintings," referring to their gestural or calli-
graphic nature, Parker worked improvisationally without
any preliminary sketches. "I would have a left hand full of
fifteen brushes with different colors, and I would take one
and make marks, take another one and make marks back-
wards, over and over, so that there eventually developed
an elaborate shifting of rhythms. Once the rhythm began
there were no additions or corrections made, all changes
occurred in process."[1]

Parker is a colorist. The colored forms in his paintings
appear to occupy the foreground, but their exact spatial
position cannot be determined in advance, since the per-
ception of color is influenced by other factors, such as the
shape and the distinctness of the forms. Parker is also
concerned with surface texture and the light-absorbing
and reflecting properties of his colors.

Parker first primes his unstretched, white duck can-
vases and then applies spots of thinned pigment, which he
spreads into fully realized forms. When the paintings are
dry, they are rolled up and stored until Parker selects the
canvases to be stretched. It is only at this point that he
determines the placement of the picture's edge.

By the early 1960s Parker, inspired by Matisse, began
to focus his attention on line, creating elongated, twisted
forms. In *Curling Red*, the ribbonlike colored shapes seem
to oscillate between being seen as figure or ground. The
vibrant blue in this painting appears illusionistically as
either an atmospheric background for the shapely ribbons,
or emerges to the foreground as a positive mass. Parker has
characteristically placed the tenuous shapes off center,
bleeding them to the edges of the canvas but never allow-
ing them to touch. Parker does not title his paintings, but
Curling Red was named with Parker's permission for an
exhibition at the Whitney Museum of Art before the paint-
ing was selected for the Empire State Plaza Art Collection.

T.G.

James Rosati
1912–

Heroic Galley, 1958
bronze
4'-6" x 6'-4" x 7"

Lippincott I, 1967
painted cor-ten steel
8'-9½" x 18'-0" x 6'-0"

Born in Washington, Pennsylvania, in 1912, James Rosati was trained as a violinist but decided instead to become a sculptor. In the first studio-workshop he attended, the training consisted entirely of copying casts of body parts, and Rosati credits his teacher, Frank Vittor, who had been a pupil of Rodin, with educating him in the craft of sculpture. Both Vittor's vocation as a sculptor of public statuary and Rosati's subsequent work as an architectural sculptor in the Work Projects Administration's Federal Art Project between 1937 and 1941, no doubt motivated Rosati to consider the problem of the interaction of sculpture with its environment. This concern has been fundamental to his work since the 1960s and is exemplified in such mature outdoor pieces as *Lippincott I*. But environmental concerns also inform his earlier work such as *Heroic Galley*, and there is a continuity in Rosati's artistic development no matter how dissimilar, stylistically, his sculptures from different periods appear to be. The two pieces in the Empire State Plaza Art Collection exemplify this consistency.

Stanley Kunitz, writing about Rosati's early work, commented on the sculptor's ability to "capture light . . . reflected from the public zone."[1] This comment, prophetic of Rosati's later work, which is situated literally in the public zone, describes the artist's attention to the role of the spectator in pieces like *Heroic Galley*. In this sculpture Rosati grouped together forms that depict the abstracted backs of slightly-larger-than-life-size figures. The outside figures press inward, giving the impression that the rectangular group is cinched together at the waist. The undulating shapes and the cuts that separate them maximize the inherent capacity of bronze to reflect light. These effects are enhanced as the viewer changes position, so that full realization of the sculpture's rhythm depends on an active spectator.

By shifting to large-scale outdoor work, Rosati has been able to further experiment with light and the mobilization of the viewer. Unlike *Heroic Galley*, whose pictorial qualities—rectangular format and indoor placement—initially tempt the viewer to remain static in front of the piece as before a painting, *Lippincott I* invites the viewer to keep moving. Each segment possesses a distinct perspective that is then multiplied, diversified, even twisted as movement and the changing effects of light produce additional geometric patterns across the sculpture's multiple surfaces. In this way the viewer is able to organize the disparate array of geometric shapes around the sculpture and to follow the various lines of perspective to their respective vanishing points in the surrounding space. Thus, *Lippincott I* can be

considered a public sculpture in the sense that it simultaneously attracts the viewing public's attention and redirects that attention to the physical space in which the sculpture stands.

Having moved East during World War II, Rosati became friends with major Abstract Expressionists such as Willem de Kooning, Franz Kline, and Ibram Lassaw, who introduced him to other members of New York's artistic circles. At the same time, Rosati was particularly drawn to the work of Brancusi, González, and Matisse. He did not employ favored contemporary techniques such as the welding of open forms, but instead turned to sources from art history. Matisse's bronze relief series of four backs (1909–30) in The Museum of Modern Art's permanent collection seems to have been the model for *Heroic Galley*. But Rosati interpreted the work in an individualistic manner, collapsing Matisse's serial format into a single image—the equivalent of taking four separate frames and editing them into a short film sequence.

In the 1960s Minimalists rejected the private realm in favor of industrial fabrication. In doing so, they attempted to purge their work of any obvious presence of the artist's hand. Rosati did not participate fully in the concerns of Minimalism. Like the Minimalists, he used industrial techniques to make pieces like *Lippincott I*. Ironically, the foundry with which he worked—the namesake of this sculpture, Lippincott Inc.—stressed personal involvement in the process of constructing the sculpture. As Barbara Rose observed: "It is the direct contact with the work . . . that differentiates the pieces executed by Lippincott from work ordered on the telephone—or blown up from scale models—which are modern equivalents of the sterile pointed-up marbles and bronzes of earlier periods."[2] This celebration of "direct contact" contradicts the Minimalists' interest in impersonality and their anti-individualism. Rosati's decision to couple a painterly medium—color—with his sculpture differentiates his work from the anti-illusionist, neutral-toned structures of the Minimalists and connects *Lippincott I* to the contemporary work of Anthony Caro, George Sugarman, or Lyman Kipp. The use of color is also reminiscent of Matisse's late cutouts. In these works Matisse resolved a lifelong struggle over how to combine various media in one work. By literally cutting into color, he merged drawing, painting, and sculpture. Apropos of this comparison, Rosati has said: "I would like one to feel as if he could slice right through one of my pieces and it would be a solid mass of color."[3]

K.O.

148

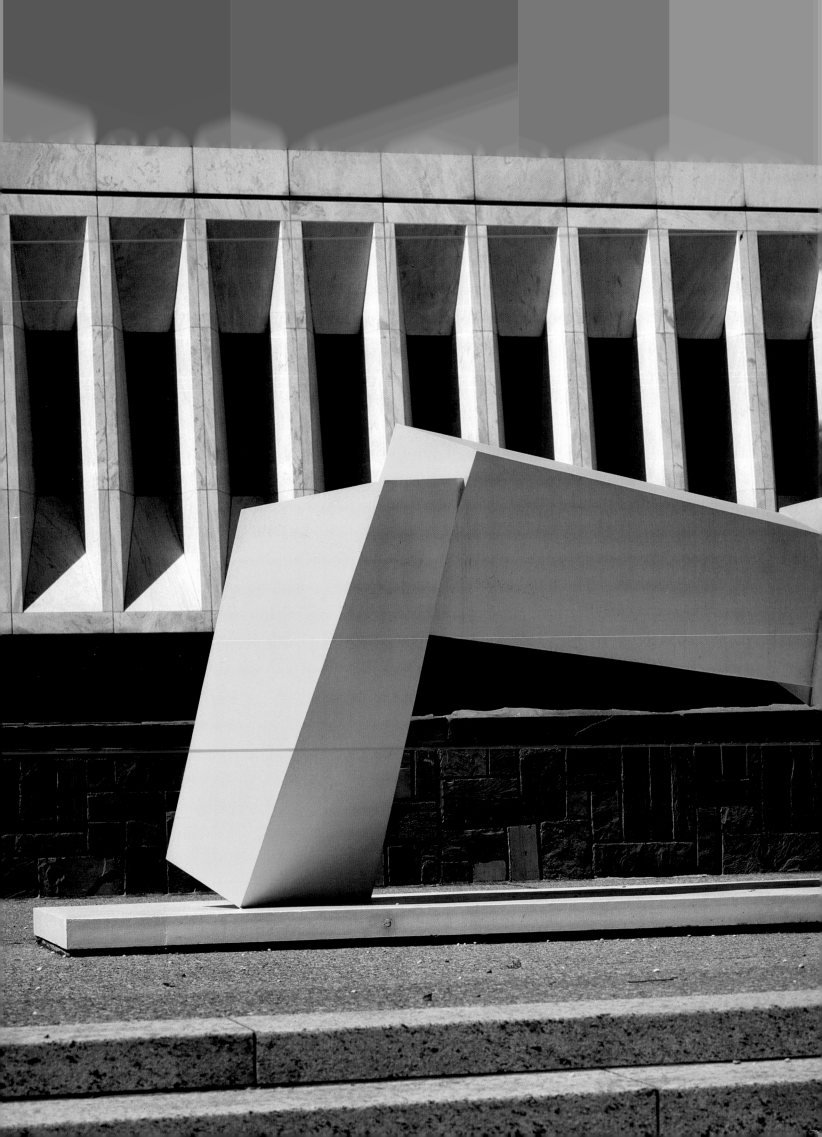

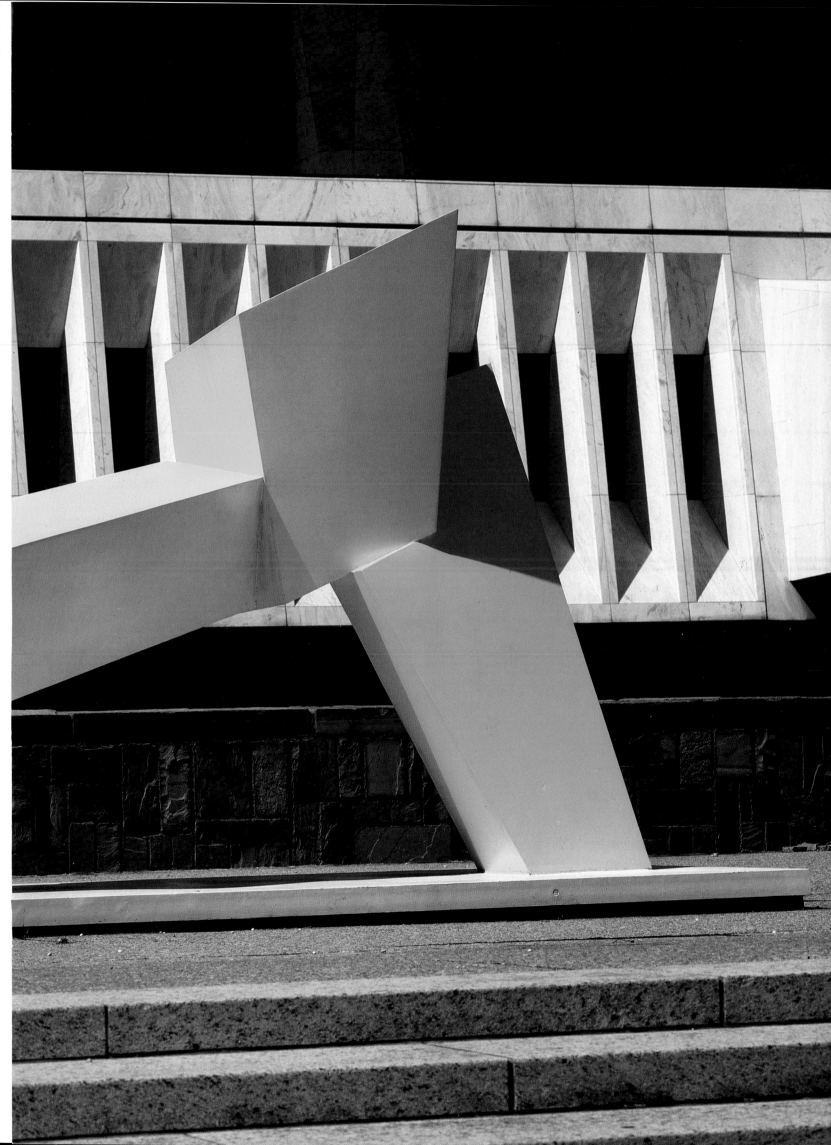

Mark Rothko
1903–1970

Untitled, 1967
oil on canvas
6'-8" x 5'-9"

Mark Rothko was a principal figure among the first-generation Abstract Expressionists who attracted international attention in the 1950s and established New York as the center of avant-garde art. Along with Clyfford Still and Barnett Newman, Rothko represented the branch of Abstract Expressionism in which color, as opposed to gesture, is the dominant expressive element. His canvases differ in appearance from the gestural abstractions characteristic of Willem de Kooning's and Jackson Pollock's work in that Rothko's are composed of loosely defined rectangles hovering in a shallow illusionistic space and are thinly painted or stained, containing no lines. The forms create spaces that blend together in an all-encompassing field of color. Rothko's technique of staining color provided an important precedent for color-field artists such as Helen Frankenthaler, Morris Louis, Kenneth Noland, Bob Duran, William Pettet, and Jim Sullivan. Rothko, Newman, and Still also introduced the use of large canvases to develop a monumental yet intimate scale that enveloped the viewer. This sense of scale, which some art historians have associated with the grandeur of the American landscape, became an important aspect of New York painting and sculpture.

Rothko, born in 1903 in Dvinsk, Russia, emigrated to Portland, Oregon, in 1913. In 1921 he enrolled at Yale University but left in 1923 and moved to New York City, where he supported himself with odd jobs while taking classes at the Art Students League from 1924 to 1929. In 1936 and 1937, like many of his colleagues, he worked for the easel division of the Work Projects Administration (WPA).

In the early 1940s Rothko began to employ the Surrealist technique of automatism to create fantastic, seemingly mythic or ritualistic forms that gave his paintings a Surrealist look similar to contemporary works by Adolph Gottlieb and Still. According to Irving Sandler: "In 1946, Rothko began to think that specific references to nature and to existing art conflicted with the idea of the 'Spirit of Myth' or what he began to call 'transcendental experience.' . . . Rothko did not specify what transcendental experience was, but his writing on the whole suggests that it involved the release from banal, everyday existence, the rising above the self's habitual experience into a state of self-transcendence."[1] Gradually he eliminated the recognizable images in his paintings and in 1949 arrived at his characteristic format of amorphous rectangles of color in an open, expansive space. Suggesting that in these mature abstract works Rothko successfully achieved his intention of evoking a "transcendent experience," critics have associated them with the experience of the sublime. In an influ-

ential essay, Robert Rosenblum wrote: "Horizontal tiers of veiled light in the Rothko seem to conceal a total, remote presence that we can only intuit and never fully grasp. These infinite, flowing voids carry us beyond reason to the Sublime; we can only submit to them in an act of faith and let ourselves be absorbed into their radiant depths."[2]

Although he varied the positioning of his forms and their color, Rothko maintained a similar format in the paintings he completed before his suicide in 1970. The painting in the Empire State Plaza Art Collection is typical, containing a brilliant blue field in which a large greenish blue rectangle floats over a smaller one of purplish blue. Small in comparison to many works in the collection, it is large enough to fill the viewer's field of vision with vibrant color. The space is elusive as the colors appear to hover in and out, merging in soft, indistinct edges. The work was painted the year Rothko finished his most ambitious project, the murals for the Rothko Chapel in Houston.

T.B.

154

Edwin Ruda
1922–

Tecumseh, 1969
acrylic on canvas
6'-2" x 12'-10"

Tecumseh marks a dramatic shift in Edwin Ruda's career, not only in terms of style and manner of production but in the artist's exhibition practices as well. Composed of brilliantly colored stripes that overlap, bleed into one another, or trail off the edge of the canvas, *Tecumseh* contrasts vividly with the shaped, precisely geometric canvases Ruda had produced throughout the 1960s. Between 1963 and 1967 he had been active with the Park Place Group in New York City along with Mark di Suvero, David Novros, and others. The artists in this collective shared the rent for a large studio and exhibition space at 79 Park Place and agreed not to have one-person shows or to affiliate with any other gallery.

Their art explored geometric formal relations that generated a centrifugal force, leading the viewer's eye outward toward the edges of a sculpture or painting and, by implication, beyond its frame to other works on display. Their interest in the reception of a work of art was manifested in the optical relationships among the works on display and in their attention to the context in which the works would be viewed. These interests bear similarities to the perceptual concerns of 1960s Minimalism. Unlike Minimalists, however, the Park Place artists also questioned the institutions that determined the reception of their art. The breakup of the group in 1967 was due to the persistence of this line of questioning. After losing their lease at 79 Park Place in 1964, they approached collectors, procured financial backing, hired a staff, and opened a new space on West Broadway. But with these changes came a shift in attitude favoring individual concerns as opposed to group interaction. As Ruda stated: "We were being duped by our own self-interests. . . . We were not functioning at an experimental level but operating much like any other gallery."[1] After much debate, the members voted to close the West Broadway space; simultaneously the group disbanded.

Born in New York in 1922, Ruda was one of the older founding members of the Park Place Gallery. A contemporary of the Abstract Expressionists, he felt uncomfortable with their mode of painting, especially their popularization in the postwar years, and left on what turned out to be a ten-year trip through the United States and Mexico, only returning to New York in 1959.[2] The formation of the Park Place Group had enabled Ruda to investigate ideas within a community of like-minded artists. When the group dissolved, Ruda entered a period of withdrawal and reevaluation of his work. *Tecumseh* marks this shift in his career.

In his earlier paintings he had drawn the viewer's eye outward by means of laser-thin beams of color that sliced across the edges of the canvas. By the late 1960s, rather than directing the viewer's attention beyond the frame, he focused that attention on the interior of the painting. Nonetheless, his rectangular striped fields occasionally touch the boundary of the painting. In *Tecumseh*, drizzles of paint intersect the frame at the left. If the painting were exhibited vertically, in the same position as it was painted, these drizzles would only demonstrate the pull of gravity and echo the viewer's own axiality. But through the simple act of tipping the painting on its side, Ruda attempts to overcome these material conditions, unhinging the painting from its logical relationship to gravity, and producing the illusion that the viewer, too, is freed from actually being positioned before the work of art. Although the appearance of Ruda's painting changed, he continued to tamper, explicitly and implicitly, with the framed boundaries of art.

K.O.

Ludwig Sander
1906–1975

Pawnee II, 1968
oil on canvas
6'-6" x 6'-0"

Unlike many other artists of his generation whose painting styles changed radically during their careers, Ludwig Sander maintained a relatively consistent approach. From 1932, when he began experimenting with nonrepresentational painting, until his death in 1975, Sander composed geometric paintings of evenly colored rectangular shapes divided by black lines. These works are closely related to de Stijl and Neo-Plastic painting, especially that of Piet Mondrian.

Sander was born on Staten Island in 1906 to a family of German origin. As a boy, he read German art magazines and was aware of developments in German Expressionist painting. He attended the Art Students League in New York City from 1928 to 1930, and traveled to Munich in 1931 to pursue his interest in European painting. In Munich he studied with Hans Hofmann, whose teaching, which emphasized the balance of surface tension through the opposing forces of contrasting colors, was to have an important influence on many younger American painters. Sander was particularly interested in Cubism and the work of Pablo Picasso. When he returned to New York, he found that the work of Burgoyne Diller and a number of other geometric abstractionists influenced by de Stijl accorded with his own aims. Surprisingly, he refused to join the American Abstract Artists — primarily a group of geometric abstractionists who united to promote the exhibition of American abstract painting — for Sander did not endorse their proscription of representational elements in painting. He was, however, a founding member of The Club, an informal group formed in 1949 of artists mainly associated with Abstract Expressionism who gathered regularly to discuss art.

Pawnee II — one of the American Indian tribe names Sander used to identify his paintings — reveals the similarities between Sander's painting and that of Mondrian. Its composition derives from Mondrian's use of primary colors contained in rectangles formed by black lines parallel to the edges of the painting. In Sander's compositions, however, color dominates. The large red rectangle in *Pawnee II* seems to push forward, barely contained by its thin black borders. It is held to the surface, however, by the blue rectangles whose color produces an illusion of depth and appears to pull the red shape back onto the canvas. The resulting tension in color is accentuated by slight irregularities in drawing, for the black lines are not strictly parallel to the edges of the canvas as they are in Mondrian's paintings. Consequently, despite obvious similarities, *Pawnee II* does not convey the same feeling of rigid control.

Sander's use of color, which appears to push and pull, creating a unifying energy, is closer to Abstract Expressionism. These irregularities and tensions generate an expressive, meditative quality, which, together with its large scale, relate *Pawnee II* to the paintings of Mark Rothko, Ad Reinhardt, and Barnett Newman.

T.B.

George Segal
1924–

The Billboard, 1966
plaster, wood, metal, and rope
15'-9" x 9'-9" x 1'-8"

George Segal studied at Cooper Union and the Pratt
Institute before graduating from New York University in
1949. In 1953, at Rutgers University, he met the artist
and art historian Alan Kaprow, who introduced him to the
Hansa Gallery in New York City. In 1956 Segal had his first
solo show of large paintings. By the late 1950s Segal, who
had been a painter for almost twenty years and who felt
constrained by the limitations of the medium, constructed
rough figures out of plaster over chicken wire, displaying
them alongside his paintings. Eventually he started to pro-
vide environments for his previously isolated figures and
then began casting them from live models. By 1963 he had
stopped painting.

Segal is fascinated by people, what they do, and how
they interact, and through his sculpture, he explores the
subtle stance and gestures that reveal both the individual-
ity and the common humanity of his models. "I discovered
that ordinary human beings with no great pretensions of
being handsome were somehow singing and beautiful in
their rhythms. . . . I discovered that I had to totally respect
the entity of a specific human being. It's a different idea
of beauty and it has to do with the gift of life, the gift of
consciousness, the gift of a mental life."[1]

Segal uses his friends and family as models, making
direct casts of their bodies, which are protected only by
Vaseline and Saran Wrap. The cast is produced in sections
from lengths of cloth dipped in hydrostone, a resilient plas-
ter used in industrial casts. After the individual sections
are removed from the model, they are reassembled — a
laborious and time-consuming task. The flexible plaster
shell can be manipulated into various forms and gestures.
"Originally I thought casting would be fast and direct, like
photography . . . but I found I had to rework every square
inch. I add or subtract detail, create a flow or break up an
area by working with creases and angles."[2]

The Billboard is an example of what Segal calls his
"work pieces," in which he investigates various occupa-
tions. *The Billboard* manifests, as does much of Segal's
sculpture, an ambiguous relationship to reality and illu-
sion. A real scaffolding provides the setting for the figure,
which was cast from a live model. The sign painter, how-
ever, is completely white and, frozen in the act of painting
the letter O, possesses an unreal, even mysterious quality.
J. F.

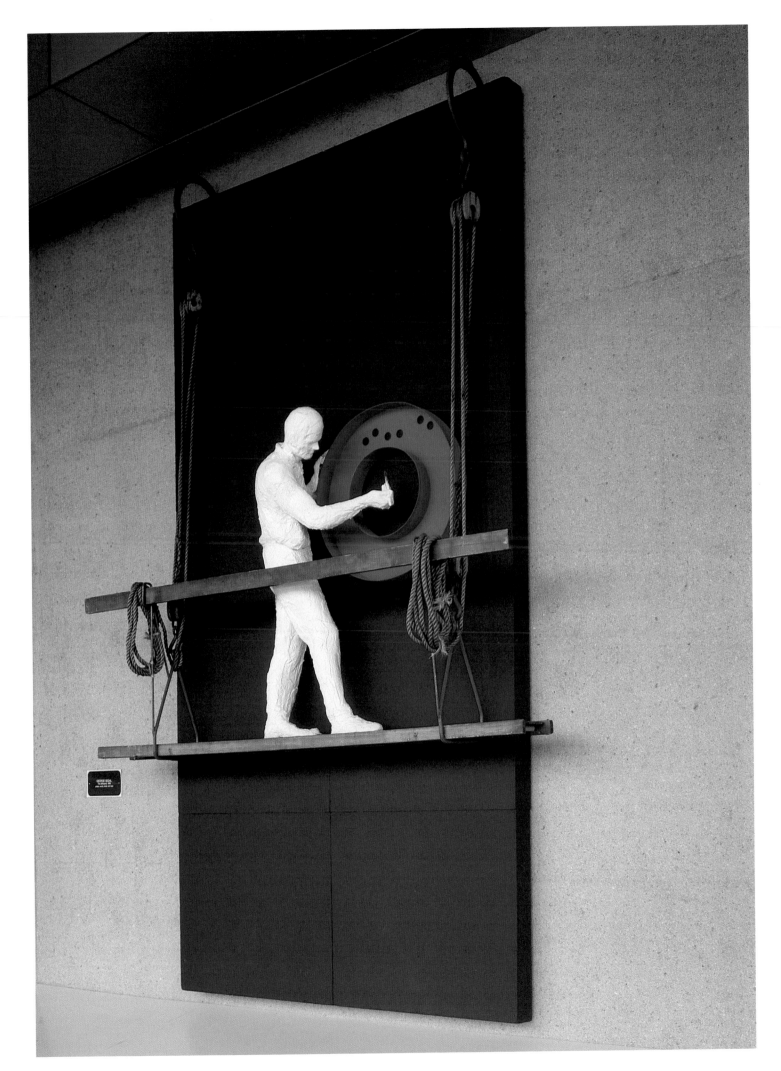

Jason Seley
1919–1983

Colleoni II, 1969–71
welded steel
11'-0" x 10'-0" x 5'-5"

Jason Seley graduated from Cornell University in 1940 and moved shortly thereafter to New York City, where he studied with direct-stone carver José de Creeft and later with Cubist sculptor Ossip Zadkine at the Art Students League. His early work in molding clay, terra-cotta, and plaster, often cast in metal, was largely figurative and influenced by Zadkine, Charles Despiau, Wilhelm Lehmbruck, and Henry Moore. During the 1950s, however, his sculpture became increasingly abstract and, like other artists of the period, Seley began incorporating found objects in his work.

In the late 1950s, impressed by the anthropomorphic qualities of a 1949 Buick Dynaflow bumper, Seley incorporated a chrome-plated automobile bumper into one of his sculptures for the first time. Automobile bumpers would henceforth become the hallmark of his work. Unlike Pop artists who deliberately exploited the associations of the artifacts of popular culture, Seley did not consciously elicit them but rather used automobile bumpers for their sculptural qualities and because they were readily available.

In the first half of the 1960s, Seley produced what might be called "action sculpture," a term coined by Peter Selz to describe the sculptural equivalent of action painting exemplified in the work of Willem de Kooning and others. This abstract sculpture, created without a preconceived plan, had the appearance of relative immediacy and took advantage of chance effects. Seley considered the work a bridge between the direct-metal sculpture of the early Abstract Expressionists such as Herbert Ferber and Ibram Lassaw and the simpler forms used by the Minimalists. During this period Seley created *Magister Ludi*, a piece included by The Museum of Modern Art in a major international exhibition, "Sculpture in the Open Air," in London. The piece was acquired by Nelson Rockefeller, who recommended Seley's inclusion in the Empire State Plaza Art Collection.

Although he continued to use automobile bumpers, Seley's style underwent a radical change in 1965 when he began to produce figurative sculpture. These included modern interpretations of well-known works such as the *Farnese Hercules*, the *Lupa Capitolina*, and the 1496 Venetian equestrian masterpiece *Colleoni* by Andrea del Verrocchio. In the late nineteenth century, many reproductions of monumental classical sculptures were erected in urban centers to provide a sense of history as well as edification for the populace; a full-scale bronze of the *Colleoni* was placed in Lincoln Park in Newark, New Jersey, where Seley grew up. Drawing on his own recollections of the statue and working from slides and reproductions, Seley produced a witty reinterpretation of the celebrated equestrian sculpture. *Colleoni II*, whose general outline was established by the sizes and shapes of the car bumpers, is smaller than the original. The intriguing surface disguises the identity of the bumpers and yet allows the contemporary and functional quality of the metal to be discerned as abstract forms.

J.F.

164

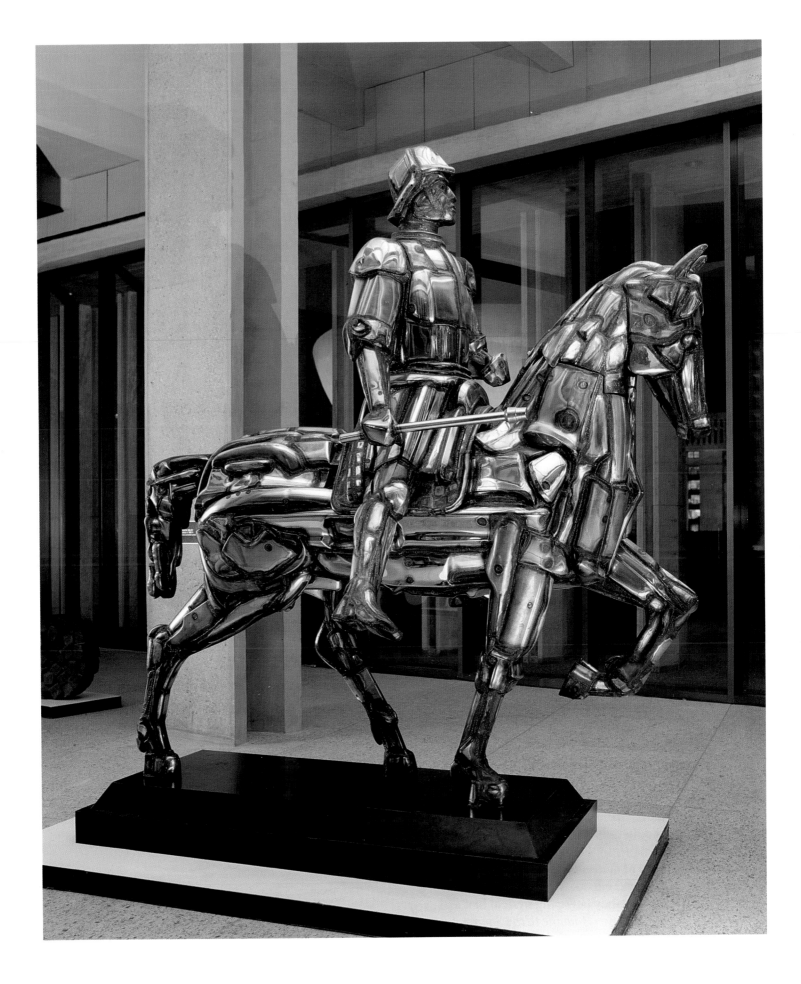

David Smith
1906–1965

Voltri–Bolton Landing Series
Voltri-Bolton III, 1962
painted steel
7′-10″ x 3′-2″ x 1′-0″

The sculpture of David Smith has been characterized as the "first major American challenge to the supremacy of . . . monolithism."[1] The assessment is appropriate, although at one crucial point in his career in the 1930s David Smith was inspired by European sculpture—the open, welded works of Pablo Picasso and Julio González. After seeing photographs of González's work, and observing the way his forms went "swinging off into space, Smith wished he could do the same."[2] From that point on, Smith explored the possibilities of "drawing in space" with welded metal.[3] Smith's sculpture from the 1940s until his death in 1965 is characterized by the contradiction between abstract and figurative work—a contradiction that is evident in the *Voltri–Bolton Landing* series, which includes the five sculptures in the Empire State Plaza Art Collection.

Smith was born in Decatur, Indiana, in 1906. After attending Ohio University, he spent the summer of 1925 working in a Studebaker plant where the assembly line had not yet been introduced and workers were required to do a wide range of technical jobs. It was here that Smith first learned to weld, as well as to rivet frames, and operate lathes and milling machines. In 1926 he moved to New York City and enrolled at the Art Students League. There he studied painting until 1932, when his conversion to sculpture took place. According to Smith: "When my painting developed into constructions leaving the canvas, I was then a sculptor, with no formal training. . . ."[4] In 1933 Smith began to work at the Terminal Iron Works in Brooklyn;[5] renting studio space on the premises, he began to apply the skills he learned there to his art. Between 1942 and 1944 Smith worked nights at the American Locomotive plant in Schenectady, New York, welding armor plate on tank destroyers. This experience profoundly affected his technique in the postwar period. He described his new method as "functional," claiming that "the equipment I use, my supply of material, come[s] from what I learned in the factory. . . . I have no aesthetic interest in tool marks, surface embroidery, or molten puddles. My aim in material function is the same as in locomotive building: to arrive at a given functional form in the most efficient manner."[6]

Often, as in the *Voltri–Bolton Landing* series, he incorporated into the finished work the very tools of metal forging—hooks, wrenches, tongs, pincers, mallets. Before starting on this series, Smith spent a month in Italy, where he had been invited to participate in the 1962 Spoleto Festival. Provided with a studio at an abandoned factory site at Voltri, outside Spoleto, he produced twenty-seven sculptures during his short stay. The sculptures from this period are called the *Voltri* series and are characterized by what Smith called a "chopped cloud" element—a flat steel sheet rolled out but not cut.[7] He also attached to the sculptures various metal-forging tools that had been abandoned at the site. When he left Voltri, he packed a crate of these found objects and had them sent to his studio-home at Bolton Landing, New York, where he announced he would "finish [his] Italian period."[8]

Smith worked on what Clement Greenberg eventually named the *Voltri–Bolton Landing*[9] series from December 1962 to mid-March 1963. The series contains twenty-five pieces, numbered sequentially according to the order in which they were completed. Smith also assigned each sculpture one of three names—*Voltri-Bolton, Volton* (no doubt a combination of the first syllable of "Voltri" and the last syllable of "Bolton"), and *VB*; unlike the numbering system, the names do not follow any logical order.

Each piece in this series incorporates items shipped from the Voltri studio and used to anthropomorphize the sculptures. In *Voltri-Bolton III* a set of pincers—open and standing on end—serves as legs. Straddling the top of the piece is a pair of tongs, jaws gaping wide to reveal a space that a head could occupy. In addition, the handles of the tongs are wrapped around each other with one end allowed to "swing out into space" like a gesticulating arm. *Volton XIII* is also figurative; its mallet legs create the impression that the form is walking to the left, a movement reinforced by the slanted piece of cut sheet metal attached to the joined ends of the mallets and by the right angle, which serves as an arm. Emptying the object of its original function, Smith used it for two purposes: both to produce representational form and to abstractly "draw in space." To understand how Smith's goals interact in the work, the viewer must move around the sculptures. If viewed from the left side of the line of sculptures at the Empire State Plaza, the two figurative pieces mentioned above form abstract patterns. Another piece, *VB XXI*, appears figurative from this vantage point. *Volton XVI*, its center formed by a wheel to which all other parts connect, has a rectangular form at the top of the work that resembles a head in profile. But the metal square can also be read as a reference to the frame of a painting. Smith was stridently opposed to the principles of Western painting represented by the frame, especially that which purports that all elements within a painting's frame form a unified whole. In opposition to this tradition, Smith's work provides the viewer with disparate views and contradictory images within the same piece of

169

David Smith
1906–1965

Voltri–Bolton Landing Series
Volton XIII, 1963
painted steel
7'-0" x 2'-3" x 1'-7"

sculpture. Contradictions are most evident in *Volton XVIII*, the most widely reproduced work in the series. Here, the complicated forms are specifically figurative at the same time that they produce a generalized design.

Although many of Smith's close friends — among them Robert Motherwell — were members of the New York School, for the most part, Smith remained — by his own choice — on the margins of its activities. Nevertheless, he is often regarded as an Abstract Expressionist who engaged in a "heroic struggle with material."[10] But if Smith can be considered to have participated in such a struggle, it was not in order to overcome the properties of his materials. Rather, he combined these properties — evident in the found objects — with illusionistic devices in such a way as to deny the supremacy of one over the other. It is not of primary importance to determine whether Smith's sculptures are ultimately figures or pure form or both. Smith's contribution to postwar American sculpture was to raise the question itself, stimulating new and different experiences of his works with each viewing.

K.O.

David Smith
1906–1965

Voltri – Bolton Landing Series
VB XXI, 1963
painted steel
6′-10″ x 1′-6″ x 1′-4″

173

David Smith
1906–1965

Voltri – Bolton Landing Series
Volton XVI, 1963
painted steel
6'-1" x 2'-3" x 2'-3"

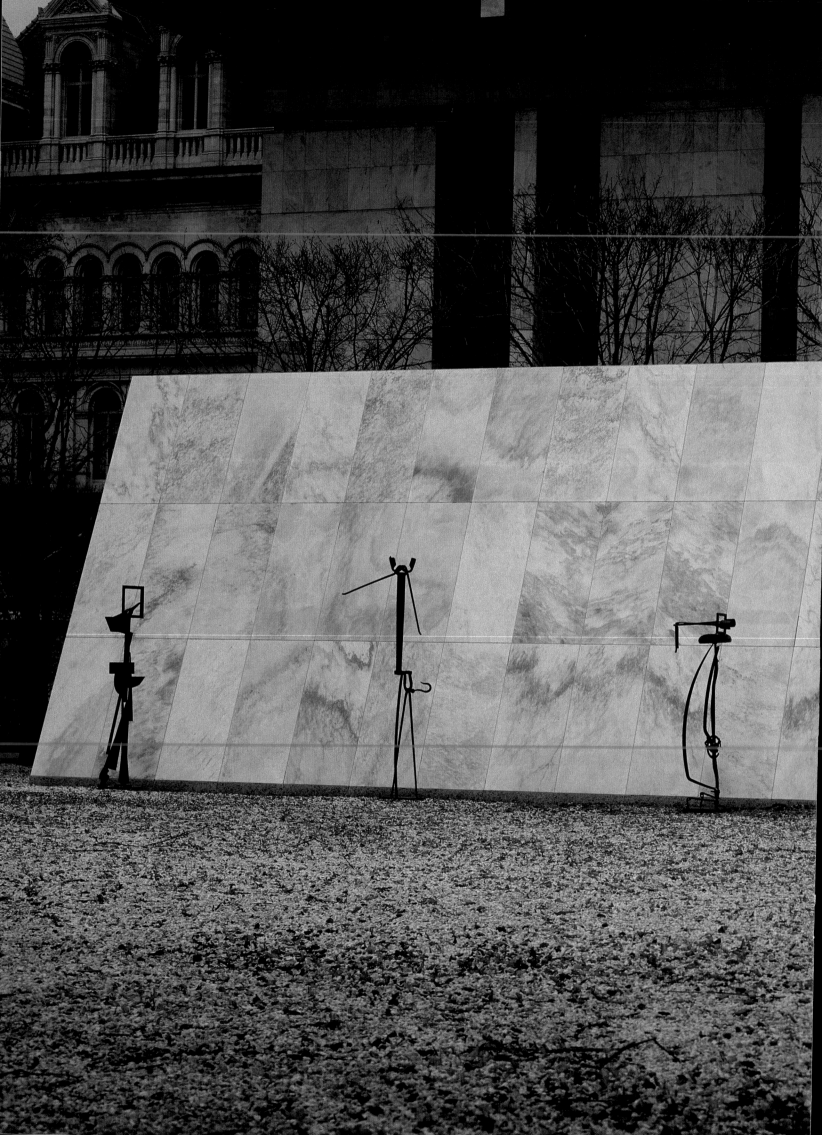

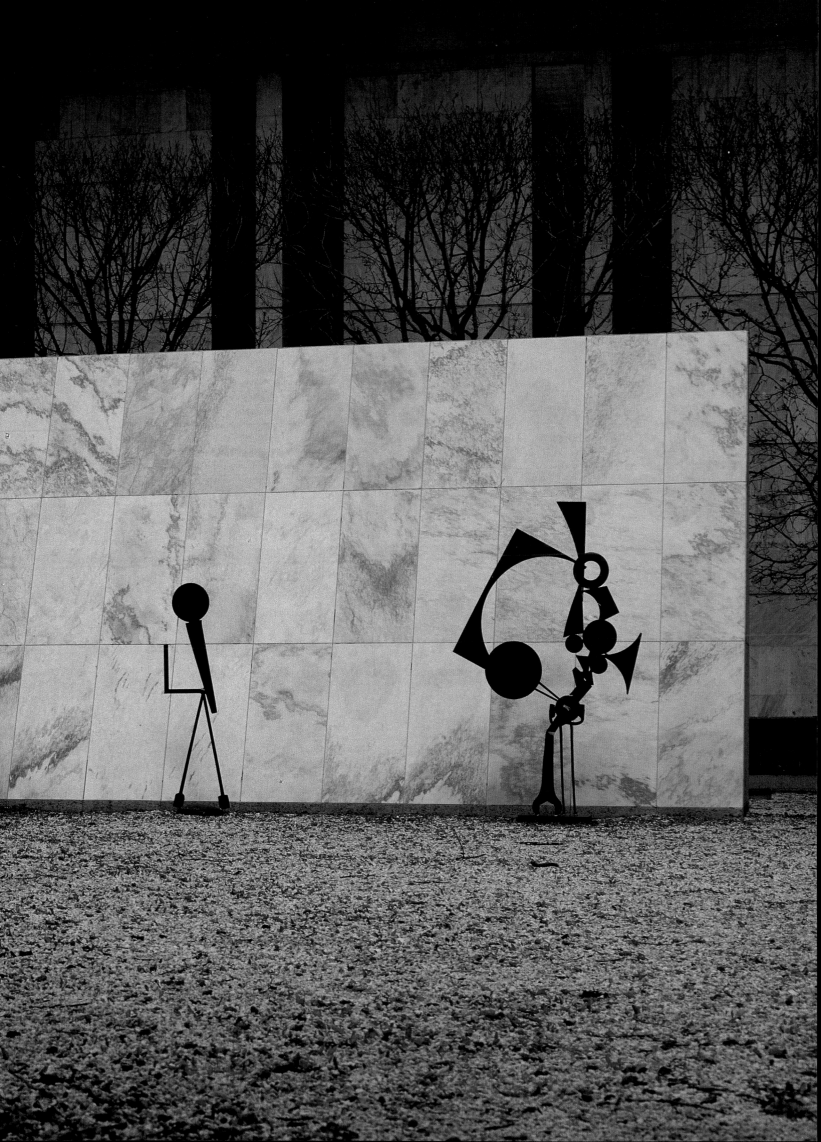

Tony Smith
1912–1980

The Snake Is Out, 1962–69
painted mild steel
14'-0" x 25'-6" x 18'-0"
edition 1/3

Tony Smith's work has been associated with both Abstract Expressionist painting and Minimal sculpture. Although he belonged to the same generation as his close friends Jackson Pollock, Barnett Newman, and Clyfford Still, he did not devote himself seriously to art until the early 1960s. The large, elegant geometric sculptures he produced at that time appeared to be related to Minimalist concerns, an association that was reinforced by Smith's initial public exposure in an important exhibition of Minimal art called "Primary Structures" held at the Jewish Museum in 1964. In contrast to the resolute avoidance of figurative references that characterizes Minimal art, however, Smith's work contains more evocative forms. Furthermore, the large scale of his work appears to have more in common with the grand, heroic, individualist gestures of Abstract Expressionism than with the impersonal assertion of objectness characteristic of Minimalism.

Smith was born in 1912 in South Orange, New Jersey. He studied at the Art Students League in New York City for several years in the early 1930s, while he worked at his father's ironworks. From 1937 to 1938 he studied architecture at the New Bauhaus in Chicago; in reaction to the rigorous formalist orientation of that school, however, he worked from 1938 to 1939 as an apprentice to Frank Lloyd Wright. Smith was a practicing architect from 1940 until 1960, during which time he built fourteen houses. From 1946 until his death in 1980, Smith was also a teacher whose ideas and encouragement were important to many younger artists. During his years as an architect, Smith also painted and, occasionally, produced sculptures, yet he thought of these activities as private pursuits. In 1960, feeling restricted by the domestic requirements of his clients, maintenance demands, and the lack of control over changes made to the houses he designed, Smith turned his attention to sculpture.

The Snake Is Out is an early work. Originally constructed in 1962 as a plywood model only 46 inches tall, it remained on Smith's back porch until 1969, when a steel version was commissioned for the Empire State Plaza. A second identical sculpture in an edition of three was also purchased by the Institute for the Arts, Rice University, in Houston, Texas. Smith explained the title of the work by the following anecdote: "As soon as I finished [*The Snake Is Out*], I realized the piece had a sense of movement, like a little dragon or a snake. . . . Then I remembered John McNulty's short story *Third Avenue Medicine*, in which he describes how bartenders watch for a vein to protrude from a man's forehead. It's a warning. He's drunk too much, and

the bartenders say 'The snake is out.'"[1] The undulating form that gives *The Snake Is Out* its name zigzags in space; one limb stretches out flat on the ground, then angles up and down again, forming a triangular opening. Massive forms interlock with the last leg so that one side has greater bulk and solidity. Because the piece changes radically from different points of view, the logic of its structure is not obvious from any single position. The viewer must experience the work by walking around the sculpture to see all its various forms and changing scale. The section resting on the ground is just above waist height; its human scale appears to invite the viewer into the space of the sculpture. Its triangular opening resembles a passageway or door. Overall, the looming height and massive forms achieve a grand and monumental scale appropriate to the sculpture's placement on the edge of the Empire State Plaza overlooking the City of Albany.

T.B.

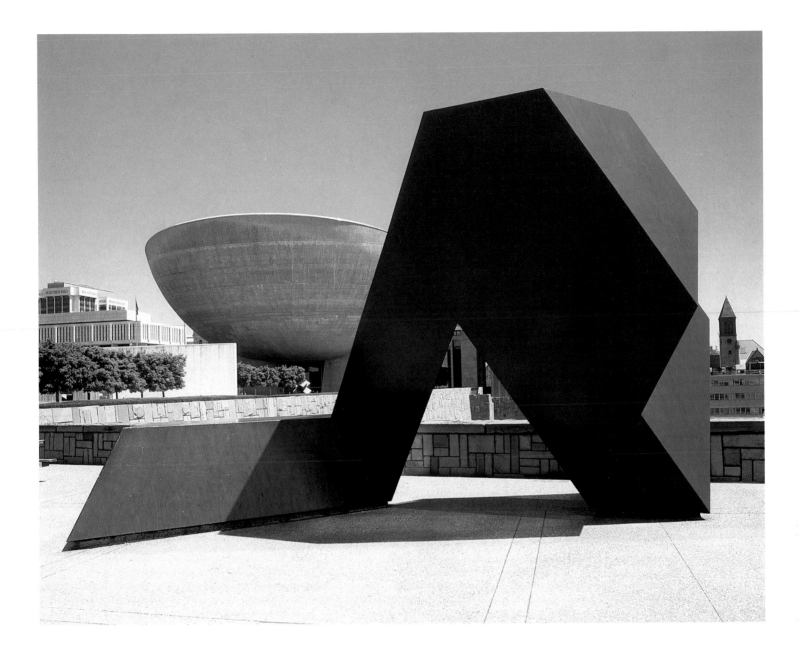

François Stahly
1911–

Labyrinth, 1970–71
teakwood
approximately 180'-0" x 70'-0"
with 39'-0" center column

True to its descriptive title, François Stahly's *Labyrinth* invites the spectator to meander through porticos of varying heights and widths, stopping at corners, crossing inner islands, or moving around the perimeter of the piece. Yet the title is somewhat inaccurate if a labyrinth is understood to be a confusing mazelike puzzle requiring a rigorous application of rational thought to navigate it successfully, for Stahly's *Labyrinth* poses no such problem. Located at the far end of the Empire State Plaza and off to one side, it serves as a secular sanctuary, an alternative environment wherein rationality can be temporarily suspended in a contemplative interaction with the piece. Stahly thus succeeded in his aim to "construct a quiet place in the midst of stress created by work and pleasure, to open up an area of calm which man today seems to be in ever greater need of."[1] Nonetheless, the specific arrangement of *Labyrinth*'s parts encourages a path of movement that echoes the daily patterns of walking through the Plaza itself, thereby reinforcing connections to the space of the real world.

Stahly's awareness of his audience and concomitant concern with the public usefulness of art perhaps stems from his training, starting at age fifteen, with former Bauhaus artists and students at the Kunstschule and Volksuniversität in Zurich, where he studied lithography and typography. Born in 1911 in Constance, Germany, Stahly grew up in Switzerland and in 1931 moved to Paris where he ultimately assumed French citizenship. There he studied art at the Académie Ranson with Aristide Maillol, had a brief encounter with Surrealism, and took part in the 1948 manifesto exhibition of the Tachistes entitled "HWPSMTB," an acronym for Hartung, Wols, Picabia, Stahly, Mathieu, Tapies, and Bryen, the artists in the show. Increasingly, his interests were directed toward the relationship between art and architecture. He began to collaborate with artists on diverse projects, including the altar decorations for a Trappist convent, the facade for a 1955 Paris Match exhibition pavilion, and the stained-glass windows of the Chapel of the Holy Sacrament at the Brussels World's Fair of 1958. Simultaneously, Stahly produced monumental freestanding sculpture that is often referred to as "totemistic."[2] Crafted in wood or stone, these sculptures are composed of interlocking, biomorphically shaped pieces arranged in vertical formations, which either stand alone or are clustered into reliefs. As reliefs, the sculptures can function as room dividers and have been commissioned for public lobbies or corridors.

In 1960 Stahly had an opportunity to experiment more fully with the process of collaborative artistic production.

He accepted invitations from several colleges in the United States—the University of California at Berkeley, the Aspen School of Contemporary Art, and the University of Washington at Seattle—where he worked with students on large, temporary sculpture projects, which he began and then allowed his students to finish. Such projects confirmed his commitment to playing an anonymous role in the production of sculpture, leaving the work open to in-progress intervention on the part of his coworkers as well as to the interpretation and participation of the viewer. These projects also stimulated Stahly to rethink the nature of the interaction between his sculpture and architecture. He writes: "It was only when I dissociated myself from the architectural context and sought within my own sculpture this hidden architecture which can link the latter to a place or to an event occurring in space that I was able to instill genuine life into so-called monumental sculpture."[3]

Stahly continued to experiment with these ideas in his studio at Meudon, outside Paris, and in his workshop in Provence. It was at his Meudon studio that Stahly developed a sculpture environment for Nelson Rockefeller's private estate on the Hudson River. While setting up *L'Eté de la forêt* there, Stahly showed Rockefeller photographs of a labyrinth sculpture he had built for the Faculty of Science complex in Paris, a work which became the prototype for the Empire State Plaza project. Despite the fact that a prototype existed and that at first glance *Labyrinth* appears to be composed of similar, seemingly mass-produced units, it is—like all of Stahly's environments—a one-of-a-kind piece. Each segment was handcrafted in teakwood and pieced together into units by Stahly and a team of four to six assistants, who lived and worked together for a year and a half at the Provence studio. After *Labyrinth* was finished and the team had disbanded, Stahly spent several months living with the piece, rearranging its parts before its shipment to Albany. Yet Stahly's commitment to producing sculpture communally has never faltered. In 1975 he published a book about his work in which he reconfirmed his belief that "the creative act is not a solitary gesture. The authenticity of a work comes from its universality, and thus links us directly to our neighbor. Within this perspective an almost anonymous collective piece of art becomes possible. The creative process can be shared."[4]

K.O.

Theodoros Stamos
1922–

Iberian Sun Box, 1967
oil on canvas
5'-10" x 4'-0"

Theodoros Stamos was born in 1922 in New York City. At the age of fourteen he was awarded a scholarship to the American Artist School, where he studied sculpture. He later turned to painting, supporting himself by working as a hat blocker, florist, printer, and frame maker. Stamos met Alfred Stieglitz, and through him became familiar with the work of Arthur Dove and Milton Avery. In 1943 Stamos had his first one-person exhibition at the Wakefield Gallery, which was managed by Betty Parsons. When Parsons later opened her own gallery, she continued to show Stamos's work along with that of Jackson Pollock, Willem de Kooning, and other Abstract Expressionists. In the 1940s Stamos met Barnett Newman and Mark Rothko, to whom he would remain close for many years. Though ten to twenty years younger than most of the other first-generation Abstract Expressionists, Stamos was closely connected with them and in 1951, when the famous group photograph entitled "The Irascibles" was taken and published in *Life*, Stamos was included.

Stamos's early paintings contain biomorphic forms that appear to flow through thin washes of color. In the 1950s his works became more gestural and were painted with a thick impasto. Eventually, Stamos returned to painting thin expanses of color, but the biomorphic forms disappeared and the paintings came to rely solely on a tension between the ground and a few lines and rectangles placed within it. The format of these compositions frequently resembles Rothko's characteristic arrangements: the canvas divided horizontally with relationships established between the edges, top and bottom halves, and the rectangles within. Stamos's thin, flat color resembles Newman's painting, although Stamos includes feathery lines and more agitated surfaces. His paintings produce the illusion of light emanating from within the painting, seducing the eye into a meditative trance.

Beginning in 1962, Stamos worked on a series of paintings he refers to as "sun boxes." These canvases are usually divided horizontally and contain floating rectangles of color. Stamos has said he was interested in echoing the effects of light seen through paper screens.[1] In *Iberian Sun Box*, a lemon yellow rectangle appears below a purple horizontal. Compared to the flat, opaque surface of the painting's yellow ground, this area appears more elusive and light filled, as though the sun were shining through it from behind. Yet it does not create the illusion of a hole in the painting. Rather, its relatively cool color establishes a tension with the warmth of the overall ground, resulting in a balance between the two. Similarly, an orange horizontal at the bottom of the canvas visually echoes the purple band which dissects the painting. The placement of the lemon yellow box between these two horizontals anchors the colors compositionally, frustrating any desire to see this painting as a landscape with a horizon.

T. B.

George Sugarman
1912–

Trio, 1969–71
painted aluminum
10'-0" x 32'-0" x 13'-10"

George Sugarman graduated from City College of New York in 1934. Until the outbreak of World War II, he supported himself with a variety of jobs including teaching arts and crafts for the Work Projects Administration (WPA). After serving in the U.S. Navy from 1941 to 1945, Sugarman returned to New York City and attended evening art classes at The Museum of Modern Art. In 1951 he went to Paris to study with Ossip Zadkine, a sculptor whose work in wood, bronze, and stone was known for its decorative qualities and expressionistic overtones.

Sugarman returned to New York in 1955. In 1957 he became a founding member of the Brata Gallery and the New Sculpture Group, formed in reaction to Abstract Expressionism's gestural ambiguity and close ties to Surrealism. The artists of the New Sculpture Group wanted to create truly abstract sculpture by eliminating the vertical orientation that alluded to the human figure. In addition, they conceived of sculpture as reaching into and activating the surrounding space rather than being confined to finite boundaries.

In 1959, with the creation of *Yellow Top*—later acquired by the Walker Art Center in Minneapolis—Sugarman began to paint sections of his sculpture different colors in order to define the individual forms. Vibrant color became a hallmark of Sugarman's work. Until 1968 Sugarman worked primarily in wood. As he became interested in public sculpture and in working on a larger scale, he changed his medium to metal, both to simplify the labor involved and to make his work suitable for outdoor installation. His first outdoor works were enlargements of maquettes created without any specific site in mind, but his later public works relate more directly to their particular environments.

Trio is one of Sugarman's earliest large-scale outdoor pieces. Unlike his later sculpture, in which he adapted his ideas to flat sheet metal cutouts, *Trio*, although simplified, is similar to his earlier pieces in wood. In this sculpture and in other works from the same period, Sugarman abandoned his use of disparate shapes and colors and explored what he calls "seed form"—a single shape that develops and changes. The right-hand shape in *Trio* is the seed form from which the other sections grow and expand. In the last of the three sections the oval form is turned around and opened up, outlining a progressively large interior volume where an interplay of light, form, and shadow may be experienced from both inside and out. Sugarman himself suggested the siting of *Trio*, and its location along a busy pedestrian walkway gives viewers the opportunity to walk through and around it, exploring its many curves and angles.

George Sugarman's inventive and exuberant sculpture invites public participation. Even when it is very large, his art retains a human scale; rarely does it impose a heavy, monumental presence on the viewer. As formal and as intellectual as his creative process may be, Sugarman believes that art has to work on a visual level and "that a one-to-one physical experience is the basis for even the intellectual aspects of art."[1]

J.F.

Jim Sullivan
1939–

Sojourno, 1969
aquatec on canvas
10'-1" x 7'-2½"

In 1971, at the age of thirty-two, Jim Sullivan had his first one-person exhibition in New York City, where his work was well received and extensively reviewed. The paintings in his first show were described as "lyrical abstractions." In contrast to color-field painting—abstractions with wide expanses of thinly applied color, often containing geometric shapes—Sullivan's paintings were thickly impastoed works that recalled the painting of gestural Abstract Expressionism. In association with several younger painters, Sullivan was reacting against color-field painting, the dominant style of abstraction in the sixties, and instead drawing on sources from the preceding generation of Abstract Expressionists.

Sojourno was painted before Sullivan's first solo exhibition. It shows that Sullivan's painting did not develop directly from Abstract Expressionism but was influenced by paintings from the sixties by artists such as Kenneth Noland, Jules Olitski, and Frank Stella. For example, the expansive field of red paint in *Sojourno* has been airbrushed on; Olitski had begun using this technique in his spray paintings of 1965. The airbrush process produced an even, velvety surface unbroken by any indication of the artist's brushstroke. This "impersonal" surface characterized many paintings of the sixties, when artists of various persuasions were reacting against the subjective, gestural brushstrokes of the Abstract Expressionists. Although the airbrush process was to some extent mechanical and left little room for error, pentimenti of covered rectangles remain in *Sojourno* as evidence of the artist's decision-making process. Furthermore, the use of light-colored rectangles that activate the surface corresponds to geometric tendencies prevalent in the art of the sixties. On the other hand, certain aspects of *Sojourno* predict changes to come in Sullivan's work. Within the carefully delineated rectangles, colors have been dripped onto the surface in a manner that recalls Jackson Pollock's paintings. These gestural markings signify concepts of chance and artistic subjectivity that would soon play a more important role in Sullivan's painting. *Sojourno* juxtaposes the two styles and derives interest from the resulting tension.

Sullivan's work has continued to change throughout his career. In the late seventies he abandoned abstraction and began to produce paintings with figurative images or scenes. This work was associated with New Image painting and has been included in shows with the work of younger artists such as Susan Rothenberg and Eric Fischl.

T.B.

194

David von Schlegell
1920–

West End, 1966
aluminum
10'-4" x 16'-6" x 2'-6"

David von Schlegell, born in St. Louis, Missouri, in 1920, studied engineering at the state university and later worked as an architect, aeronautical engineer, and boat builder before attending the Art Students League in New York between 1945 and 1948. At the League he studied with the painter Yashuo Kuniyoshi and his father, William von Schlegell, also a painter and well-respected teacher. Von Schlegell's first solo exhibition was held at the Poindexter Gallery in New York in 1948. He continued to paint throughout the 1950s, showing his work in Boston while living in Maine. In 1961 Von Schlegell abruptly stopped painting and devoted his attention to sculpture. His first sculptures were made of steamed wood. Within a short time, however, he became dissatisfied with the medium's organic qualities and explored instead the use of metal, specifically, aluminum, which he found to be a stronger but less assertive material.

During the 1960s Von Schlegell was closely allied to the Park Place Group, begun in the fall of 1963 as a cooperative founded by Paula Cooper at 79 Park Place in New York City. Among the group's early members were Mark di Suvero, Forrest Myers, Edwin Ruda, Robert Grosvenor, and, later, David Novros. Inspired by the sculpture of David Smith and Alexander Calder, the Park Place artists constructed abstract sculptures and paintings, utilizing flexible geometric forms. Although they were interested in science and mathematics, their geometric compositions were frequently eccentric and contrasted with the impersonality and rigidity of Minimalist forms.

In 1966 Von Schlegell was included in the influential "Primary Sculptures" exhibition at the Jewish Museum in New York. That same year he made *West End*, which was among the first sculptures to be selected by the Art Commission for the Empire State Plaza. In *West End*, two asymmetrical projections thrust outward from a tilted triangular base and perch precariously in space. The sculpture's placement contributes to the sense of imbalance: only the tip of one wing and the edge of the triangular base touch the floor. Earlier, Von Schlegell had constructed self-balancing pieces, but during the mid-sixties he produced more enigmatically supported structures, which were unobtrusively bolted in place. During this period, Von Schlegell also used polished aluminum for the ambiguous effects created by reflected light on its polished surface.[1] *West End's* mirrorlike finish seductively reflects its surroundings; the Justice Building's marble and teakwood walls and the sunlight streaming in through floor-to-ceiling windows contribute to the sculpture's overall impact.

Since the 1970s Von Schlegell has worked primarily on monumental outdoor commissions. Although he believes sculpture should maintain its own presence, he allows the sculptural environment to influence his form and maintains that successful public art must attain a balance between site and sculpture.

T.G.

Peter Voulkos
1924–

Dunlop, 1967
bronze
7'-0" x 13'-0" x 4'-0"

Peter Voulkos is best known for his innovative ceramic pots and sculptures, which are considered by many critics and art historians to have diminished the traditional hierarchical distinctions between craft and fine art. Influenced by the Abstract Expressionists Jackson Pollock, Franz Kline, and Willem de Kooning, Voulkos adapted their spontaneous gestural techniques to his work in clay, abandoning the more traditional shapes of functional pottery for asymmetrical forms that are gouged and torn and painted with slashing strokes of color and glaze. A well-known teacher in California and a charismatic personality, he popularized Abstract Expressionist ideas in Los Angeles, influencing the painting, sculpture, and ceramics produced there.

Voulkos was born in 1924 in Bozeman, Montana, to parents of Greek origin. After serving in the U.S. Army Air Force from 1943 to 1946, he entered Montana State University to study art. Intending to study painting, he developed an interest in ceramics during his senior year. Although Voulkos continued to paint, he attended the California College of Arts and Crafts in Oakland for graduate studies in ceramics and sculpture. In 1953 he was invited to teach at Black Mountain College in North Carolina for the summer. From there he traveled to New York, where he was introduced to Abstract Expressionism by Kline, De Kooning, and Philip Guston, among others. In 1954, already well known as a potter, he was invited to become chairman of the new ceramics department at the Otis Art Institute in Los Angeles. Voulkos built a pottery studio and developed the program into a center of artistic discussion and activity. At this time he began to integrate Abstract Expressionist concepts and stylistic features into his painting and ceramics. In the late 1950s he developed techniques that enabled him to construct large-scale ceramic sculptures of stacked and protruding forms, although many of these were destroyed during the process of firing. Feeling limited by the clay medium, Voulkos began to work with metals, experimenting with larger sculptures which, like those of David Smith, expanded into surrounding space and changed in appearance from different points of view.

In 1959 Voulkos accepted a teaching position at the University of California at Berkeley, where the following year he set up a bronze casting foundry. His first bronze sculptures were small, and by casting gnarled pieces of wax he gave them agitated, expressionistic surfaces. By the mid-1960s Voulkos's forms became more geometric; they were cast separately, assembled, and welded together. Despite the standardization of his sculptural vocabulary,

Voulkos's direct working procedure allowed him to retain his spontaneity, changing and reworking forms intuitively.

Named for a manufacturer of racing-car tires, *Dunlop* consists of elements drawn from Voulkos's repertoire of standard shapes—cylinders, domes, elbowlike forms, as well as T forms built from sheet metal. Derived from everyday objects, such as the inner tube of a tire and cooking kettle, these forms are welded together in a curvilinear rhythm. The feeling of elasticity contrasts with the actual rigidity of the metal. Different vantage points offer new juxtapositions of shapes and spaces as the viewer walks around the work; the open composition allows forms to interweave and overlap in various combinations.

T.B.

William T. Williams
1942–

Sweets Crane, 1969
acrylic on canvas
9′-7″ x 9′-2″

William T. Williams was born in North Carolina in 1942, but grew up in New York City, where, for the most part, he has remained. He began his training as an artist at Pratt Institute, earned a master of fine arts degree at Yale University, then returned to New York to paint. Since 1971 he has been a professor of art at Brooklyn College.

In the late 1960s, in addition to producing the colorful, geometric, hard-edge abstractions for which he is best known, Williams experimented with more unusual materials and formats — paintings with ground glass, constructions of linoleum and sequins, exhibitions accompanied by blaring radios.[1] These works, incorporating elements from everyday life, appear radically different from paintings such as *Sweets Crane*. Even within the boundaries of painterly formalism, however, Williams refers to artistic forms other than painting.

Sweets Crane contains references to the decorative arts, sculpture, and architecture. From a distance, the gold color of the center suggests the gold leaf used in Japanese folding screens. At close range, however, visible brushstrokes in this section convey a sculptural, tactile quality. The tactility is heightened by the contrast between this section and the flat, unmodulated colors of the squares, which echo the painting's central form. These overlapping "frames" direct the eye outward toward forms painted a highly reflective bronze color — another reference to sculpture. While these frames are composed of unmodulated, flat color, their oblique geometry makes them appear to hover at an angle to the picture plane. They recede toward an illusory background space at the right or project forward at the left. Polelike forms of blue-black, blue, and yellow intersect the squares, seeming to push them back and shove them up like scaffolding in an architectural construction.

Despite apparent similarities, Williams's paintings differ significantly from the work of several prominent contemporaries. For example, comparisons could be drawn between his work and Frank Stella's "protractor paintings" — both artists use bright color and geometric curves — yet Stella's work at this time unequivocally reinforces the flatness of the canvas as opposed to Williams's illusionistic warping of the picture plane. It might at first also seem appropriate to relate Williams's work to Op Art, since both employ color and references to mathematical systems in order to activate the viewer's vision. Yet Op Art stayed within the rigidly established boundaries of modernist painting wherein the flatness of the picture plane is continually reaffirmed.

Williams's references to sculpture and architecture and to processes of folding, shaping, or constructing create the illusion of a vast three-dimensional space. In part, the artist's inspiration may have come from the same source as his more experimental work of the late 1960s: everyday life. As Marcia Tucker has asserted: "One of Williams's color ideas comes from his sense of color in crowds — that is, the unexpected and fluctuating combinations that cannot be systematized or fixed at any particular point in space."[2]

K.O

James Wines
1932–

Grey Disc, 1968
painted cement and steel
8'-0" diameter x 1'-4"

Since 1970 James Wines, who was trained as an architect, has become better known for his architecture than for his sculpture. In that year, with Alison Sky, an experimental sculptor and photographer, and Michelle Stone, a photographer and writer, he opened the architectural design firm SITE, an acronym for "Sculpture in the Environment." Intending to make art that related to its surroundings and to the people who live with it, SITE designed buildings that successfully avoided the debased Bauhaus aesthetic pervasive in architecture in the 1950s and 1960s. In fact, they often used the functional design elements of modern architecture in a completely nonfunctional way. SITE is most famous for their Best Products Company showrooms in which the facades literally peel or crumble into their surroundings.

Born in 1932 in Chicago, Wines moved to Baltimore in 1947. His artistic ability gained him a scholarship to Syracuse University and, after graduating in 1955, he won a Rome Prize Fellowship the following year and moved to Italy. His early figurative sculpture developed by 1960 into abstract works with forms that referred to landscape elements. It was his intention to make sculptural environments in which the viewer could become involved. Increasingly interested in environmental sculpture, Wines moved to New York City in 1962 in search of commissions for public works. Influenced by the urban architectural environment, Wines used cement and metals to produce geometric, architectonic forms. In 1966 he stated: "It is the scale, constructivist approach, and almost classic clarity of architecture and the machine that interests me now as a source. . . . In my work using steel and reinforced concrete I have taken my cue from the construction process of architecture. When the supporting steel skeleton is erected there is open-work sculpture. The concrete fills in to complete the mass. In sculpture this wedding of linear shape with the monolith makes it possible for me to relate the textural variety of soft and hard surfaces, industrial geometry with organic form, graphic line against modeled shape —all this within a tightly woven construction."[1]

Grey Disc is made of these construction materials—steel and cement—and colored black. Seen from its dominant frontal side, polished, black-lacquered bands emphasize the vertical and horizontal slits that divide the circular disc into quarters. Their smooth, shiny surface contrasts with the softer black mat of the cement. Similarly, the large scale and weight of the piece contrasts with the illusion created by its suspension in space. Hanging from the ceiling, this massive disc appears to float several inches off the floor. The slits in the surface, positioned at the points of greatest stress, also reinforce the illusion of airiness, allowing background light to penetrate the sculpture's mass and reveal its softly molded edges and variations of material. The view from the opposite side similarly contrasts the large, architectonic construction with the illusion of weightlessness.

T.B.

204

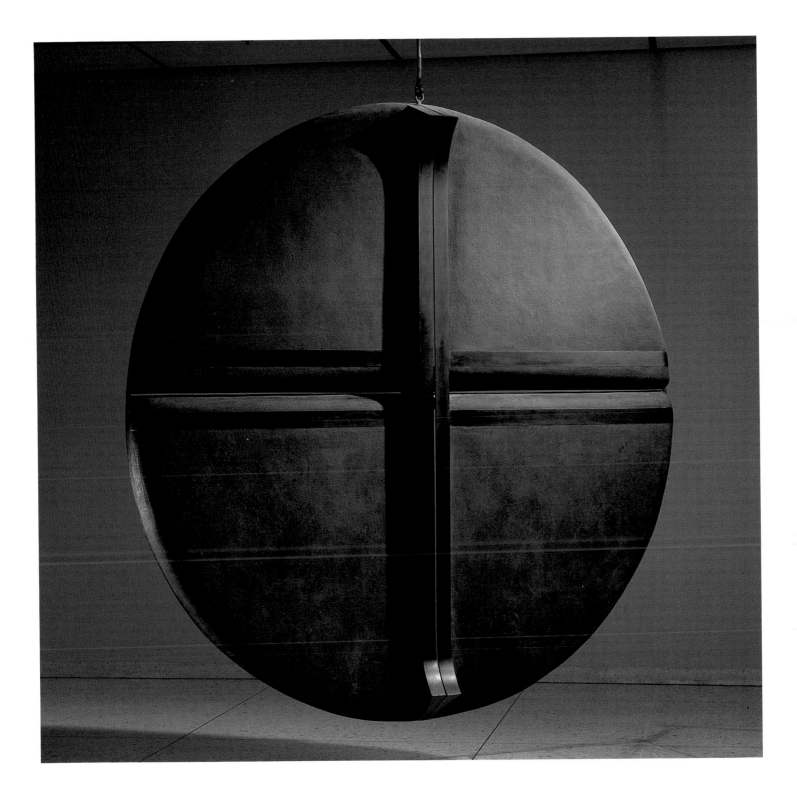

Jack Youngerman
1926–

Eastward, 1967
acrylic on canvas
9'-0" x 16'-0"

Characterized by unmodulated colors and large, organic forms with precisely defined edges, the hard-edge paintings of artists such as Jack Youngerman developed independently from the gestural canvases of the New York School. The roots of the style of Youngerman and other hard-edge abstractionists such as Ellsworth Kelly can be found in the works of Henri Matisse, Joan Miró, Jean Arp, and Constantin Brancusi, which these artists saw in Paris. Working in New York, however, they integrated features of Abstract Expressionism into their art, establishing an important new direction for New York School painting.

Born in St. Louis, Missouri, in 1926, Youngerman moved in 1929 to Louisville, Kentucky, where he grew up. He did not begin his serious art training until he enrolled at the Ecole des Beaux Arts in Paris in 1947. Remaining in Paris until 1956, Youngerman met other Americans working there, including Kelly, and visited the studios of Brancusi and Arp. Returning to New York, Youngerman settled at Coenties Slip in lower Manhattan, where his neighbors included Kelly, Jasper Johns, Robert Rauschenberg, and Agnes Martin, among others. By 1958 he was exhibiting at Betty Parsons Gallery, and in 1959 he was included in the important exhibition "Sixteen Americans," curated by Dorothy Miller. Soon his work was purchased by major collectors including Nelson Rockefeller.

In his work of the late 1950s, Youngerman adopted the craggy, impacted contours and dark color typical of Clyfford Still's paintings and applied them to his own free-form images seen against a contrasting ground. In the 1960s, increasingly attracted to Kelly's work, he painted flatter surfaces and smoother edges with brighter color. Although he shares "an insistence on economy of means" with Kelly, Youngerman is more concerned with "finding and inventing new shapes."[1] In contrast to Kelly's gently curvilinear forms, Youngerman's are generally more eccentric and dynamic. They evolve from black-and-white ink drawings in which Youngerman "try[s] to let things happen spontaneously, to allow the shape to burst into being." He is attracted to shapes that appear "buoyant and soaring" yet locked within the confines of the borders and flat surface of the canvas.

Youngerman does not deny that his abstract forms evoke figurative associations, but it is his intention that the references remain ambiguous and, therefore, individual for each viewer. "We are immersed in the powerful and autonomous images of the world," he has written, "before these forms are possessed and diminished by names and uses — the names preempting the form. Painting involves the restoring of the image to that original primacy."[2]

Eastward was commissioned for the lobby of one of the agency buildings in the Empire State Plaza. Like Nicholas Krushenick's and Oli Sihvonen's paintings in similar locations, it is a bright, active composition that attracts attention in the otherwise muted, gray lobby. The wide angle of the back wall echoes the curvilinear quality of the painted forms. A brilliant white, vaguely triangular form resting on a sloping horizontal dominates the painting. The shape of this image, placed against a rich blue background, is reversed below in a similar, but splintered, form on a lime green ground. The painting is reminiscent of a landscape with a blue sky, green ground, and a mountain and its shadow. The formal relationships between figure and ground and the top and bottom halves of the canvas assert themselves independently of these associations, however. Emphasis lies in the flat, solid rendering of the image seen in contrast to an expansive energy conveyed by the forms.

T.B.

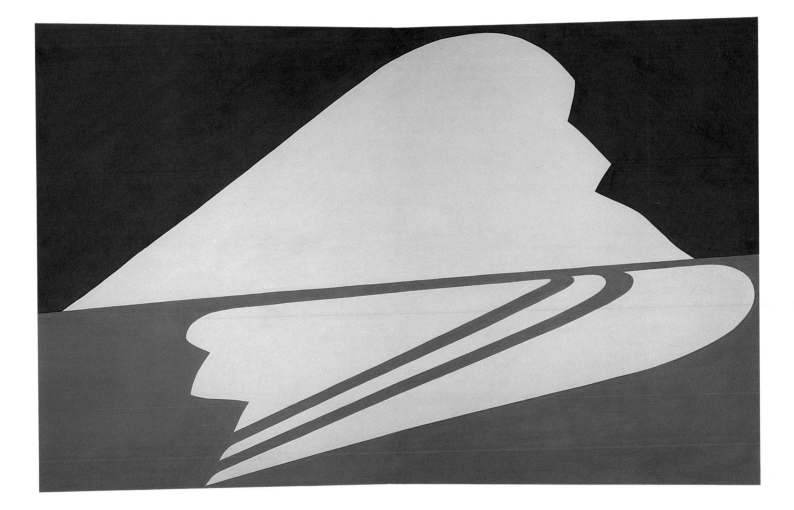

Larry Zox
1936–

Gemini Series I, 1968
acrylic on canvas
6'-6" x 18'-0"

Larry Zox is one of the generation of artists who reacted against the free-wheeling gestures of Abstract Expressionism by devising more mechanical processes of making art. Explaining his motivation, he stated: "I couldn't deal with the dilemma of the idea of an empty canvas the way the Abstract-Expressionists did — so what I had to do was find a mechanical or an automatic way of getting into a painting."[1]

Zox did not arrive at his method immediately. Born in Des Moines, Iowa, in 1936, he spent several years at the University of Oklahoma. He then returned to Des Moines to attend Drake University and take classes at the Des Moines Art Center, where he studied with George Grosz. He came to New York in 1958 and remembers being especially impressed with paintings by Willem de Kooning and Franz Kline. In New York, Zox began making collages that consisted of painted pieces of paper stapled to plywood supports. It was not until 1962 with his "rotation" paintings that Zox began his first series of works employing a regularized, more mechanically produced format. This format changed little from painting to painting, although the works were distinguished by variations in color. Zox's development toward a mechanical mode of painting was not unlike that of his contemporary Frank Stella, whose famous Black canvases of the late 1950s initiated a swing toward a systematic approach to art.

With the *Gemini* series, which Zox worked on between 1967 and 1970, his emphasis on color became even more evident. The canvases of the paintings from this group are either squares or narrow vertical rectangles. Large expanses of painted color form stretched-out, four-pointed stars bordered by triangles of color that fill out each side of the stars to form squares. *Gemini Series I* is made up of three of these square configurations. The color was applied with a silk-screen squeegee, the paint soaking into the canvas to produce smooth, even surfaces. Masked off with tape before the paint was applied, the edges are even. A thin band of unpainted canvas has been left between each shape to allow the color to breathe, a technique also used by Stella. The colors are brilliant, expansive reds, yellows, purples, and greens that push forward and back within a shallow space, activating the surface. They are not the rich, deep colors of oil but the more eye-catching, plastic colors of acrylic. Although Zox claims that his colors were chosen randomly,[2] the painting seems carefully structured. The overall brilliance of the painting, relieved here and there with more subdued color, and the repetition of the design work to form a decorative whole. T.B.

Notes

Introduction

1. Carol Herselle Krinsky, "St. Petersburg-on-the-Hudson: The Albany Mall," in Moshe Barasch and Lucy Freeman Sandler, eds., *Art the Ape of Nature: Studies in Honor of H. W. Janson* (New York: Harry N. Abrams, 1981), p. 772.
2. Ibid., p. 777.
3. Ibid., p. 774.
4. Nelson A. Rockefeller, "Albany Mall," *Architecture Plus* (July–August 1974): 78.
5. Ibid., p. 77.
6. *National Endowment for the Arts: 1965–1985 (A Brief Chronology of Federal Involvement in the Arts)*, booklet (Washington, D.C.: Office of Public Information, National Endowment for the Arts, 1985), pp. 12, 17.
7. Nelson A. Rockefeller, Acknowledgments (dated 1978), in *The Nelson A. Rockefeller Collection: Masterpieces of Modern Art* (New York: Hudson Hills, 1981), p. 5. Lee Bolton, photographs; William S. Lieberman, text; Nelson A. Rockefeller, introduction; Alfred H. Barr, Jr., essay; and Dorothy Canning Miller, ed., preface.
8. Robert Rosenblum, "An Appreciation," *Dorothy C. Miller: With an Eye to American Art*, exhibition catalogue (Northampton, Mass.: Smith College Museum of Art, 1985), unpaginated.
9. Memorandum from Wallace K. Harrison to Robert M. Doty, February 26, 1969, appendix to Minutes of the Art Commission meeting, February 18, 1969.
10. Meyer Schapiro, "The Liberating Quality of Avant-Garde Art," *Art News* (Summer 1957): 39.
11. The sixteen commissioned works of art in the Empire State Plaza are by Ronald Bladen, Roger Bolomey, Gene Davis, Fritz Glarner, Al Held, Nicholas Krushenick, Alvin D. Loving, Jr., Sven Lukin, Clement Meadmore, Forrest Myers, George Rickey, Oli Sihvonen, François Stahly, George Sugarman, Jack Youngerman, and Larry Zox.

12. Among the factory-made pieces on the Empire State Plaza are those by Ellsworth Kelly, Lyman Kipp, Clement Meadmore, Forrest Myers, James Rosati, Tony Smith, and George Sugarman.
13. Brian O'Doherty, *American Masters: The Voice and the Myth* (New York: Ridge Press, Random House, 1973), p. 201.
14. Thomas B. Hess, "A Descent into the Mall Storm," *New York Magazine* (August 16, 1976): 66.
15. Russell Lynes, *Good Old Modern: An Intimate Portrait of The Museum of Modern Art* (New York: Atheneum, 1973), p. 120.

Richard Anuszkiewicz

1. Rosalind Krauss, "Afterthoughts on 'Op,' " *Art International*, vol. 9, no. 5 (June 1965): 75.

Ronald Bladen

1. Barbara Rose, "ABC Art," *Art in America* 53 (October-November 1965): 63.

Roger Bolomey

1. Roger Bolomey, telephone conversation with author, June 16, 1986.
2. Roger Bolomey, letter to Nelson Rockefeller, April 10, 1967.

Ilya Bolotowsky

1. Magdalena Dabrowski, *Contrasts of Form, Geometric Abstract Art 1910–1980* (New York: The Museum of Modern Art, 1985), p. 153.

Lee Bontecou

1. Carter Ratcliff, *Lee Bontecou* (Chicago: Museum of Contemporary Art, 1972), unpaginated.
2. Donald Judd, "Lee Bontecou," *Arts Magazine* 39 (April 1965): 20.

James Brooks

1. April Kingsley, "James Brooks: Critique and Conversation," *Arts* 49 (April 1975): 56.
2. Michael Preble, *James Brooks* (Portland, Maine: Portland Museum of Art, 1983), p. 10.
3. April Kingsley, "James Brooks: Stain into Image," *Art News* 71 (December 1972): 48.

Lawrence Calcagno

1. Anthony Bower, "Introduction," *Lawrence Calcagno: Retrospective Exhibition* (Greensburg, Pa.: The Westmoreland County Museum of Art, 1967), unpaginated.

Alexander Calder

1. Joan M. Marter, "Alexander Calder: Cosmic Imagery and the Use of Scientific Instruments," *Arts Magazine* 53 (October 1978): 108–113.

Mary Callery

1. Christian Zervos, quoted in *Mary Callery, Symbols*, M. Knoedler & Co., New York, March 28–April 22, 1961, unpaginated.

Chryssa

1. Sam Hunter, *Chryssa* (New York: Harry N. Abrams, 1974), p. 9.

Nassos Daphnis

1. Irene Rousseau, "Nassos Daphnis: An Artist in the Art World," *Arts Magazine* 57 (May 1983): 129.
2. Robert M. Murdock, *Nassos Daphnis: Work Since 1951*, Albright-Knox Art Gallery, March 9–April 13, 1969, unpaginated.
3. Al Brunelle, "Nassos Daphnis:

Obsession with the Harvest," *Art News* (April 1973): 72.

Gene Davis

1. Walter Hopps, "Gene Davis and the Stripe as Subject Matter," *Art News* (February 1975): 32.
2. Donald Wall, "Gene Davis and the Issue of Complexity," *Studio* (November 1970): 190.
3. Gene Davis, Art at the Plaza Lecture Series, Empire State Plaza, Albany, New York, lecture delivered March 23, 1982.

Herbert Ferber

1. Herbert Ferber, Art at the Plaza Lecture Series, Empire State Plaza, Albany, New York, lecture delivered May 12, 1980.
2. Lisa Phillips, *The Third Dimension* (New York: Whitney Museum of Art, 1984), p. 20.

Naum Gabo

1. Christina Lodder, *Russian Constructivism* (London: Yale University Press, 1983), p. 38.

Fritz Glarner

1. James Fitzsimmons, "Fritz Glarner," *Arts and Architecture*, vol. 73 (July 1956): 4.

Adolph Gottlieb

1. Jeanne Siegel, "Adolph Gottlieb, Two Views," *Arts Magazine*, vol. 42, no. 4 (February 1968): 30.
2. Thomas B. Hess, "The Artist as a Pro," *New York Magazine* (December 4, 1972): 97.
3. William S. Rubin, "Adolph Gottlieb," *Art International*, vol. III, no. 3–4 (1959): 37.

Philip Guston

1. Dore Ashton, "Art," review of exhibition at the Jewish Museum, *Arts and Architecture* 83 (April 1966): 7.

Dimitri Hadzi

1. Peter Selz, "Dimitri Hadzi," in *2 Pittori 2 Scultori* (exhibition catalogue for the American Pavilion, Biennale XXXI, Venice, 1962), unpaginated.
2. Albert Elsen, "Sculpture with a Memory," *Art News*, vol. 77 (September 1978): 80.

Grace Hartigan

1. Stephen Westfall, "Then and Now: Six of the New York School Look Back," *Art in America* (June 1985): 118.
2. Grace Hartigan, Art at the Plaza Lecture Series, Empire State Plaza, Albany, New York, lecture delivered April 14, 1980.
3. Ibid.
4. Westfall, "Then and Now," p. 118.

Will Horwitt

1. As quoted in a press release from Vanderwoude Tananbaum, May 8–31, 1985.

Paul Jenkins

1. Alain Bosquet, *Paul Jenkins* (Paris: Editions Prints, 1982), p. 18.
2. Paul Jenkins, *Anatomy of a Cloud* (New York: Harry N. Abrams, 1983), p. 84.
3. Harold Rosenberg, "The American Action Painters," *Art News*, vol. 51, no. 5 (December 1952): 22.
4. Albert Elsen, *Paul Jenkins* (New York: Harry N. Abrams, 1975), p. 75.

Alfred Jensen

1. Linda Cathcart, "Paintings and Diagrams from the Years 1957–1977," in *Alfred Jensen* (Buffalo: Albright-Knox Gallery of Art, 1977), p. 9.
2. Marcia Tucker, "Mythic Vision: The Work of Alfred Jensen," in *Alfred Jensen*, p. 13.

Ellsworth Kelly

1. E. C. Goossen in *Ellsworth Kelly* (New York: The Museum of Modern Art, 1973), pp. 87–88.

Lyman Kipp

1. Bruce Glaser et al., "Where Do We Go from Here?," in *Contemporary Sculpture/Arts Yearbook 8* (New York: The Art Digest, 1965), p. 154.
2. Sidney Zimmerman, "Review," *Arts Magazine*, vol. 40, no. 3 (January 1966): 62.
3. Jay Jacobs, "Projects for Playgrounds," *Art in America*, vol. 55, no. 6 (November-December 1967): 44.

Franz Kline

1. Harry Gaugh, *The Vital Gesture: Franz Kline* (New York: Abbeville Press, 1985), p. 138.
2. Robert Goldwater, "Franz Kline: Darkness Visible," *Art News*, vol. 66 (March 1967): 43.
3. Elaine de Kooning, "Franz Kline: Painter of His Own Life," *Art News*, vol. 61 (November 1962): 31.
4. The title of Harry Gaugh's recently published book on Kline (see note 1).

Alexander Liberman

1. Thomas B. Hess, "Notes for an Interview with Alexander Liberman," in *Alexander Liberman,*

Painting and Sculpture 1950–1970 (Washington, D.C.: The Corcoran Gallery of Art, April 19–May 31, 1970), p. 20.

Seymour Lipton

1. Andrew Carnduff Ritchie, "Seymour Lipton," *Art in America* 44 (Winter 1956–57): 15.

Morris Louis

1. Michael Fried, "Some Notes on Morris Louis," *Arts Magazine* 38 (November 1963): 25.

Alvin D. Loving

1. *Alvin Loving* (New York: Whitney Museum of American Art, 1970), unpaginated.

Sven Lukin

1. Donald Judd, "Specific Objects," in *Donald Judd, Complete Writings 1959–1975* (Halifax: The Press of Nova Scotia College of Art and Design; New York: New York University Press, 1975), pp. 181–189.
2. Sven Lukin, quoted in Elizabeth C. Baker, "Solid Anti-Geometry," *Art News* (March 1966): 75.

Conrad Marca-Relli

1. H. H. Arnason, *Conrad Marca-Relli* (New York: Harry N. Abrams, 1963), unpaginated.

Clement Meadmore

1. Jeanne Siegel, "Clement Meadmore: Circling the Square," *Art News* (February 1972): 56.
2. In a 1967 interview by David Sylvester, quoted in Harold Rosenberg, *Barnett Newman* (New York: Harry N. Abrams, 1978), p. 246.

Forrest Myers

1. Corinne Robins, "Four Directions at Park Place," *Arts Magazine* 40 (June 1966): 24.

Louise Nevelson

1. Hilton Kramer, "Introduction," in Jean Lipman *Nevelson's World* (New York: Hudson Hills Press and Whitney Museum of American Art, 1983), p. 13.
2. Laurie Wilson, "Bride of the Black Moon: An Iconographic Study of the Work of Louise Nevelson," *Arts Magazine* 54 (May 1980): 141, 145.
3. Lipman, *Nevelson's World*, p. 164.

Isamu Noguchi

1. Nancy Grove, "Isamu Noguchi: The Image of Energy," *Arts Magazine* 60 (September 1985): 112.
2. Ibid.
3. Sam Hunter, *Isamu Noguchi, 75th Birthday Exhibition* (New York: The Pace Gallery and Andre Emmerich Gallery, 1980), unpaginated.

Kenneth Noland

1. Kenworth Moffet, *Kenneth Noland* (New York: Harry N. Abrams, 1977), p. 15.

Gyora Novak

1. J.P., "Reviews and Previews," *Art News* 65 (December 1966): 15.

David Novros

1. Corinne Robins, "Four Directions at Park Place," *Arts Magazine* 40 (June 1966): 23.

Kenzo Okada

1. Gordon Washburn, *Kenzo Okada, Painting 1952–1965* (Tokyo: The Asahi-Shimbun Press, 1966), unpaginated.
2. Ibid.

Claes Oldenburg

1. Claes Oldenburg, *Oldenburg: Six Themes*, with introduction and interviews by Martin Friedman (Minneapolis: Walker Art Center, 1975), pp. 32–33.
2. Ibid., p. 25.
3. Barbara Haskell, *Claes Oldenburg: Object into Monument* (Pasadena, Calif.: Pasadena Art Museum, 1971), p. 110.

Raymond Parker

1. Jon Hutton, "Dialogue: Conversations with Ray Parker and Doug Ohlson," *Arts Magazine*, vol. 56 (April 1982): 128.

Beverly Pepper

1. "Beverly Pepper: 'A Space Has Many Aspects,'" interview by Jan Butterfield, *Arts Magazine* 50 (September 1975): 91.
2. Ibid.
3. Beverly Pepper, "The Artist on Her Sculpture: Excerpts from a Letter, July 22, 1975," in *Beverly Pepper Sculpture 1971–75* (San Francisco: San Francisco Museum of Art, 1975), unpaginated.

William Pettet

1. Jane Livingston, "Reviews: Los Angeles," *Artforum*, vol. VII, no. 6 (February 1969): 70.

George Rickey

1. Nan Rosenthal, *George Rickey* (New York: Harry N. Abrams,

1977), p. 27.

James Rosati

1. Stanley Kunitz, "Sitting for Rosati the Sculptor," *Art News* (March 1959): 38.
2. Barbara Rose, "Blow Up—the Problem of Scale in Sculpture," *Art in America*, vol. 56, no. 4 (July-August 1968): 91.
3. James Rosati, *Art Now: New York*, vol. 2, no. 9 (1970), unpaginated.

Bernard Rosenthal

1. Gibson Danes, "Bernard Rosenthal," *Art International*, vol. 7, no. 3 (March 20, 1968): 47.
2. Transcript of lecture delivered by Bernard Rosenthal at the Empire State Plaza, April 1, 1981.

Mark Rothko

1. Irving Sandler, *Mark Rothko Paintings 1948–1969* (New York: Pace Gallery, 1983), p. 6.
2. Robert Rosenblum, "The Abstract Sublime," in *New York Painting and Sculpture: 1940–1970*, ed. Henry Geldzahler (New York: E.P. Dutton, 1969), p. 353.

Edwin Ruda

1. Ed Ruda, "Park Place 1963–1967," *Arts Magazine*, vol. 42, no. 2 (November 1967): 33.
2. David Bourdon, "E = MC² à Go-Go," *Art News*, vol. 64, no. 9 (January 1966): 23–24.

Julius Schmidt

1. Julius Schmidt, *Sixteen Americans*, ed. Dorothy Miller (New York: The Museum of Modern Art, 1959), p. 64.
2. Irving Sandler, "Reviews and Previews: New Names This Month,"

Art News, vol. 60, no. 2 (April 1960): p. 18.

George Segal

1. Phyllis Tuchman, *George Segal* (New York: Abbeville Press, 1983), p. 115.
2. Jan Van Der Marck, *George Segal* (New York: Harry N. Abrams, 1979), p. 29.

Oli Sihvonen

1. Josef Albers, as quoted in George Heard Hamilton, *Painting and Sculpture in Europe 1880–1940* (Baltimore: Penguin Books, 1972), p. 345.
2. Oli Sihvonen, in conversation, New York, April 23, 1985.

David Smith

1. Stanley E. Marcus, *David Smith: The Sculptor and His Work* (Ithaca, N.Y.: Cornell University Press, 1983), p. 17.
2. From a 1975 interview with Dorothy Dehner, cited in Marcus, *David Smith*, p. 39.
3. "Aerial drawing," "drawing in air," and "drawing in space" have been used throughout the writings on Smith's work by two of his chief critics, Clement Greenberg and Rosalind Krauss.
4. Cleve Gray, ed., *David Smith by David Smith* (New York: Holt, Rinehart and Winston, 1968), p. 52.
5. Smith ultimately used the name of this foundry as the name for his workshop-studio at Bolton Landing, New York. He lived and worked at Bolton Landing from 1940 until his death in 1965.
6. Gray, *David Smith*, pp. 52–53.
7. See Rosalind E. Krauss, *The Sculpture of David Smith: A Catalogue Raisonné* (New York: Garland Publishing Co., 1977), p. 101.
8. Cited in Giovanni Carandente, *Volton* (Philadelphia: Institute of

Contemporary Art, University of Pennsylvania, 1964), p. 14.
9. Clement Greenberg, "David Smith's New Sculpture," *Art International*, vol. 8, no. 4 (May 1964): 36.
10. Rosalind E. Krauss, *Terminal Iron Works: The Sculpture of David Smith* (Cambridge, Mass.: The MIT Press, 1971), p. 6.

Tony Smith

1. Tony Smith, as quoted in "Sculpture by Order," *Time* (September 14, 1970): p. 72.

François Stahly

1. François Stahly, *François Stahly*, preface by Pierre Descargues (Brussels: La Connaissance, 1975), p. 162.
2. See, for example, Julien Alvard, "Paris," *Art News* (December 1966): p. 18.
3. Stahly, *François Stahly*, p. 157.
4. Ibid., p. 163.

Theodoros Stamos

1. Ralph Pomeroy, *Stamos* (New York: Harry N. Abrams, n.d.), p. 55.

Clyfford Still

1. E.C. Goossen, "Painting as Confrontation: Clyfford Still," *Art International*, vol. 4, no. 1 (1960): 39.

George Sugarman

1. George Sugarman, Art at the Plaza Lecture Series, Empire State Plaza, Albany, New York, lecture delivered August 1, 1979.

Jack Tworkov

1. Jack Tworkov, "Notes on My

Paintings," *Art in America*, 61
(September 1973): 69.

David von Schlegell

1. Jay Jacobs, "The Artist Speaks:
David von Schlegell," *Art in
America*, 59 (May-June 1968): 56.

William T. Williams

1. See April Kingsley, "From
Explosion to Implosion in the Ten
Year Transition of William T. Wil-
liams," *Arts Magazine* (February
1981), pp. 154–155.
2. Marcia Tucker, *The Structure of
Color* (New York: The Whitney
Museum, 1971), p. 19.

James Wines

1. Quoted by David Sellin in *James
Wines Recent Sculpture 1963–66*
(Hamilton, N.Y.: Charles A. Dana
Creative Arts Center, Colgate
University, 1966), unpaginated.

Jack Youngerman

1. Quoted in Barbara Rose, "An
Interview with Jack Youngerman"
(also the two following quotations),
Artforum 4 (January 1966): 27–30.
2. Jack Youngerman, "Portrait:
Jack Youngerman," *Art in America*
(September-October 1968): 53.

Larry Zox

1. Lawrence Campbell, "Larry in
the Sky with Diamonds," *Art News*
66 (February 1968): 59.
2. Ibid.